FROM THE RECORDS OF THE MID-CONTINENT PUBLIC LIBRARY

J709 D56
Dickins, Rosie.
The Usborne introduction to art

MID-CONTINENT PUBLIC LIBRARY Raytown Branch 6131 Raytown Road Raytown, MO 64133

				٠	
				Σ	
			Ç.ºº		
			5		

In association with The National Gallery, London

Rosie Dickins with Mari Griffith

Art Historical Advisor: Dr. Erika Langmuir OBE

Edited by Jane Chisholm

Designed by Mary Cartwright,

Vici Leyhane and Catherine-Anne MacKinnon

Americanization editor: Carrie Seay

Internet-linked

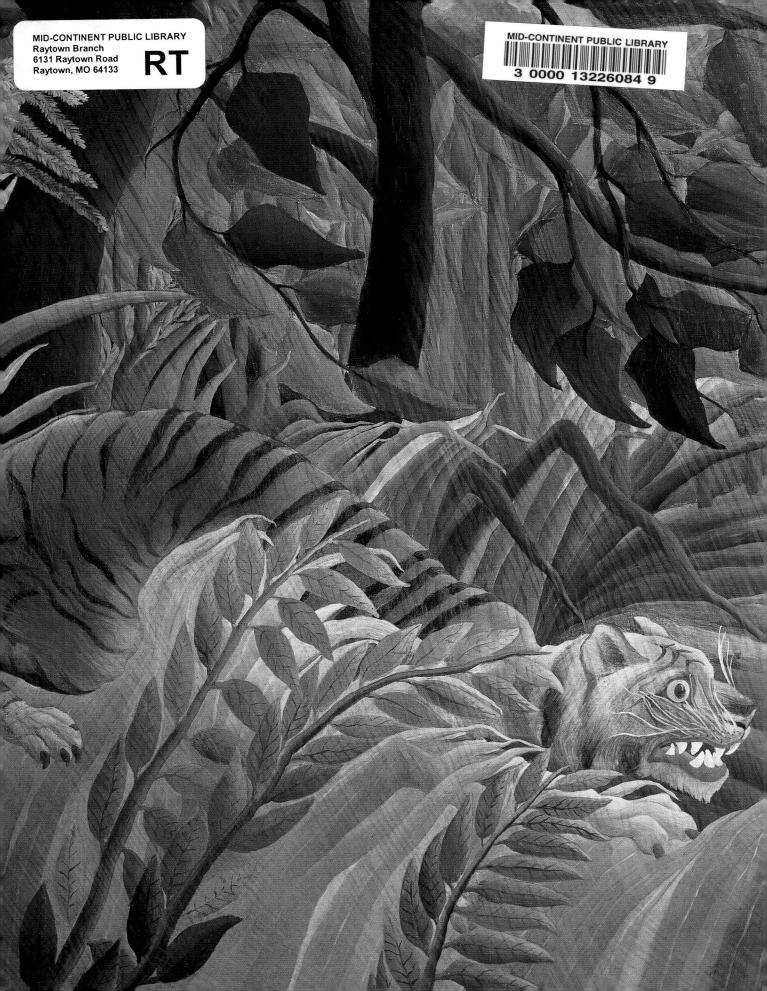

Contents

Introduction What is art?	6	Baroque and Rococo		The modern world		
Looking at paintings	8	1600 to 1800		New perspectives	100	
Fact and fiction	10	Dramatic art	54	Art and emotion	102	
Familiar faces	12	The Supper At Emmaus	56	Less is more	104	
Setting the scene	14 16	Wars of religion	58	Fantastic art	106	
The art of illusion		Fit for a king	60	War and propaganda	108	
		Peace And War	62	Guernica	110	
Ancient and		Town and country	64	Pop and performance	112	
medieval art		Everyday life	66	Art today	114	
Art and magic	20	Making arrangements	68			
Classical art	22	Flights of fancy	70			
Patterns and monsters	24 26	High society Vacation snapshots	72	Behind the		
Saints and sinners			74	scenes		
The Wilton Diptych	28			Artists' materials	118	
Art and prayer	30	Revolution		Tricks of the trade	120	
Courtly delight	32	1800 to 1900		Preserving pictures	122	
Courty delight	32	Making history	78 80	Faking it	124	
The Renaissance		Sun and storm		Timeline	126	
1400 to 1600		Dreams and legends	82	About the artists	128	
Making it real	36	City life	84	Glossary	134	
Born again	38	Rain, Steam And Speed	86	Amazing art facts	138	
Renaissance portraits	40	The great outdoors	88	Using the Internet	139	
The Arnolfini Portrait	42	Bathers At Asnières	90	Index	140	
A fresh look	44	Colorful ideas	92			
Telling stories 4		Getting away from it all	94	These pages shows a local Company		
Venus And Mars	48	Breaking the window	96	These pages show a detail from <i>Tiger In A Tropical Storm – Surprised!</i> (1891) by Henri Rousseau. You can see the whole picture on page 95.		
Outdoor scenes	50					

Internet links

Look for Internet link boxes throughout this book. They contain descriptions of websites where you can find out more about art. For links to these websites, go to the **Usborne Quicklinks Website** at **www.usborne-quicklinks.com** and type the keywords 'introduction to art'.

The websites described in this book are regularly reviewed and the links in **Usborne Quicklinks** are updated. However, the content of a website may change at any time and Usborne Publishing is not responsible for the content of any website other than its own. Please follow the Internet safety guidelines on page 139.

What is art?

The word 'art' can be used to describe anything from prehistoric cave paintings to a heap of junk in the corner of a gallery. It can even be used to refer to music and literature, but most often it means *visual* art, or things which are made to be looked at – especially paintings.

The great debate

People have argued about art, what it is and why it's so great, for centuries. Artists and experts often have very different ideas, leading to some violent disputes. The French painter Manet disagreed with a critic so strongly, he challenged him to a duel. There are lots of controversial questions, but no right or wrong answers. Everyone has different tastes and opinions, so it is up to you to decide what you think.

Some people think art should be beautiful or lifelike; others think it is more important to capture a mood or feeling. Just compare the two paintings on this page. One looks almost photographic. The other is much sketchier and painted with only a few colors, but very atmospheric.

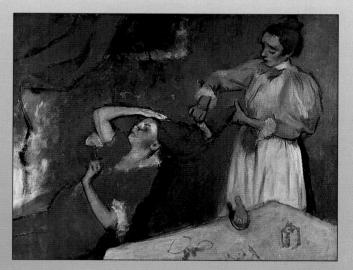

Some surprising things have found their way into galleries.

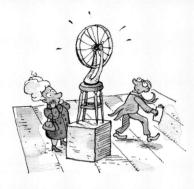

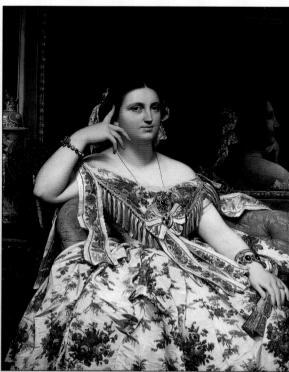

Madame Moitessier (1856), by Ingres. Although this looks very realistic, Ingres cheated with the angle of the mirror to make it reflect Madame Moitessier's profile.

Combing The Hair (about 1896), by Edgar Degas. Degas used warm, reddish colors to make this scene feel cozy and intimate.

Detail from *Bathers At Asnières* by Georges Seurat. This painting caused huge controversy because of the way it showed ordinary people. Find out more on pages 90-91.

What's it all about?

Some people believe art should be about ideas. Others prefer to enjoy art for its own sake. The Impressionists (see page 89) had some heated debates over this very question. Some of them felt it was important to paint scenes of modern life; others were more interested in exploring the effect of light on things.

What's it worth?

People often disagree wildly about the value of art. Vincent van Gogh died in poverty, because no one would buy his paintings – even his friends said they looked like the work of a madman. Now, they are among the most valuable pictures in the world. And critic John Ruskin ended up in court in a dispute over *Nocturne In Black And Gold*, by James Whistler.

Ruskin thought Whistler's painting was far too haphazard. He couldn't believe the artist wanted 200 guineas for "flinging a pot of paint in the public's face." Whistler's response was that the painting's value didn't depend on how long it took him to paint, but on his genius and years of study. He sued Ruskin for libel and won – although he was awarded only a farthing (a quarter of a penny) in damages. So it seems the judge really agreed with Ruskin.

Nocturne In Black And Gold – The Falling Rocket (1875), by U.S. artist James Whistler. This painting caused a huge dispute in the 1870s. It's so blurry, it's hard to see what's going on. In fact it shows a firework display. At the time, people were used to glossy, highly finished pictures, so this one seemed very sketchy by comparison.

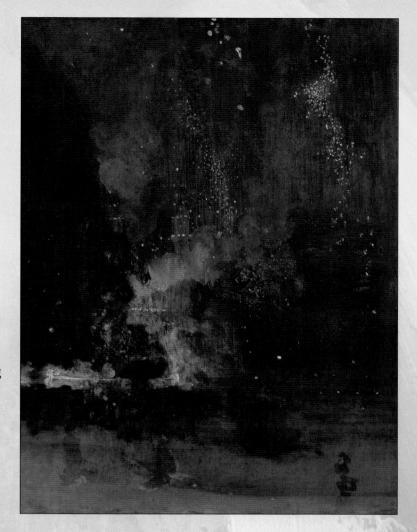

But is it art?

Today, there is a bigger emphasis than ever on making art new and original. Artists are constantly pushing the boundaries of what we think of as 'art.' So there is more and more controversy about it, and about the high prices collectors sometimes pay for it. Some of the things artists have exhibited include a bicycle wheel on a stool, a painting of a pipe labeled *This Is Not A Pipe*, a pile of bricks, a plain white canvas, a pile

of garbage from a party (later thrown away by mistake) and an unmade bed. Does that sound like art to you? Some of them weren't even made by the artist – they were just things he or she had found. You might not expect to find them in a gallery at all. Does seeing them there make them art? They can certainly provoke strong reactions and make you see things in a new way – which traditional paintings often do, too.

Styles and themes

This book traces the history of western painting. It is arranged roughly in order of date, so you can see how artists' styles and techniques have changed over time. Each section covers a major period of art history, introducing its main themes and ideas, and looking at a few important paintings in more depth. If you can, try to visit an art gallery or museum to look at real paintings as well. Then you can examine all the details and see how big they really are. The sizes of paintings in this book are given at the back.

There is nothing quite as vivid and exciting as seeing a real painting in front of you.

Looking at paintings

You don't have to know much about paintings to enjoy looking at them, but you may find you get more out of them if you do. These pages suggest things to look for and think about in paintings.

For a link to a website where you can explore the different parts of an artist's toolkit, go to www.usborne-quicklinks.com

What's it all about?

One of the first things to decide about a painting is what it's about. Paintings are divided into different groups, or 'genres,' according to what they show. The main genres are story-telling scenes, portraits, landscapes and 'still lifes' or arrangements of objects. These are all explained in more detail over the next few pages. This picture, by Raphael, is a scene from a story about a knight and a dream he had. The women are meant to be from the dream, not real people.

How is it arranged?

Scenes are usually arranged, or 'composed,' to make you look at them in a certain way. Important figures or objects may be bigger, brighter or more centrally placed, to make you notice them first. So here, you automatically look at the knight first. He lies in the middle of the picture, beneath the gaze of the two women.

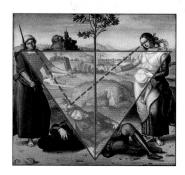

The picture has a triangular structure, divided by the tree. The lines of the women's gazes meet on the knight's head.

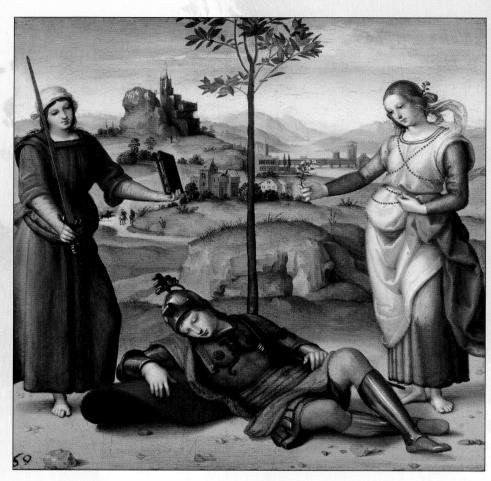

Vision Of A Knight (about 1504), by Raffaello Sanzio, known as 'Raphael.' The knight is asleep and dreaming about the choice he will have to make between duty, represented by the serious figure on the left, and pleasure, shown by the beautiful woman on the right. Raphael probably based the knight on the Roman hero Scipio, who described a dream like this.

What does it mean?

Artists often put in hidden clues, or symbols, to help you guess what a picture means. Sometimes, the clues represent general ideas. For example, the book and sword in the picture above symbolize learning and action, while the sprig of flowers represents beauty

and pleasure. Symbols can also help identify who's in the picture. Well-known characters, such as saints, are often shown with a symbol from their lives, so experts can tell who they are meant to be. You can see some examples of saints' symbols on page 27.

Paintings are full of clues, if you know what to look for.

Why was it made?

When you look at a picture, it helps to know the motive behind it. Was it meant to decorate a grand palace, or to hang in a church to help people pray? Or was it just made to be seen in an art gallery, where people could admire its beauty or think about the ideas behind it? Was it meant to have a political, social or moral message, or was it made to express an emotion?

Raphael's painting was made to order, so he would have been told what to paint. It was probably a gift for a young nobleman, and was meant to make him think. But the painting on this page was made for pleasure – it doesn't have an obvious message. The artist, Pierre-Auguste Renoir, painted what he wanted, and people bought his pictures just because they liked how they looked.

How was it painted?

The style of a painting, and even the paint itself, is worth looking at, too. Painting materials and techniques have changed hugely over time. And artists' brushwork can be as distinctive as handwriting. Some paint in a smooth, polished way, while others use expressive dabs and swirls. You can see the difference if you look at the two patches below.

Raphael used tiny brushstrokes to create a neat, even surface.

Renoir painted in a quick, loose style. You can still see his brushmarks in the paint.

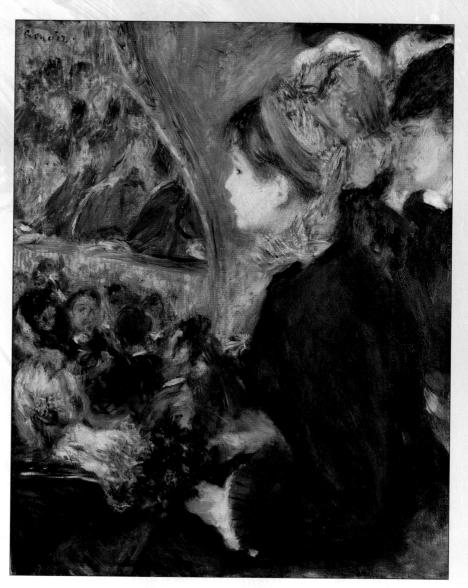

At The Theatre (1876-77), by Pierre-Auguste Renoir. Sometimes called *The First Outing*, this shows a young woman on her first trip to the theatre. She is sitting in a box, gazing out at the rest of the audience, looking slightly overwhelmed by the sight.

Do you like it?

Another question to ask yourself is whether you like a painting or not, and why. People have very personal feelings about art, so this is a

matter of taste - and tastes change. When paintings like Renoir's first appeared, some critics attacked them for looking too sketchy. But now they are greatly admired. There are no rules. It is up to you to decide what you think about the pictures you see.

People often have very different ideas about what makes a 'good' painting.

Fact and fiction

Until about 150 years ago, the most important, expensive and prestigious kind of painting was something known as history painting. This meant any large-scale picture that told a story – whether real or fictitious – and included Classical myths and Bible stories, as well as historical scenes. History painting first became popular during the 15th century, and remained so until well into the 19th century.

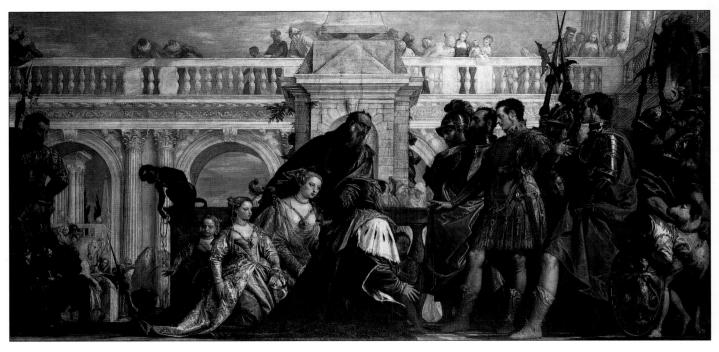

The Family Of Darius Before Alexander (1565-70), by Paolo Veronese. This came from a palace in Venice.

The hardest challenge

A great 15th-century writer named Leon Battista Alberti described history painting as the hardest challenge for an artist. To choose suitable subjects, he said, artists had to be well-read. Then they had to know how to tell stories without words, using only gestures and expressions. To create lifelike scenes, they had to understand perspective, lighting and anatomy – and they had to be able to arrange everything into interesting compositions. So history painting needed a lot of thought and imagination, as well as skill with brushes and paint. In Alberti's time, most people thought of artists as just craftsmen. But he used history painting to argue they were really intellectuals and deserved greater respect.

Veronese's painting shows the ancient Greek leader, Alexander the Great, receiving the family of Darius, king of Persia, whom he has defeated in battle. Veronese makes Alexander stand out by giving him red clothes and showing him with his arms spread wide, as he steps forward to reveal his identity.

Top of the heap

When the French Academy of Painting and Sculpture was founded in 1648, its members decided to rank the different genres of painting in order of importance. Pride of place went to history painting. This order formed the basis of art theory for over a hundred years, helping to make these narrative scenes very popular.

In the news

Large-scale paintings used to be reserved for grand religious or patriotic subjects. But that changed in the 19th century, as artists began creating history paintings based on contemporary news stories. One of the first of these was *The Raft Of The Medusa*, inspired by the wreck of a French ship in 1816.

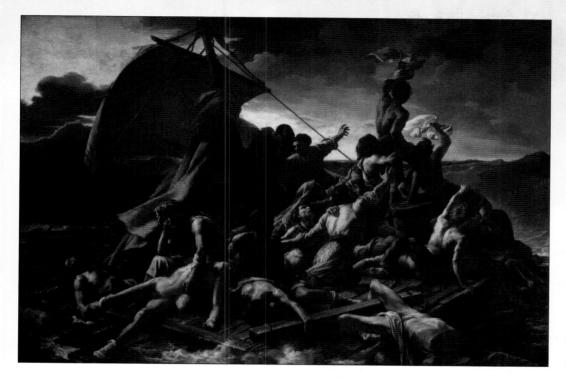

The Raft Of The Medusa (1818), by French painter Théodore Géricault. This shows the survivors of the wreck, adrift on a raft littered with corpses, as they try to signal to a distant ship. When they were rescued, they told how they had been abandoned by their captain, while he sailed to safety in a lifeboat. Starving, they had to resort to eating each other to survive – though this picture makes them look heroic rather than violent.

When the Medusa story broke, it caused a huge scandal - as did this painting. Some people thought the artist meant to criticize the French king, who had been involved in appointing the ship's captain.

Notice how the figures are piled into a pyramid, with the man waving the flag at the top.

Art and revolution

History paintings like *The Raft Of The Medusa* showed how art could have a powerful political impact. The picture caused a huge outcry, with critics arguing about its politics as much as its artistic merits. Not long afterwards, another topical French painting, *Liberty Leading The People*, created such a stir, it had to be hidden. This was a very volatile period in French history, and the government feared it might incite public unrest. It was a scene of French revolutionaries storming the barricades, as had happened only the year before.

Liberty Leading The People: 28 July 1830 (1831), by French painter Eugène Delacroix. Delacroix included himself in the scene. He's the one in the top hat, on the left.

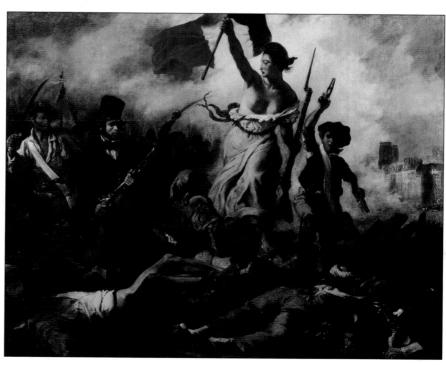

Familiar faces

People have been making portraits for thousands of years. Most early portraits were made to honor and remember the dead. By the 15th century, though, people were having their portraits painted for all kinds of reasons. Small portraits were often made as keepsakes. But grand, large-scale portraits were usually an exercise in public relations, helping to create an impressive public image for someone important.

Portrait Of A Lady In Red (probably 1460-70), by an unknown artist. This profile view is typical of early Italian portraits. The lady has a fashionably high forehead (she would have plucked or shaved her hair) and fancy clothes, showing that she was from a rich family.

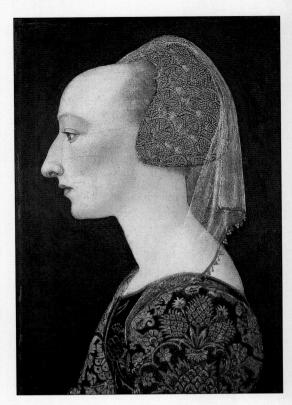

True to life?

Nowadays, we tend to rely on photographs to show what people really look like. But, before photography, people had to rely on portraits. So artists had to pay careful attention to facial features, often exaggerating the most distinctive ones – such as a big nose – in order to emphasize the likeness.

But a portrait does more than create a physical likeness. It is also highly contrived and designed to present someone in a particular way. So the pose, expression and clothes are usually chosen to show the sitter from the best possible angle, and to convey a sense of his or her character and social status. Many portrait painters became successful because they were good at flattering their subjects.

Self Portrait Aged 63 (1669), by Rembrandt van Rijn - one of many self portraits he made during his life. He dressed up for some of the earlier ones. But in old age, he no longer seemed concerned with vanity. Here, he shows himself in ordinary clothes, in a frank, informal pose.

In this enlarged detail, you can see how Rembrandt painted his hat and clothes with broad, loose brushstrokes, but used much smaller touches of paint around his eyes and mouth.

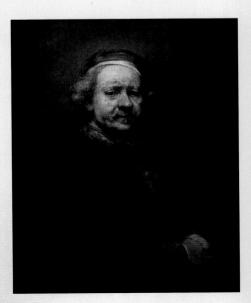

Mirror image

After good-quality glass mirrors became available in the 16th century, many artists started painting themselves. This gave them a chance to examine their own appearance and character. It was also a good way for them to practice and try out new techniques without having to worry about pleasing anyone else. Even more importantly, self portraits were a way for artists to show off their skill to people who might pay to have their own portraits done, like an early form of advertizing.

Picking props

Portrait artists put great care into picking the right props and accessories to reflect the lives and personalities of their sitters – for example, to show what they did for a living. Props can also tell stories. Some old family portraits included an empty cot to refer to a baby who had died, which sadly used to happen quite often. Fashions change, too. So 17th-century portraits tended to have plain, dark backgrounds while, in the 18th century, colorful, open-air settings became popular.

For a link to a website where you can investigate the house and studio of the artist Rembrandt van Rijn, go to www.usborne-quicklinks.com

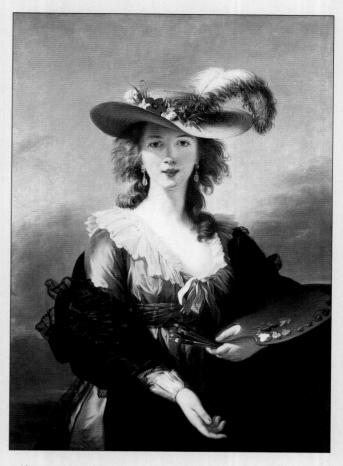

Self Portrait In A Straw Hat (after 1782), by Elisabeth Vigée-Lebrun, a successful portrait artist. Here, she chose to show herself with the tools of her trade. Her glamorous outfit does not look very practical for painting, but was the height of fashion at the time, and the kind of thing her clients might wear.

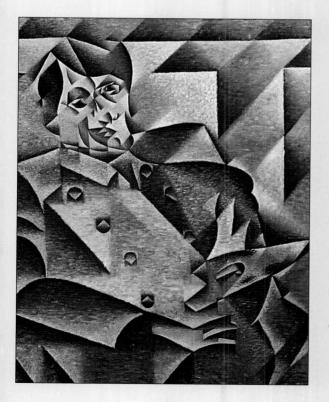

Modern times

Paintings have always been expensive – whereas photography is now so cheap that almost everyone can have a portrait taken. Inevitably, after the invention of photography nearly 200 years ago, many people became less interested in having their portraits painted. But some artists tried to outdo photographs by painting in a radically different way.

Traditionally, portraits only recorded one view of a person – whether a profile, front or three-quarters view – though painters occasionally added an extra one, as a sculpture or reflection in the background. In modern times, artists have taken this idea even further by combining intersecting views of people seen from different angles. This might seem strange, and less lifelike than conventional painting styles. But, by showing several angles at once, artists were trying to create portraits which represented people more completely.

Portrait Of Picasso (1912), by Juan Gris. The artist Pablo Picasso invented the technique of multiple views used here. So this portrait isn't just a picture of Picasso himself - it also reflects one of his best-known achievements.

Setting the scene

In medieval times, people didn't really think landscapes made good paintings by themselves. When they were painted, it was usually only as a backdrop to a story-telling scene. Some were no more than a few rocks in the background – one 14th-century artist's handbook actually advised artists to collect rocks. But, in the 16th and 17th centuries, all that began to change.

This 15th-century landscape is the setting for a Bible story. It's not very lifelike. The mountains get smaller as they get farther away, but St. John stays the same size, to ensure he stays the focus of attention.

Saint John The Baptist Retiring To The Desert (1453), by Giovanni di Paolo

Getting things in perspective

In the 16th century, artists made ground-breaking discoveries about perspective, which enabled them to represent space more accurately (see page 38). This meant they could create much more lifelike landscapes. Gradually, painters began to design pictures where the landscape was more important

than the people, or even where there were no people at all. By the 17th century, landscape had become a popular subject in its own right. A huge number were produced, especially in northern Europe, ranging from idyllic imaginary scenes to detailed views of real places, like the country scene below.

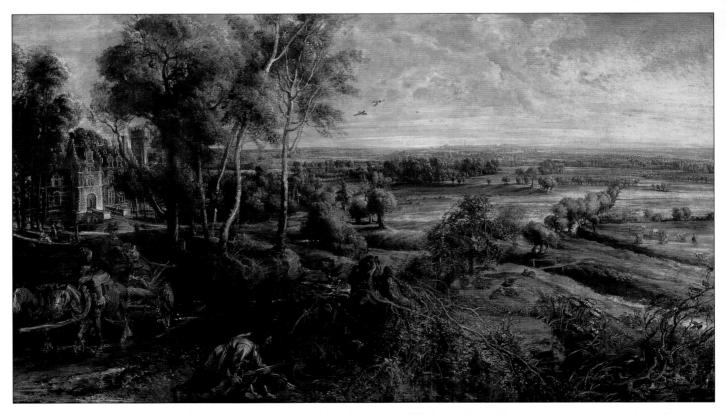

An Autumn Landscape With A View Of Het Steen (1636), by Flemish artist Peter Paul Rubens. The 1600s saw a massive increase in landscape painting, particularly in nothern Europe, where this was done. It shows the countryside near Rubens' home in Flanders (now Belgium).

Getting out

The first landscape painters didn't paint on location. They would make sketches outside, but return to the studio to complete their paintings. But, from the mid-19th century, there was a new fashion for painting in the open air. Inspired by the changing effects of light and weather, many artists now wanted to paint landscapes directly from nature.

The Water Lily Pond (1899), by Claude Monet. Notice how sunlight catches the leaves and lily flowers, and glints off the bridge.

Monet painted this scene in his own backyard at Giverny in northern France. It shows a calm, peaceful world, very far from the revolutions and wars going on at the time. Even after World War One broke out and troops were going past his home, Monet stuck to painting lilies.

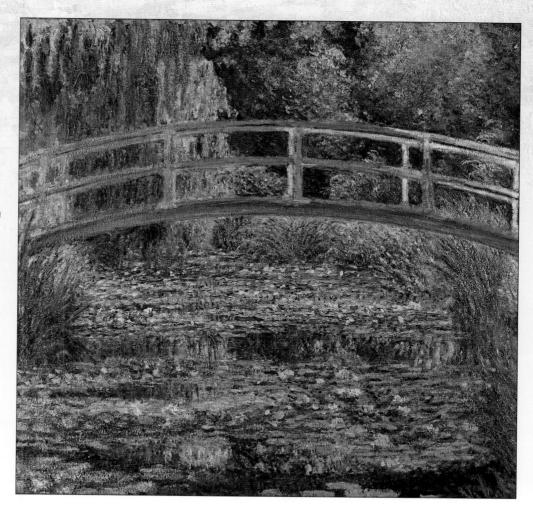

For a link to a website where you can go on an interactive landscape adventure, and create landscapes that show different places, moods and weather, go to www.usborne-quicklinks.com

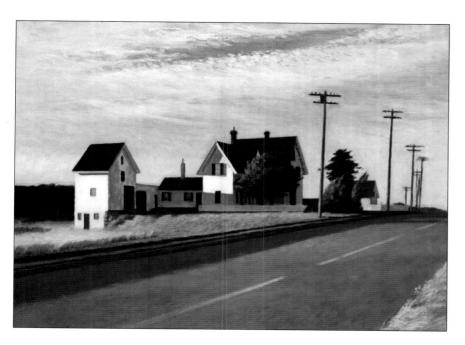

Personal views

Over the centuries, artists' approaches to landscapes have changed as much as the landscapes themselves. In the last hundred years, especially, there has been a huge variety of styles. These range from the startling cityscapes of the Cubists (see page 101) and the atmospheric urban views of Edward Hopper to 'Land Art' (see page 114). This is where artists work within the landscape itself, using dirt, stones and other natural materials. From these, they build monuments inspired by the surrounding scenery - works which then become part of the landscape themselves.

Route 6, Eastham (1941), by Edward Hopper. This landscape looks almost photographic. But it is full of emotion. It's a lonely scene, with no people, just houses seen from the side of a long road, as if by someone just passing through.

The art of illusion

C till lifes are paintings of objects that can't move, Such as flowers and fruit, musical instruments, or whatever else catches an artist's fancy. Until the late 19th century, the goal of most still lifes was to look as realistic as possible. And artists became so good at it, they could create anything from grapes which look good enough to eat, to jugs and bowls which seem to jut right out of the painting.

Tricking the eye

Still life paintings can be very demanding. Artists have to create an attractive composition, while also trying to make everything the light, the textures - look as lifelike as possible. The most lifelike pictures are known as trompe l'oeil, which is French for 'tricking the eye.' These pictures try to fool you into thinking you are looking at real objects, not flat, painted surfaces. But, despite this, until the 19th century most critics looked down on still lifes. They saw them as just technical exercises which didn't require much creativity to make, or thought to understand.

paintings of the Virgin Mary often included a vase of lilies,

symbolizing purity. It wasn't until the 17th century that still lifes really became a genre in their own right. They were soon popular with a very wide audience, perhaps because you didn't have to know anything about Classical myths or the Bible to understand them.

> Fruit, Flowers And A Fish (1772), by Dutch painter Jan van Os. Sumptuous arrangements of flowers and food are a common theme of still life paintings. Notice the different textures in the enlarged detail on the left.

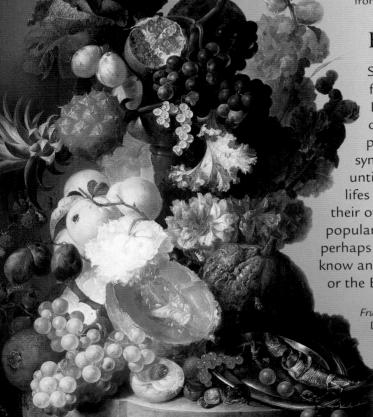

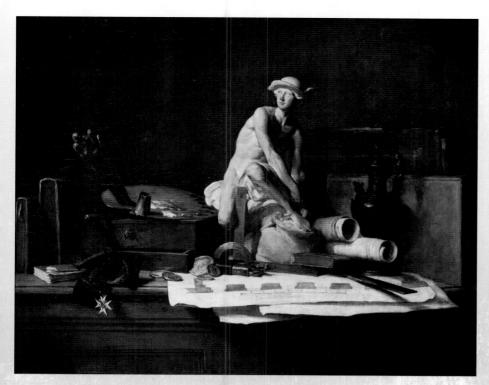

The Attributes Of The Arts And Their Rewards (1766), by Jean Chardin

Hidden meanings

A still life may be a straightforward picture, or it may contain hidden meanings. Artists often pick objects to represent particular ideas. For example, books mean knowledge, musical instruments symbolize pleasure, and skulls, flickering flames or decaying fruit are meant to make us think about death. Paintings with symbolic meanings are known as allegories. They became so popular, some artists ended up painting little else.

In this still life, the objects were chosen to represent the arts: drawing, painting and sculpture. (See how many art-related items you can spot.) The small replica statue shows the god Mercury, who was supposed to be the patron of the arts.

Express yourself

In the 19th century, still lifes tended to become less lifelike, as artists began experimenting with using them to express their feelings. They often chose objects which had some special significance in their own lives, and used styles and colors which reflected how they felt, rather than how things really looked. According to the French painter Edouard Manet, "A painter can express all that he wants with fruit or flowers."

Today, artists are still experimenting. Now, still lifes don't even have to be painted. Ordinary, everyday objects – previously the subject of still lifes – can appear as works of art in their own right. For example, in the 1960s, the American artist Andy Warhol exhibited life-size copies of boxes of soap powder.

This still life, by Dutch artist Vincent van Gogh, is a kind of symbolic self portrait. It shows a chair and pipe which belonged to the painter - plain, ordinary objects, as rustic and down-to-earth as the man himself.

For links to websites where you can find out about the meaning of different scientific objects shown in paintings, and zoom in on details from a work by William Harnett, go to www.usborne-quicklinks.com

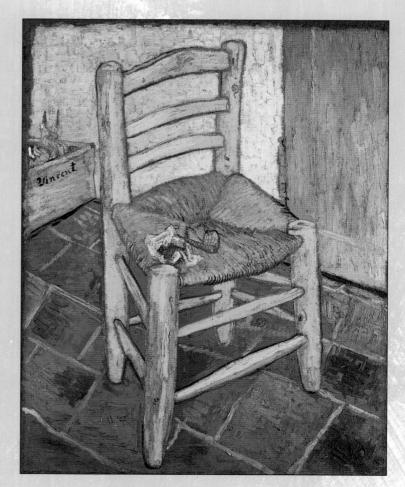

Van Gogh's Chair (1888), by Vincent van Gogh. Notice the sprouting bulbs in the box. They are symbols of nature and renewal, and may also be a witty reference to Dutch flower paintings like the one on the previous page.

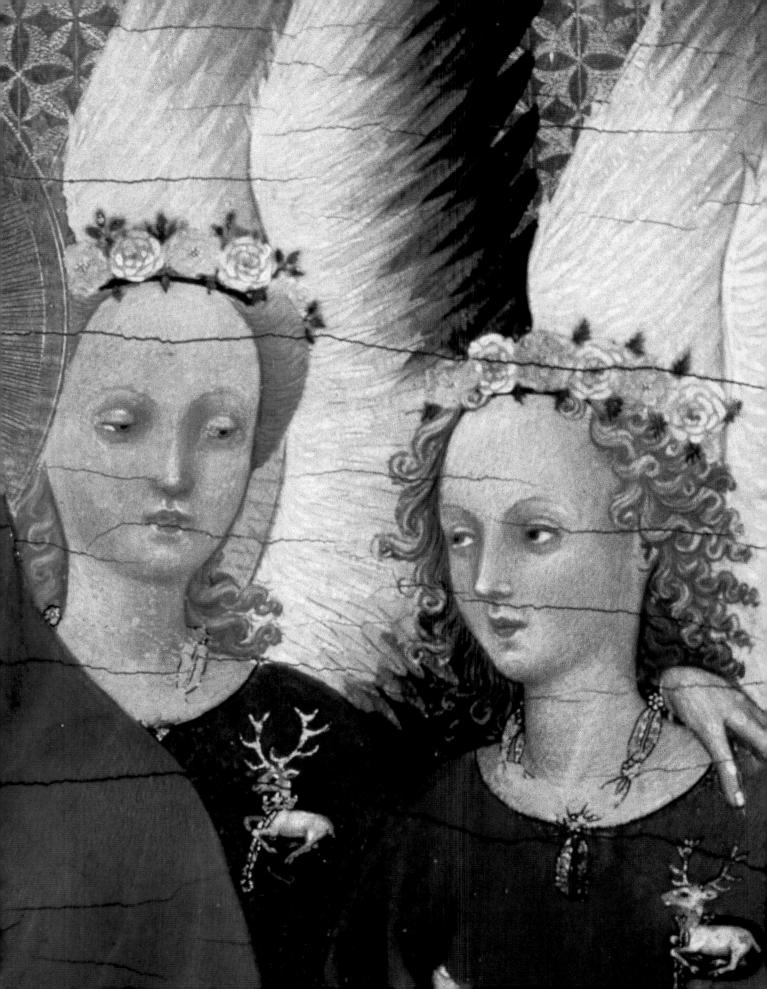

Art and magic

Many beautiful works of art survive from ancient times – from Egyptian tomb paintings to Minoan palace decorations. But the earliest artists would not have thought of their work as 'art,' the way we do today. Most early art was actually made for ritual or magic purposes.

Walk like an Egyptian

Egypt was ruled by kings, called pharaohs, from about 3000BC to 30BC. Much of the art that survives from that period was made for tombs, including carved stone statues and elaborately detailed paintings. The painting on the right dates from about 1350BC.

Egyptian artists followed strict rules when drawing people. They would always draw a person's head, arms and legs from the side, and usually showed the upper body twisted to face us. This is not a natural pose, but it did show each part of the body very clearly

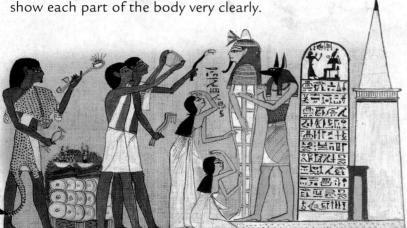

Staying alive

The ancient Egyptians believed art had magical powers. They decorated tombs with images of everyday life, because they really believed these would help the person live on in the next world. People thought it was more important to record details clearly than to create natural-looking scenes. For them, art was a way of preserving life. In fact, one Egyptian word for sculptor can be translated as 'he-who-keeps-alive.'

This painting of ancient Egyptians preparing a dead body is from *The Book Of The Dead*, which was full of spells supposed to help the dead in the afterlife.

Island art

From about 2000BC, art flourished on the Greek islands, particularly on Crete, where a people called the Minoans lived. The Minoans were great seafarers and traded with the Egyptians, and their art shows an Egyptian influence. But the Minoan style was less stiff and formal. Look at the flowing shapes of the Minoan figures on the right.

A lot of Minoan art had to do with religious rituals. For example, many statues show gods or worshipers. But some Minoan art – such as animal designs on storage jars – was probably just for decoration. So, for the first time, people were making art for its own sake, just because they liked the way it looked.

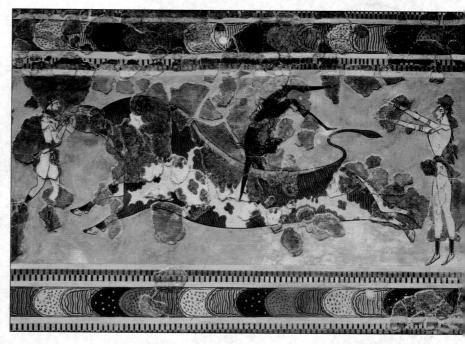

This painting was made on the wall of a Minoan palace in about 1500BC. It shows the Minoan sport of bull jumping, in which athletes would seize a bull by its horns and vault over it. The figures are simplified and their faces are in profile, just like in Egyptian art, but their bodies are more lively.

Artists and warriors

Then, from about 16001100BC, a people known as the
Mycenaeans dominated most of
Greece. They were great warriors
and fought many battles,
including the Trojan War. You can
see their preoccupation with war
reflected in their art, which often
shows warriors and fight scenes.

The Mycenaeans took over Crete from the Minoans, and were influenced by their art too. But compared with Minoan art, Mycenean paintings seem much less fluid. The difference between the two styles shows how early Greek art developed and changed, unlike Egyptian art, which remained virtually the same for thousands of years.

The Mycenaean vase on the right was made about 1400-1300BC. It shows horse-drawn chariots of the kind the Mycenaeans used in battle.

For links to websites where you can explore Minoan and Egyptian art, go to www.usborne-quicklinks.com

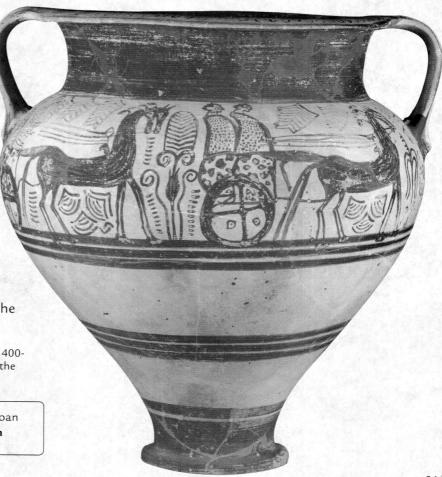

Classical art

The brilliant age of what is now called Classical art began in Greece over 2,500 years ago, in the 5th century BC. During Classical times, the ancient Greeks developed amazing new styles of painting, sculpture and architecture, and came up with ideas about politics, law, philosophy and science, which have influenced western civilization ever since.

This Classical statue - a Roman copy of a Greek original - shows a man throwing a discus.

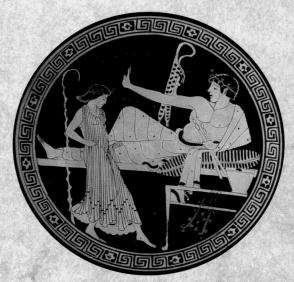

This scene, from a 5th-century Greek cup, shows a dancer and a young man. Their clear profiles show an Egyptian influence, but their poses are more natural.

The art of observation

The ancient Greeks were fascinated by the world around them and studied it closely – and they used their observations of real life in their art. Sculptors of the period tried to show the human body in a realistic, natural-looking way. The standards they set, for both beauty and technical skill, have been admired and imitated for centuries.

Unfortunately, very few ancient Greek paintings have survived. Paintings made on wood rotted away, and wall paintings were lost when buildings were destroyed. But we know quite a lot about Greek painting from ancient writings. And the Greeks were famous for making painted vases and dishes, many of which did survive.

One ancient Greek writer described how a painter named Zeuxis made a picture of grapes that looked so real that birds tried to eat them. But his rival Parrhasius outdid him by painting a curtain which looked so real that Zeuxis tried to pull it.

An ideal world

Although Classical Greek artists created detailed, natural-looking figures, these were not necessarily meant to be real people. Artists wanted to create ideal images of people rather than recording how they really looked.

The statue on the left shows a Greek athlete. His appearance was determined by what the Greeks thought was beautiful. The proportions of his body are perfectly balanced, and his features are calm and regular. These ideals of beauty have had a lasting influence on artists.

This marble figure is a Roman copy of a 5th-century bronze. Sadly the original, made by a Greek sculptor named Myron, was lost centuries ago.

The art of Rome

The Romans dominated Europe for almost 1,000 years, between about 500BC and AD500. But. in art, they were influenced by the Greeks, who were absorbed into their empire. The Romans admired and copied Greek sculptures and techniques. In fact, many Greek sculptures were destroyed or looted at the end of the Classical age, and are now known only from Roman copies which lasted well because they were made of stone.

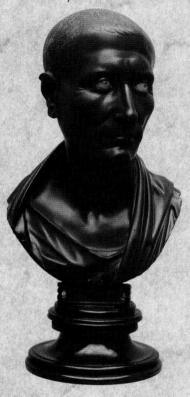

This portrait bust shows the famous Roman leader Julius Caesar. You can see how lined and careworn his face is compared with the Greek athlete's.

But whereas the Greeks only sculpted idealized or mythical figures, the Romans also wanted to create lifelike portraits of real people. So Roman portraits show faces with expressive features and individual details, such as wrinkles, as you can see on the carved head above.

Buried treasure

In AD79, a volcanic eruption buried the Roman town of Pompeii and, for centuries, it lay hidden under layers of ash. When the town was finally uncovered in 1748, archaeologists discovered houses with walls covered in paintings - portraits, landscapes, mythical scenes and still lifes, painted in a variety of styles.

The paintings from Pompeii show how skilled artists were, over 2,000 years ago, at using texture, shading and some forms of perspective. Roman artists were trying to paint scenes as they would look

Many rooms in Pompeii had no windows, but the false landscapes painted on the walls made it seem as if you could see out.

• For links to websites where you can find out more about the art of ancient Greece and Rome, go to www.usborne-quicklinks.com

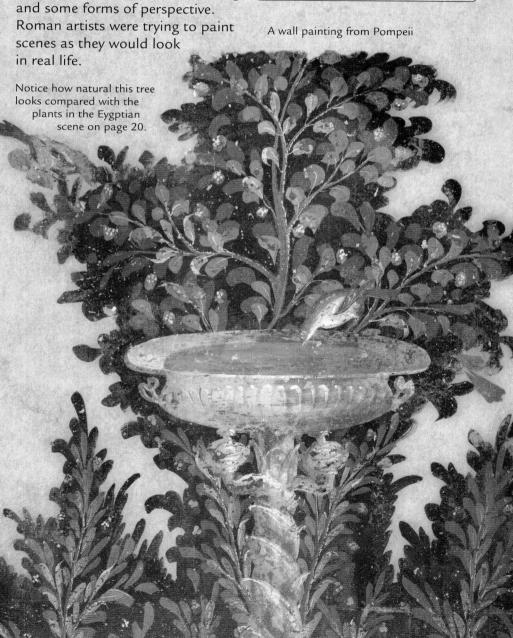

Patterns and monsters

Just over 1,500 years ago, the Western part of the Roman empire collapsed, plunging most of Europe into a period of chaos, fighting and upheavals, sometimes referred to as 'the Dark Ages.' Without the unifying influence of the empire, many different styles of art began to emerge.

Live and learn

During the Dark Ages, monasteries played a vital role in keeping art and literacy alive. The Church encouraged monks to produce illuminated manuscripts (books written and decorated by hand) of religious texts. This helped them to spread the Christian message.

This is an image of St. Matthew from a manuscript known as *The Book Of Kells*. Notice how the figures are simplified, so they look like parts of the pattern.

Irish illuminations

The Book Of Kells, made around the end of the 8th century, is one of the oldest surviving illuminated manuscripts. It was named after the monastery of Kells, in Ireland, where it was kept until 1007. The book contains the four gospels in

Latin, decorated with ornate pictures.

These round, interlacing patterns are known as Celtic knots.

For a link to a website about another 8th-century illuminated manuscript, go to www.usborne-quicklinks.com

In medieval times, books had to be made and written out laboriously by hand, so they were rare and highly prized possessions. No one in Europe knew how to make paper yet, so books were usually made from animal skin, or 'parchment.' Sheets of parchment were covered with text and pictures drawn using a quill or reed pen dipped in colored ink. Then the sheets were folded, sewn together, and attached to a leather or wooden spine.

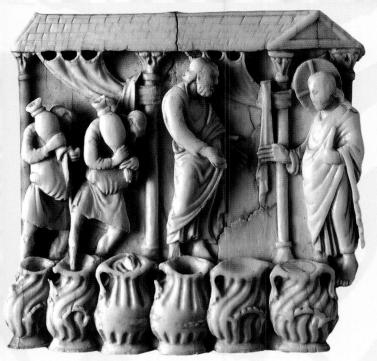

Reviving the classics

In the 9th century, there was a revival of art and learning during a period of relative peace in the reign of Charles the Great, or Charlemagne. Charlemagne was King of the Franks, in what is now France. He later came to control most of Europe. He was eager to revive ancient Roman culture and spread Christianity. So he encouraged religious art in a Classical style, which is now known as Carolingian. Unfortunately, few paintings have survived from this time. But some Carolingian art does still exist – mainly illustrations from Classical and Christian manuscripts, made in a natural-looking style inspired by Classical art.

The scene on the left shows Jesus miraculously turning water into wine. It is part of an ivory panel carved in the 9th century, in France, to decorate the cover of a religious book.

Fighting spirit

At the end of the 9th century, Viking raiders from Scandinavia began to attack the lands ruled by Charlemagne's successors. These attacks caused disruption and chaos which largely destroyed Carolingian culture. But the Vikings did bring with them an art of their own. They were expert wood-carvers and metal-workers, who created elaborate animal figures and patterns to decorate their boats, weapons and clothes. They did not share Charlemagne's Christian faith, and may have believed that some of their art – such as the fierce monster heads on their ships – actually had magical powers.

Fear of God

In the 11th and 12th centuries, as Europe emerged from the Dark Ages, many new churches and cathedrals were put up. They were built in a grand style based on Roman architecture and known as 'Romanesque,' with stone columns, round arches and vaulted ceilings. These churches were adorned with carvings of people, animals and monstrous devils, designed to put the fear of God into churchgoers. One of the most popular subjects for carvings was the Last Judgement. This was the day when people believed their souls would rise up to Heaven or be sent to Hell.

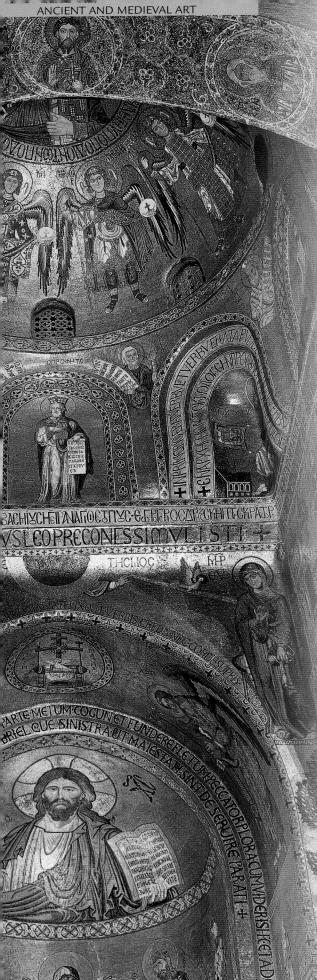

Saints and sinners

The Roman empire had been split in two at the end of the 4th century. The eastern part became known as the Byzantine empire, after the old name of its capital, Byzantium (now Istanbul, in Turkey), and its art is known as Byzantine art. This empire outlasted the western empire by a thousand years.

A new religion

Christianity became the official religion of the Roman empire in the 4th century, and Christian themes were common in Byzantine art. Interest in religion made artists more concerned with the spirit and less with what things looked like. They thought it was more important to create symbols of religious experience than to show natural-looking scenes.

This 6th-century mosaic shows a scene from the Bible. Jesus is blessing the loaves and fishes which, according to the story, fed 5,000 people. The artist created naturallooking, shaded figures, but the rich gold background emphasizes the holy and miraculous nature of the scene.

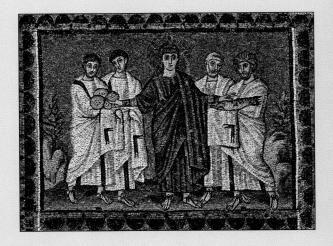

At this time, few people could read, so pictures were used to tell stories and they had to be easy to understand. The scene above has simplified outlines, strong colors, and a plain background to focus attention, a bit like a modern comic strip. The people have big, soulful eyes and contemplative expressions, to show their spiritual nature. But the artist still used realistic techniques such as shading, as the Romans had done.

Marvellous mosaics

Brilliantly colored, shiny mosaics, like the ones on the left, were used to decorate Byzantine churches. Mosaic pictures are made up of tiny pieces of glass or stone; a large mosaic can contain several million pieces. The pieces were all set at slightly different angles, so they would reflect light from different directions and create a shimmering effect.

Mosaics on the ceiling and walls of a 12th-century chapel in Palermo, Sicily

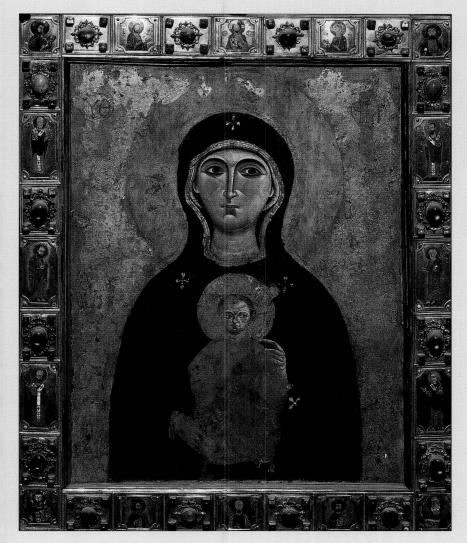

For a link to a website where you can see Byzantine paintings, carvings and jewels, and find out about them, go to www.usborne-quicklinks.com

Saints and symbols

In paintings, saints are often shown with symbols to help identify them. The spear and monster in the picture on the right show it is an icon of St. George, who was said to have killed a dragon with a spear. When a symbol was associated with a particular group of people, the saint would be chosen to be their protector or patron. For example, St. Catherine, who is identified by a wheel, became the patron saint of wheelwrights.

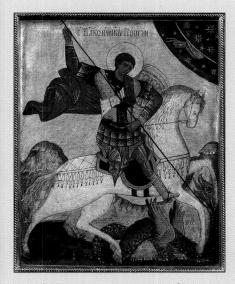

A 15th-century Byzantine icon of St. George, made in Russia

Image-smashers

With the growth of Christianity, richly decorated images of religious figures, known as icons, became popular. But these led to arguments about art among church leaders. Some thought icons could help teach religion. Others believed icons were idols, or false gods, and wanted to destroy them. These people were known as iconoclasts, which means 'image-smashers.'

In the early 8th century, across most of eastern Europe, Turkey and Syria, religious art was banned by the Church. Many early icons were destroyed, so it is rare to see examples of them today. Even when the ban was lifted in the 9th century, there were still restrictions on holy images. Artists could only show saints in certain approved styles and poses, like the one on the left. This is why their pictures often look very similar.

This is a 10th-century Italian icon which shows the Virgin Mary holding the infant Jesus. The figures may look a bit stiff, but their face-on pose was quite conventional.

Palm leaf - a martyr (someone who died for their beliefs'

> Dove - the holy spirit

Wheel - St. Catherine, who was sentenced to be put to death on a wheel (which broke)

Halo - holiness; most halos are round, but if you spot a square one, it means that the person was alive when the picture was made.

The Wilton Diptych

This precious 14th-century painting shows King Richard II of England kneeling before the Virgin Mary and Jesus, who are surrounded by angels. Richard II is being presented to them by three saints: St. Edmund, St. Edward and St. John the Baptist.

Title: The Wilton Diptych Date: about 1395-99

Artist: Unknown English or French artist

Materials: egg tempera on oak Size: two panels, each 53 x 37cm (21 x 15in), joined together by hinges

A portable painting

This picture is made up of two hinged panels, so it can be folded and carried, or unfolded to stand on an altar. A picture with two panels is known as a diptych. Small diptychs like this were usually painted for wealthy patrons. Larger diptychs or triptychs (pictures with three panels) were generally made for churches.

This diptych is known as the Wilton Diptych because it was once kept in Wilton House in Wiltshire, England. Originally, it probably belonged to

Richard II himself. It is littered with symbols – if of you know where to look for them.

The king wears a gold collar made to look like the seed pods of broom plants. This was the emblem of his family, the Plantagenets, whose name sounded like the Latin for broom, *Planta Genista*.

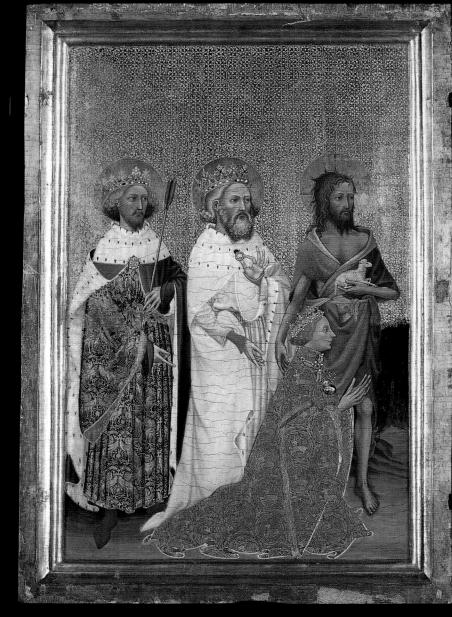

From left to right, the standing men are St. Edmund, St. Edward and St. John the Baptist, Richard II's patron saint. St. Edmund, a former English king, holds the arrow which killed him. St. John holds a lamb, because he called Jesus 'the lamb of God.'

St. Edward, another former king, holds a ring he was mean to have given to St. John

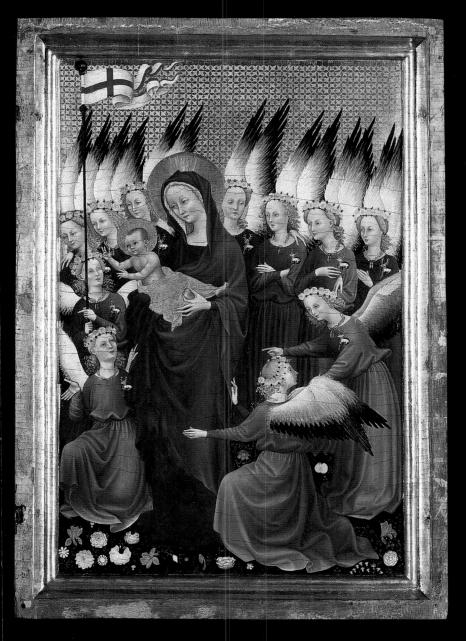

Divine right

The picture was designed to link Richard II's reign with the rule of Heaven. The angels bear the king's emblems, and the infant Jesus holds out his hand toward the king as if to bless him. This illustrates the belief that the king got his authority from God, because he was God's representative on Earth.

A heavenly carpet of flowers contrasts with the bare ground of the ordinary world.

Fit for a king

This painting is covered in sumptuous materials, generally used only in small amounts, making it fit for a king. The background is real gold leaf, and the robes worn by Mary and the angels are painted in an expensive blue. To make this rich blue color, the artist used ground lapis lazuli, a semiprecious stone which had to be brought all the way from Afghanistan.

The angels wear collars of broom plants and badges with white harts (the king's emblems) to show their loyalty to the king.

Art and prayer

In the 14th century, most paintings were made for Christian churches and other religious buildings, so the scenes they show are religious too – pictures of saints or stories from the Bible. The few paintings made for private individuals tend to be religious as well, as they were usually designed to help them pray.

Heaven and Earth

The Virgin Mary was an extremely important figure in religious paintings at this time. She was regarded as a link between Heaven and Earth, a channel between us and God – human, like us, but also the mother of Jesus, the son of God. So Mary is at the center of the grand altarpiece on the right. You can see her more clearly in the enlarged detail below.

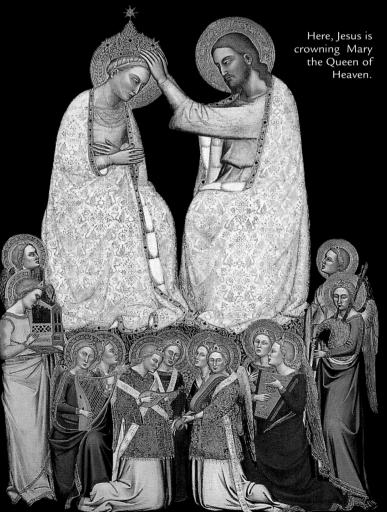

The Coronation Of The Virgin (1370-71), by Italian artist Jacopo di Cione and his workshop. This was originally made for a church in Florence.

Dress to impress

The grandest paintings were made to adorn church altars, as the altar was the focus of worshipers' attention. Enormous altarpieces made up of many separate panels were designed to stand directly behind the altar. They were richly colored and often coated ir gold leaf. Their huge scale and costly materials were designed to impress people with the glory of God. The pictures themselves were meant to help people who couldn't read to learn stories from the Bible.

Workshops

At this time, artists were seen as craftsmen, whose work depended on their manual skills. They worked together in large workshops, so one picture would be the work of several people. A large altarpiece like the one above would take the workshop about a year to make. It was hard for artists to win individual fame, but successful ones might end up running a workshop

Donors and devils

Paintings in churches were often paid for by a wealthy individual, or donor, rather than the church itself. The donors were sometimes included in the paintings as well, though they were generally made smaller than the holy figures, to show they were less important. Including donors in religious scenes was a way of advertising the donors' devotion to their religion, as well as their generosity.

Saint Michael And The Devil shows
St. Michael (also known as the Archangel Michael) slaying a sharp-toothed little devil. To one side, a much smaller man kneels praying. This is the donor who baid for the picture, Don Antonio Juan. No one knew what St. Michael would nave looked like, so he is just made to ook handsome and heroic. But Don Antonio has very distinctive features, so this is probably a real portrait. He seems uninvolved with the drama happening in front of him, but prays with a distant expression, perhaps to St. Michael.

Saint Michael And The Devil (1468), by Bartolomé Bermejo. This was probably the center of an altarpiece in a church in Spain. The devil combines details from several animals, including snakes, ducks and frogs.

For a link to a website where you can explore a picture of St. George slaying the dragon, go to www.usborne-quicklinks.com

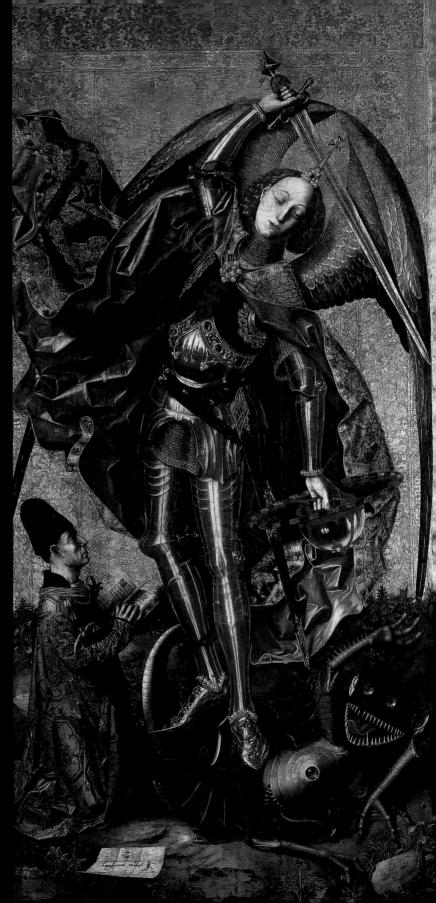

Courtly delight

In the rich and glamorous European courts of the 15th century, a new kind of art began to emerge. The princes and their courtiers still wanted art that showed how religious they were. But they also wanted it to reflect their aristocratic lifestyle, or an idealized version of it. So they encouraged an ornamental, richly colored style of art, full of carefully observed details of plants and animals. This is often known as International Gothic.

Beautiful books

The lords and ladies of the courts liked to surround themselves with elegant objects, such as beautifully illustrated books. 'Books of Hours' were especially popular. These were prayer books used at home for private devotions, rather than in church. They contained prayers for different times of day, different days and different seasons, illustrated lavishly. One of the best-known surviving examples, *The Very Rich Hours* (often called by its French title, *Les Très Riches Heures*), was made for a French nobleman, the Duke of Berry. It is full of details of everyday life, such as laborers working on a farm or people celebrating festivals.

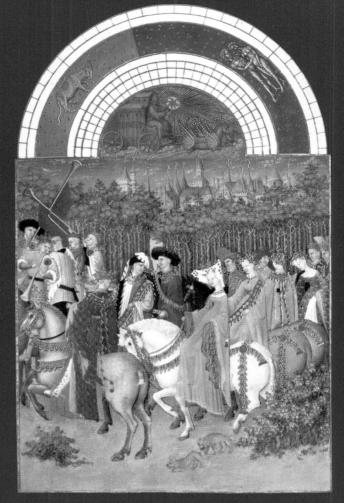

An illustration from one page of *The Very Rich Hours: May* (about 1416), by the Limbourg brothers. These riders – some dressed in 'May green' – are taking part in a procession to celebrate the month of May

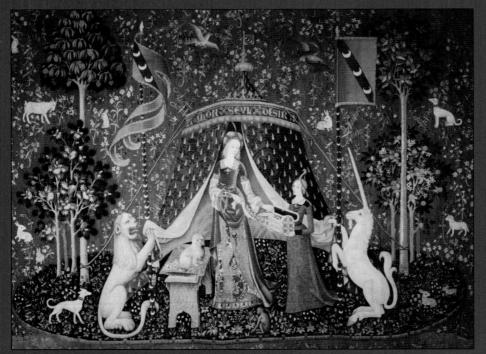

To My One Desire (15th century), a tapestry by an unknown artist or artists

My one desire

In those days, large, luxurious tapestries were used as wall-coverings, helping to keep rooms warm as well as giving people something to look at. They often showed hunting scenes or ladies at court, decorated with animals and flowers. Others dealt with love, a popular subject in medieval poetry.

The tapestry on the left is from a famous series known as *The Lady And The Unicorn*. Love is the theme. An elegantly dressed lady stands by a pavilion which is embroidered with the words, in French, 'To my one desire.' A maid is offering her a chest – perhaps it contains a gift from the lady's lover?

Model animals

The Italian artist Antonio Pisano, known as 'Pisanello,' spent most of his career working in the courts of Italian princes. Many of his paintings show hunting and other noble pastimes. He made 'model' books full of detailed drawings of birds and animals, which he could refer to later.

Pisanello probably copied this hare from one of his model books.

If you look at the painting below, you'll see the animals are drawn to different scales, and almost without overlapping. This is because they were copied from model books and preparatory sketches. The animals are all associated with hunting – birds, deer, a hare, and even a bear, as well as the huntsman's own horse and dogs. But the subject is religious too. It tells the story of St. Eustace, the patron saint of

hunters. He was out hunting one day and was about to shoot a stag. Then he had a vision of Jesus on the cross between its antlers. This was so powerful it made him convert to Christianity. The story provides a perfect excuse for a decorative and elegant hunting scene. Although Eustace was meant to have been an ancient Roman, Pisanello shows him in the clothes of an Italian courtier of the time.

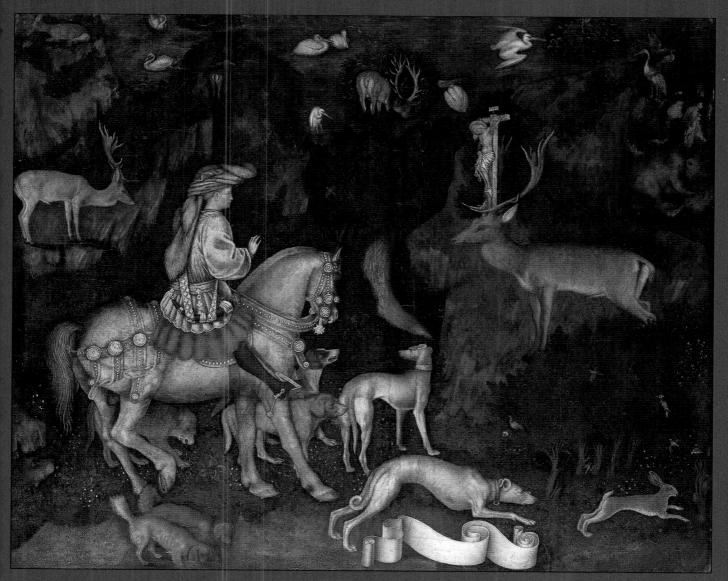

The Vision Of St. Eustace (about 1438-42) by Antonio Pisano, or 'Pisanello.' Notice how detailed all the animals are.

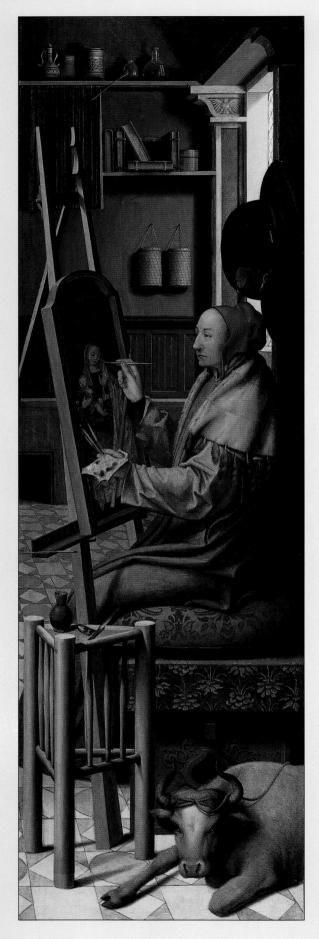

Making it real

In the 15th century, paintings in the Netherlands became much more realistic. For the first time, it became common for artists to use settings and people drawn from life. They paid careful attention to tiny details, especially the effects of light on things, using smooth brushwork and delicate shading to create an almost photographic finish.

Egg and oil

This more realistic way of painting was made possible by the kind of paint these artists used. In Italy, at this time, painters mainly worked in egg tempera – a mixture of colored pigments and egg. But, in the Netherlands, artists began mixing pigments with oil. Unlike egg, oil takes a long time to dry, so artists who used oil paint were able to work more slowly and put in more details.

St. Luke Painting The Virgin (about 1530), by an unknown artist. St. Luke, who lived in the 1st century AD, was the patron saint of painters. Here, he is shown as a 15th-century artist.

Light fantastic

The new oil paintings had another important feature light. They showed the effects of light very accurately, with the light often coming from a source, such as a window, that you could see in the picture itself. Even where the background is dark, as in van Eyck's portrait, it is the light falling across the face that brings it to life. Oil paint was good for representing these effects because it is translucent, which means light can pass through it (unlike egg tempera, which is opaque.)

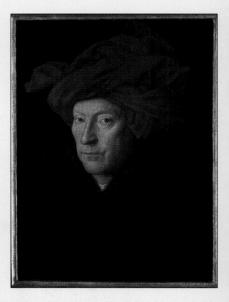

Man In A Turban (1433), by Jan van Eyck. This is probably a self portrait. The artist signed his work with some lettering on the frame. This reads: 'As I/Eyck can; Jan van Eyck made me, 21 October 1433.'

Setting the scene

At this time, artists often chose up-to-date settings, even for historical scenes. This picture from the Netherlands shows the Virgin Mary nursing the infant Jesus, but it makes her look like a wealthy 15thcentury lady. She's wearing a jewel-edged dress and is surrounded by luxuries, including an embroidered cushion and a beautifully illuminated prayer book. To people at the time, this setting would have made her seem closer to them.

The window opens onto a scene of everyday life in the Netherlands, with riders on horseback and a man climbing a ladder.

The picture is very detailed, right down to the hairs on Mary's head – each individual hair was painted separately, using a brush with only one or two bristles. But not all the details are original. The strip on the right, including the goblet and cupboard, was added in the 19th century, to replace a section which had been destroyed.

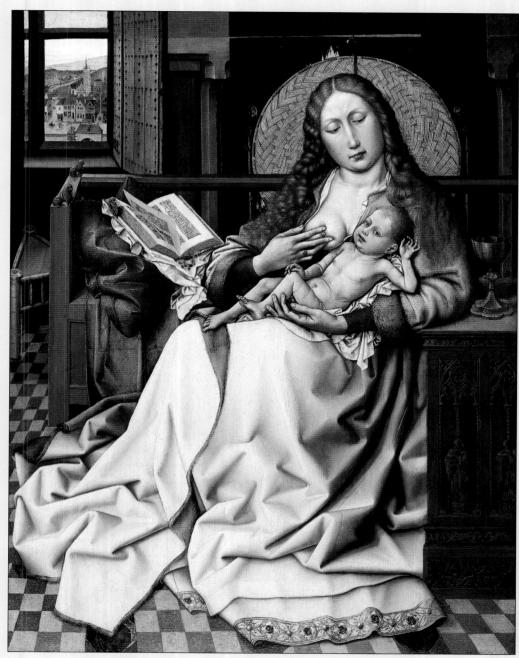

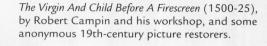

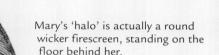

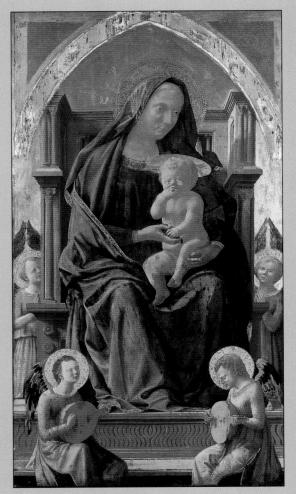

The Virgin And Child (1426), by Tommaso di Giovanni, known as 'Masaccio'

Seeing in 3-D

Since Classical times, painters had used perspective to create an impression of 3-D space on a flat surface. For example, Roman painters made distant objects appear smaller. But, during the Renaissance, artists worked out a system of rules for constructing whole scenes in 'unified' perspective, as if everything was seen from the same viewpoint. This made the illusion of space much more effective.

The Annunciation (1486), by Carlo Crivelli. This painting clearly shows the use of perspective. It is designed to make us feel we are looking through a window rather than at a flat, painted surface.

Born again

The Renaissance saw an amazing buzz of creativity, especially in Italy, where many leading artists lived. Their discoveries had a profound effect on painting. But although Renaissance artists were inspired by the Classical age, they hadn't actually seen any Classical paintings. Instead, they found out what they could from ancient texts and sculptures.

True to life

Renaissance painters read what Classical writers had to say about the value of making art look lifelike. So they began to study optics (the science of sight) and perspective, in order to make accurate, convincing drawings. Some artists even dissected dead bodies to learn more about anatomy.

Going by the book

In 1436, a writer named Leon Battista Alberti published a book called *On Painting*. It described ways artists could make pictures more realistic by using light, color and perspective. This required a lot of study, especially of the math needed for perspective. Alberti's book was very influential and, as artists adopted his techniques, people began to think of artists more as creative, intellectual types than just skilled craftsmen.

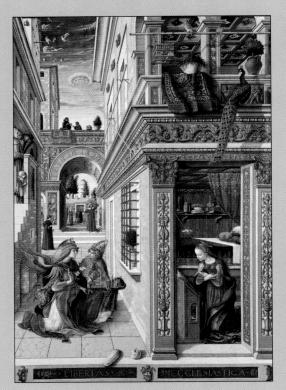

This diagram shows how Crivelli constructed the painting on the left.

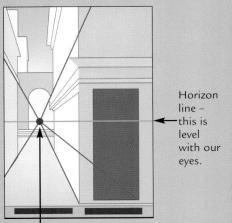

Vanishing point - all the lines pointing into the picture converge at this point.

For a link to a website that shows how to draw in perspective, go to www.usborne-quicklinks.com

Art of Florence

The Renaissance spread across Europe, but its earliest champions were Italian, and many of them worked in the same place: Florence, then an independent and wealthy city-state. They included the painter Masaccio, the architect Filippo Brunelleschi and, later, Leonardo da Vinci and Michelangelo Buonarroti.

Patrons of the arts

Most Renaissance artists worked for patrons – rich institutions or individuals who would commission and pay for works of art. Perhaps the most important patrons were the Medici family. They were powerful bankers from Florence, who bought art to decorate their palaces and show off their wealth.

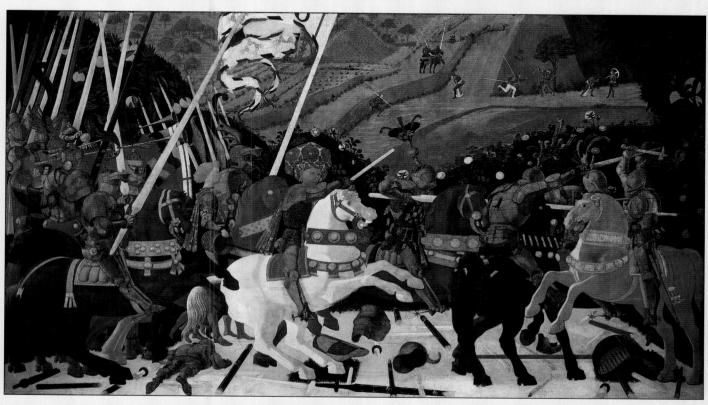

Renaissance portraits

Portraits became increasingly popular during the Renaissance period. It was no longer just kings and queens who commissioned them, but bankers, merchants, diplomats and scholars – anyone with enough money to pay an artist. The style of portraits changed too, and they became more varied and characterful.

Pictures with a purpose

Renaissance portraits served many purposes. Having your portrait painted was a status symbol, and men's portraits were often designed to show how powerful or rich they were. Women's portraits, on the other hand, tended to emphasize beauty or virtue. Such portraits were sometimes sent to prospective husbands.

A portrait could also be a way of commemorating someone and preserving his or her likeness, even after death. Occasionally, portraits were based on models, or 'death masks,' of dead people's faces.

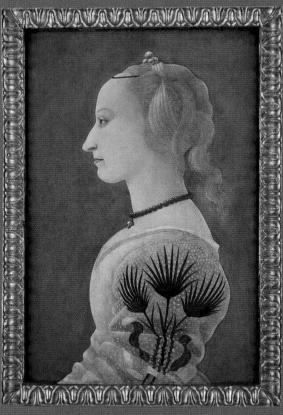

Portrait Of A Lady In Yellow (1465), by Alesso Baldovinetti. The palm leaf pattern on the lady's sleeve is probably a family emblem, but her identity remains a mystery.

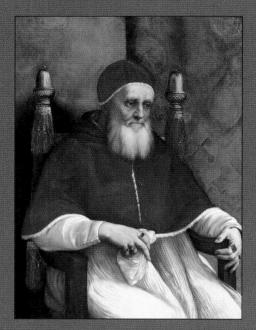

Pope Julius II (1511-12), by Raffaello Sanzio, known as 'Raphael.' Raphael painted many portraits of important church leaders.

Different views

Many early Renaissance portraits show people in profile, just like Classical art. But later portraits often depict three-quarter or full-face views, which were better for capturing facial expressions. They also tend to show more of the person's body and surroundings.

If you compare the Lady in Yellow with these portraits by Raphael and Titian, painted about 50 years later, you can see how they use different poses and settings to help show the person's character.

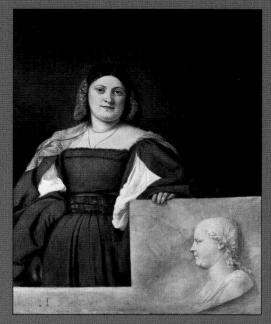

Portrait Of A Lady (about 1511), by Tiziano Vecellio, known as 'Titian.' The Classical-style carving on the wall shows the same lady in profile.

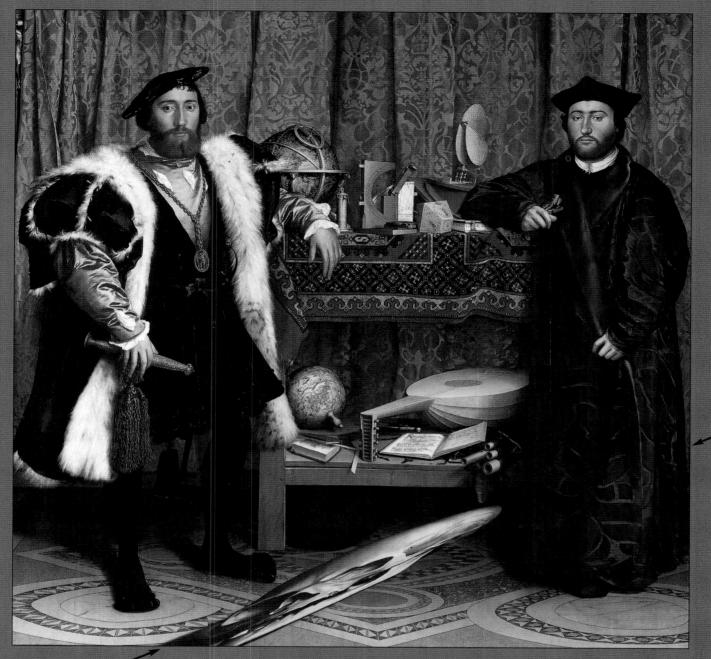

The Ambassadors (about 1533), by Hans Holbein the Younger. Try looking at it along the line of the arrows.

Characters, signs and symbols

As portraits got more elaborate, artists began to include symbolic objects to represent aspects of people's characters. A famous example is *The Ambassadors*, a portrait of the French ambassador Jean de Dinteville (on the left), and his friend, Bishop Georges de Selve. It is packed with symbols. The objects on the table represent the

men's interests: music (a lute), learning (books and astronomical instruments) and travel (a globe.) Ominously, a distorted skull stretches across the bottom of the picture. It is a memento mori – a reminder that death comes to us all. But there is also a tiny crucifix in the top left corner, a symbol of the Christian belief in an afterlife.

Life and death

The skull was distorted using a technique known as 'anamorphosis,' so it can be seen properly from only two angles. To view it, you need to shut one eye and look at it from the direction marked by either of the two arrows. The distortion is meant to grab our attention. And, of course, it shows off the artist's skill.

The Arnolfini Portrait

The Arnolfini Portrait, by Dutch artist Jan van Eyck, is one of the best-known portraits of the Renaissance. It shows a wealthy Italian banker, Giovanni Arnolfini, and his wife, standing together in their house in Bruges.

Title: *The Arnolfini Portrait*Date: 1434
Artist: Jan van Eyck

Materials: oil on oak Size: 82 x 60cm (33 x 25in)

Play of light

Van Eyck specialized in painting beautifully lit and detailed scenes like this. He was also one of the first and most skilled artists to use oil paint. For a time, he was even credited with inventing it. He built up translucent layers of color, creating subtle variations in light and shade. Light catches and defines everything in the room, from the brassy chandelier to the soft fur and fabric of the couple's clothes.

Notice how individual hairs in the dog's coat shine in the light. Van Eyck may have included the dog as a symbol of love and fidelity.

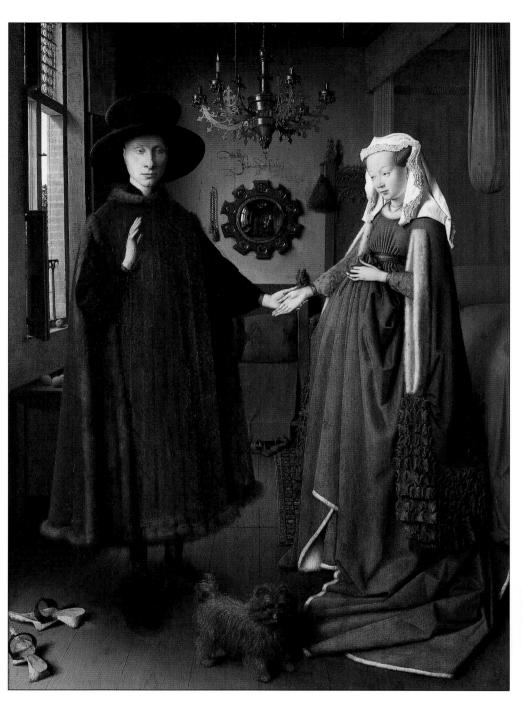

High fashion

The Arnolfinis are expensively dressed. Giovanni has a fur coat, though the tree blossom outside suggests it isn't very cold. You might think his wife looks pregnant, but she's just wearing the latest fashion: a high-waisted dress with bunched skirts.

Hands up

Giovanni holds up one hand, as if taking a vow, and grasps his wife's hand with the other. Some people think this means the picture shows a marriage ceremony, and refer to it as *The Arnolfini Wedding*. But his gesture is probably just a way of greeting visitors.

Sacred scene

The Arnolfinis must have been very religious, because the picture is full of religious references. A string of glass rosary beads, used to count prayers, hangs on the wall, and the mirror is decorated with scenes from the life of Christ. A carving on the chair shows St. Margaret, along with the dragon she was supposed to have defeated. The single candle flame in the chandelier may be meant to suggest the presence of God. Even the discarded shoes may be significant – it was usual to remove shoes when entering a holy place.

Mirror, mirror

The convex mirror reveals a part of the room we would not otherwise see. As well as reflecting the couple's backs, it shows two figures approaching them through an open door. One of the figures may be the artist himself, who signed his name on the wall above the mirror. Some people think this signature was meant to record the artist's presence as a witness at the Arnolfinis' wedding ceremony, but it is more likely he wanted to sign the picture just to show he had made it.

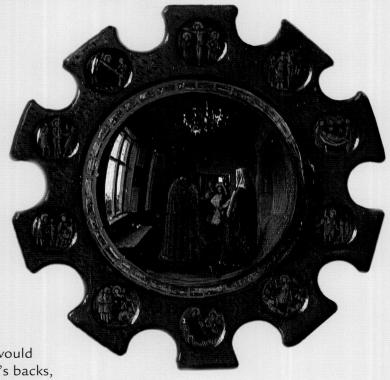

The lettering above the mirror says (in Latin): 'Jan van Eyck was here 1434'.

Lap of luxury

The room is full of expensive objects which show off the Arnolfinis' wealth. You would only have found the chandelier, carpet, mirror and glass

windows in very rich homes. There are also oranges, which were rare and exotic in northern Europe at the time.

Funny face

Giovanni looks a bit funny, with heavy eyelids, a big nose and a cleft chin. But his wife has more idealized features - her high forehead, small mouth and pale skin all conform to 15th-century ideas of beauty. So van Eyck may have been flattering her, rather than trying to show how she looked in real life.

Van Eyck used tiny brushstrokes, and blended them very smoothly. So you can hardly see any brushmarks, even in these enlarged details. For a link to a website where you can see many more paintings by Jan van Eyck, go to www.usborne-quicklinks.com

A fresh look

Religious pictures were very popular in the Renaissance, just as they had been in the Middle Ages. But now when artists painted old, familiar Bible tales, they did it in a very different way. They often moved the stories to their own time and country, and used Renaissance techniques like perspective to make scenes more realistic.

Made to order

Most religious paintings made in the Renaissance were designed for particular churches. The patron paying for the painting would usually tell the artist what to include, but the rest was up to the artist. Different artists adopted very different styles, as you can see from these two pages.

Piero made this scene for a chapel in his hometown, Borgo San Sepolcro, in northern Italy. The chapel was devoted to St. John the Baptist, so he was probably asked to paint St. John baptizing Jesus. In the Bible, this took place in the River Jordan, in the Middle East, but Piero set the event in an Italian landscape. He even included Borgo San Sepolcro in the distance.

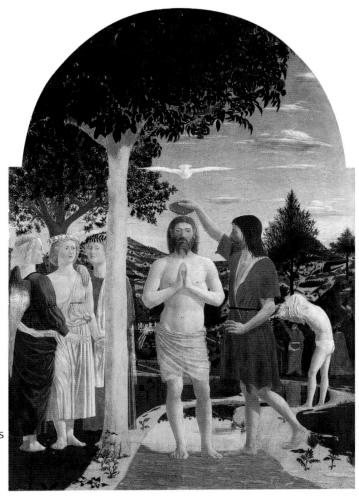

Baptism Of Christ (1450s), by Piero della Francesca. This is full of lifelike details, from the reflections in the water to the perspective on the dove.

Divine work

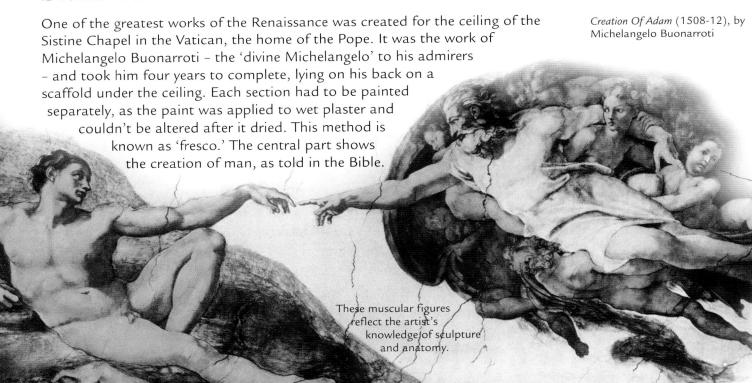

On the rocks

Leonardo da Vinci was one of the most soughtafter painters of his time - though he was not just an artist, but a scientist and inventor too. He made *The Virgin Of The Rocks* for a church in Milan. It shows the Virgin Mary kneeling in a rocky landscape. Mary is accompanied by an angel and two children, Jesus and St. John the Baptist.

St. John carries a cross made of reeds, one of his traditional symbols. This wasn't painted by Leonardo, but added later, probably to stop people from confusing St. John with Jesus. He also holds a scroll saying, in Latin: "Behold the lamb of God," meaning Jesus.

Leonardo used his knowledge of botany to draw delicate, realistic plants. He had also studied perspective, including 'aerial' perspective – an atmospheric effect which makes colors fade and become bluer in the distance. He imitated this effect by painting the water and rocks in the background in lighter, bluer tones.

The angel's face and veil are beautifully detailed. You can see how Leonardo highlighted individual hairs with bright gold. Her hands, by contrast, were never fully finished, though probably nobody would have noticed this when the painting was lit by candlelight in church.

The Virgin And Child With St. Anne And St. John the Baptist (about 1507-08), by Leonardo da Vinci.

Leonardo used chalk and charcoal to create this delicately shaded drawing. It was meant as a study for a painting which, unfortunately, he never got around to doing.

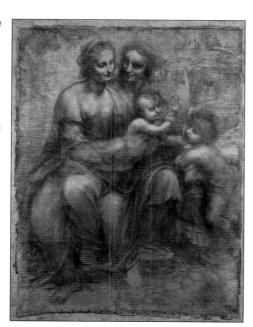

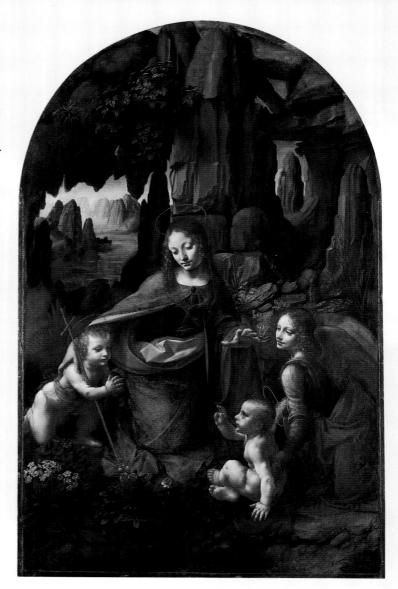

The Virgin Of The Rocks (about 1508), by Leonardo da Vinci

Leonardo the cartoonist

Leonardo is known for his drawings as well as his paintings. Before starting a painting, he would make large preparatory drawings like the one on the left. These are known as 'cartoons.' In fact, this was the original meaning of the word – it was only much

later that it came to mean comic drawings too. He also sketched designs for many strange machines and inventions.

Leonardo designed a flying machine based on birds' wings, though he never built it.

Telling stories

The Renaissance enthusiasm for the Classical world led many artists to paint scenes from ancient stories, often to satisfy customers who wanted to show off their knowledge of Classical texts. Artists found the stories a rich source of inspiration – and the fictional settings gave them greater freedom to paint nudes, which would otherwise have been considered far too daring.

The moral of the story

Paintings of stories were meant to be entertaining. They often contained lots of detail, so they could be looked at over and over. Some were just meant to tell the story, using dramatic gestures, expressions and compositions to show events unfolding. But others used the story to make a moral point, too. So *Cupid Complaining To Venus* is meant to make us think about the consequences of love, and *Narcissus* (below right) shows the danger of vanity.

Cupid, the god of love, complains to his mother, Venus, that he's been stung by bees while eating honey. The moral of this is that sweet things, like honey or love, are often followed by pain.

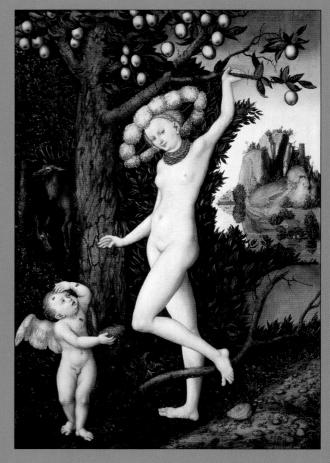

Cupid Complaining To Venus (early 1530s), by Lucas Cranach

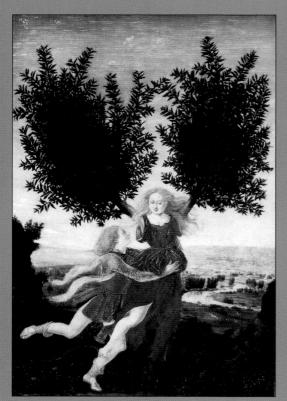

Apollo And Daphne (probably 1470-80), by Antonio del Pollaiuolo

Local character

Although Renaissance artists loved to paint Classical scenes, that doesn't mean they always made them historically accurate. They were quite happy to change the settings and people's appearances to make them look more familiar to viewers at the time. So Venus and Narcissus have contemporary accessories and clothes and, on the left, Apollo chases Daphne through an Italian landscape.

The scene on the left illustrates a story told by a Roman writer called Ovid. In the story, Daphne was chased by Apollo, and her father turned her into a tree so she could escape him. You can see the city of Florence in the distance.

The picture on the right shows Narcissus, another character described by Ovid. According to myth, he fell in love with his own reflection and gazed at it until he died.

Narcissus (about 1490-99), by a follower of Leonardo da Vinci

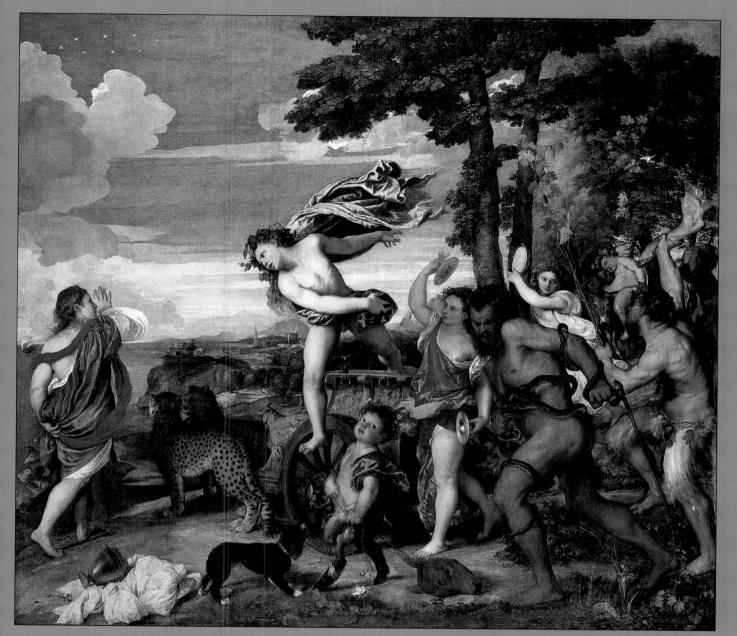

Bacchus And Ariadne (1521-23), by Tiziano Vecellio, known as 'Titian.' Notice how Titian divides the picture into two triangles, to emphasize different parts of the story. The top left-hand triangle is

blue and empty, containing just the lonely Ariadne and a tiny ship disappearing over the horizon. But the lower right-hand triangle, with Bacchus, is crowded with colorful, unruly figures.

Big and small

In the 15th century, most story paintings were fairly small. They were often made to decorate the furniture people bought to celebrate special occasions, such as weddings. But, by the 16th century, they began to be painted on a bigger scale, sometimes on canvas, sometimes directly onto the walls of grand villas and palaces. This painting by Titian, made for a duke's castle, is many times bigger than any of the ones on the previous page.

Gods and grand schemes

Bacchus And Ariadne was painted for Alfonso d'Este, a learned Italian duke. He wanted to recreate a Greek picture gallery, and asked Titian to work from specific Classical texts to paint this canvas for it. The scene tells several parts of the story. On the left, the princess Ariadne turns, startled, from watching her old lover, Theseus, sail away. Her fearful eyes meet those of Bacchus, the god of wine (you can tell who he is from the vine wreath on his head). He will become her new lover. His passion for her is shown by the way he leaps out of his chariot, his eyes fixed on hers. The stars in the sky are from the story's end, when Bacchus turned Ariadne's crown into a constellation, to make her live forever.

Venus And Mars

The Italian artist Sandro Botticelli is famous for his beautiful paintings based on Classical myths. Here, he shows two lovers reclining in a wooded grove. They are Venus, the goddess of love, and Mars, the god of war. Four young fauns, mythological creatures supposed to be half-human, half-goat, play around them.

Title: Venus And Mars Date: about 1485

Artist: Alessandro Filipepi, known as Sandro 'Botticelli,' or 'little barrel' Materials: Egg tempera and oil on

poplar wood

Size: 69 x 173cm (27 x 68in)

Venus can be identified by her pearl brooch and the myrtle bushes behind her. Pearls were her emblem because, like a pearl, she was meant to have been born from a shell. And myrtles were sacred to her because they are evergreen, so they last as love is meant to last.

You can tell that the man is Mars because of his weapons and armor, even if he isn't actually using them. In fact, he is so fast asleep that not even a conch shell, blown like a trumpet in his ear, can wake him.

In mythology, fauns were meant to be wild and mischievous. But Botticelli painted them as small children, comically dwarfed by Mars' armor, so they won't seem threatening.

Home, sweet home

In Renaissance times, long, rectangular paintings were made to decorate walls or furniture. This one was probably designed for a chest or bed. Paintings like this are known as 'spalliera' panels and usually show scenes from history or myths. Often, several panels were made together, telling a story in stages. They were meant to be fun, but some had a moral too.

Opposites attract

Mars is asleep and vulnerable, while Venus is alert. They embody the opposites of love and war, female and male, and strength and weakness. Venus looks on calmly as the fauns steal Mars's weapons - they may be acting on her orders. So Mars, the warrior, has been disarmed by the goddess of love, proving the moral that love is stronger than war.

Ideal beauty

Venus was meant to be incredibly beautiful. Botticelli painted her according to 15th-century ideals of beauty, with a 15th-century dress and hairstyle. Her features resemble Botticelli's other famous picture of her, *The Birth Of Venus* (about 1483-84). But there is something odd about the way she is lying. If you look closely, her right leg seems to be missing completely.

Deliberate mistakes?

Although the scene is beautifully painted, the bodies of Venus and Mars aren't anatomically correct. As well as Venus' missing leg, Mars' left shoulder juts out too much, and his left leg is shorter than his right. Botticelli may have distorted them by mistake. Or he may have done it deliberately, to make them fit his composition better.

Wasps and wedding bells

Spalliera panels were usually bought when people were married, which seems appropriate for a panel showing the triumph of love. We don't know if it was made for a particular couple, but the wasps buzzing around Mars' head may be a clue. The Italian for wasp is *vespa*. Wasps were the emblem of a rich Italian family named Vespucci that Botticelli had worked for. But there is no record of them commissioning this panel. So perhaps the wasps are only meant to remind us how love may be followed later by a painful 'sting.'

For a link to a website where you can see more paintings by Sandro Botticelli, and find out more about his life and work, go to www.usborne-quicklinks.com

Outdoor scenes

Renaissance artists' use of perspective and observation of nature gave them important new tools for creating natural-looking landscapes. At the start of the 15th century, most landscapes were still only painted as backdrops. But, as the century

wore on, artists really came to treat landscapes as a subject in their own right. This was helped by the increasing numbers of patrons and collectors who wanted to buy them, after reading about landscape painting in Classical times.

Dawn light

The Italian painter Giovanni Bellini was one of the first to set his figures firmly within a landscape, rather than just using it as a background. The Agony In The Garden is a good example of this. It shows Jesus praying as he waits for the soldiers in the distance to come and take him to his death. This landscape is also symbolic, designed to enhance the picture's meaning. The setting is rocky and bare, to suit the bleak subject. But the rising sun is meant to remind us how, in the Bible, Jesus rises from the dead.

The Agony In The Garden (about 1465), by Giovanni Bellini. Notice the glow on the horizon. Bellini used thin layers of translucent oil paints to capture the subtle effects of dawn light.

In the shadows

Flemish artist Joachim Patinir was perhaps the earliest painter to specialize in landscapes. Although he still included religious or mythological figures in his pictures, they seem much less important than the scenery around them. Patinir may have been inspired to focus on landscapes in this way by the new science of 'cartography,' or map-making.

In this painting of St. Jerome, the saint – a religious hermit – is a small figure tucked away at the bottom of the picture. The scene is dominated by a dramatic panorama of rocks and mountains. Patinir used aerial perspective (see page 45) to create the sense of a vast expanse of space, applying cool, blue colors in the distance, while filling the foreground with warm, reddish browns.

Saint Jerome In A Rocky Landscape (probably 1515-24), by Joachim Patinir

Hunters In The Snow (1565), by Pieter Bruegel. The blue-gray color scheme emphasizes the cold.

Ordinary things

The paintings of the Dutch artist Pieter Bruegel were unusual at the time because they had real people in them doing ordinary things, instead of biblical or mythological characters. Many of his pictures reflect

the changing seasons. This winter scene includes a range of typical activities: hunters with their dogs, food cooking on a fire and people skating. It's so lifelike you can almost feel the cold.

Moody blues

Giorgione was one of the most influential artists of the 16th-century, but he died young and few of his works have survived. His paintings are very moody and atmospheric, but it is hard to say what they are about. The Sunset doesn't tell any particular story. A mountainous wasteland stretches back, past glimpses of Italian-style farmhouses, to a startlingly blue horizon. In the foreground are two mysterious figures. One may be St. Roch, who was supposed to have had a bad leg.

The Sunset (1506-10), by Italian artist Giorgio da Castelfranco, known as 'Giorgione'

In the middle distance, you can see St. George and a dragon. They were added by a 19th-century restorer, to cover a damaged area where there seemed to be a dragon. Nobody knows what Giorgione originally painted.

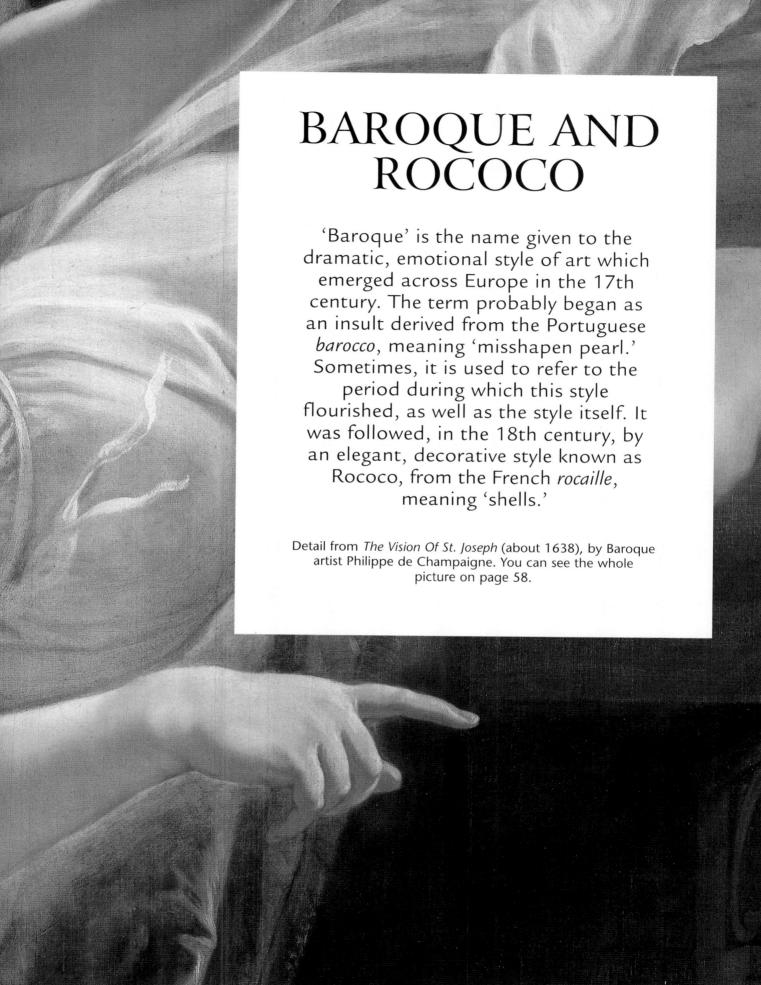

Dramatic art

Designed to appeal to the heart rather than the mind, Baroque art was full of drama and movement. It can seem a bit over the top by today's standards, but at the time, it made a lively change from cool, Classical styles.

The Ecstasy Of St. Theresa (1647-52), by Gian Lorenzo Bernini

High drama

Baroque artists had lots of ways of producing dramatic effects. *The Ecstasy Of St. Theresa*, made for a church in Rome, shows St. Theresa seeing an angel in a vision. The scene was cleverly designed to make it look as strange and miraculous as it must have felt to Theresa. The figures are carved in ghostly white marble, and gilded rays of heavenly light mingle with real light from a window above.

Baroque painters used strong lighting to create extreme contrasts between light and shade. Often, scenes are shown close up, so they seem to be happening right in front of you. And many scenes are constructed along diagonal lines. You can see this in the picture below, if you follow the lines of the figures' spears, arms and legs. This emphasizes their movements, making them look more urgent.

Turned to stone

If you look closely at the scene on the left, you'll see it is built a bit like a stage set. The characters, from a Greek myth about the hero Perseus, are arranged in theatrical poses, and the building in the background looks like a stage backdrop. The spears, arms and rays of light all direct your eye toward the severed head that Perseus is grasping. According to the myth, this head came from a monster named Medusa and turned anyone who saw it into stone. As Perseus holds it up in front of his enemies – careful not to look at it himself – their bodies start to turn an ominous gray.

Perseus Turning Phineas And His Followers Into Stone (about 1680), by Luca Giordano

Breaking out

Baroque artists had ways of creating drama in portraits, too. In this self portrait, the Spanish artist Bartolomé Murillo painted himself, framed by a carved oval. On the ledge beneath the oval are his artist's tools: a preparatory drawing in red chalk, a palette and brushes. But it isn't clear whether the frame is meant to be a mirror or a painting-within-the-painting. He breaks the illusion in a startling and rather creepy way, by showing his hand emerging out of the frame, as if his picture is coming to life. This is known as a *trompe l'oeil* device.

Self Portrait (1670-73), by Bartolomé Murillo. The inscription says: "Bartolomé Murillo portraying himself to fulfil the wishes of his children" – it is to be a portrait they can remember him by after he is dead.

For a link to a website where you can view another of Rembrandt van Rijn's most famous history paintings in an interactive exhibition, go to www.usborne-quicklinks.com

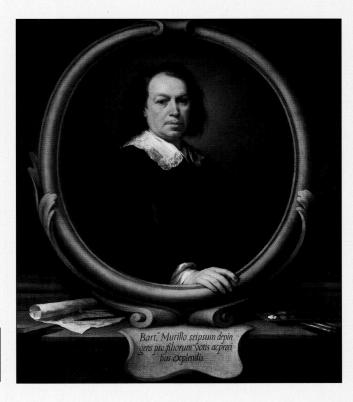

In extremity

Baroque artists loved extreme situations, such as battles and supernatural tales, which suited dramatic paintings. Both Italian artist Luca Giordano and Dutch

painter Rembrandt van Rijn chose scenes of intense drama, such as people being turned into stone (previous page), or a miraculous apparition (below).

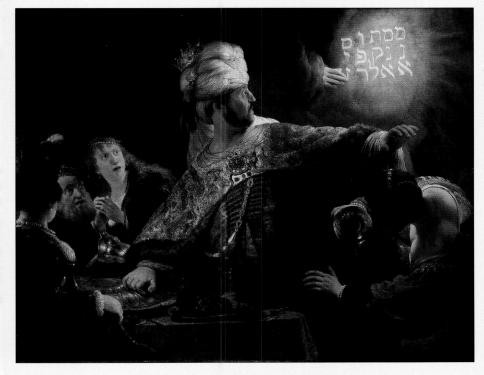

Belshazzar's Feast (about 1635), by Rembrandt van Rijn. The writing on the wall is in Hebrew script. Notice how the scene is illuminated by the light blazing out of these letters.

Writing on the wall

According to the Bible, King Belshazzar gave a great feast where he served wine in golden goblets stolen from a temple in Jerusalem. Suddenly, a hand appeared and wrote a mysterious message on the wall. When it was deciphered, the message turned out to be a warning from God: "You have been weighed in the balance and found wanting."

Like Giordano, Rembrandt used extreme gestures and expressions to create the impression of a dramatic split second. But Belshazzar's Feast seems more intimate and immediate because it is so close up. We could almost be sitting at the table ourselves, among the astonished guests.

The Supper at Emmaus

Italian painter Caravaggio is famous for his dramatic but realistic paintings, often of religious scenes, such as *The Supper At Emmaus*. It might be hard to imagine now but, at the time, some people found his paintings shocking. They thought he was disrespectful, because he made holy figures look like ordinary, everyday people.

Title: The Supper At Emmaus

Date: 1601

Artist: Michelangelo da Merisi, known

as 'Caravaggio'

Materials: oil on canvas Size: 142 x 196cm (56 x 77in)

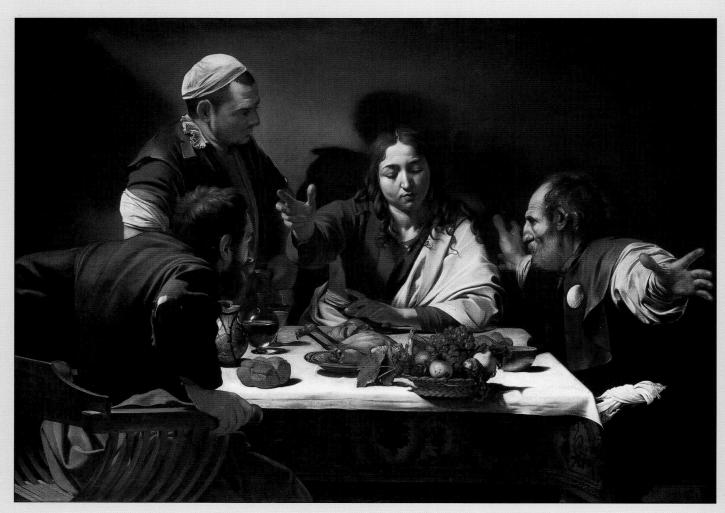

Back from the dead

This picture tells a Bible story about two of Jesus' disciples. After Jesus had been crucified, they walked to the town of Emmaus. On the way, they met a stranger and invited him to eat with them at an inn. After the inn-keeper had brought the meal, the stranger blessed it in an oddly familiar way – and the disciples realized he was Jesus, miraculously returned from the dead. The painting shows the moment when the shocked disciples recognize their guest.

Living drama

You can see this scene so close up, it is almost as if you are sitting at the table too. There isn't much space around the figures, and the arms of Jesus and the disciples are foreshortened, so they seem to reach right out of the picture toward us. Dynamic poses and strong lighting add to the dramatic tension. Caravaggio's sense of drama may have been influenced by his own colorful lifestyle – he was a fiery character who constantly got into brawls.

Center stage

Jesus sits in the middle of the picture, clearly the center of attention. His red robe makes him stand out from everyone else, and the dark background ensures nothing distracts from his radiant face. He is also clean shaven although, at the time, most paintings showed him with a beard. This made him harder to recognize, so anyone seeing the picture would hesitate – like the disciples – before identifying him.

Here and now

The scene has a gritty realism about it. The disciples are dressed in shabby old clothes, like 17th-century workmen. And the food on the table is what ordinary people might have eaten: bread, fruit and a roast guinea fowl. They look very lifelike – some of the fruit is even beginning to rot. All this helps to make the miracle feel more real, as if it were taking place in front of us and not in the distant past.

Caravaggio turned his realism on himself, too. Experts think this sickly figure is actually a self portrait, painted shortly after he had been in the hospital - which explains his unhealthy color.

Trick of the light

Although Supper At Emmaus looks very real, Caravaggio has twisted reality to suit his purpose. The shadow under the fruit basket forms the shape of a fish, an early Christian symbol. And the shadow of the inn-keeper serving the meal creates a dark halo around Jesus' head. Given where the light is coming from, the shadow should really fall across his face.

Sick Bacchus (1593-94), by Caravaggio

A violent life

Despite his religious paintings, Caravaggio was a violently argumentative man. He was prosecuted several times, once for throwing a dish of hot artichokes at a waiter's head. In 1605, he was jailed for carrying a sword. And, just a year later, at the height of his success, he killed a man in a dispute over a game of tennis. He had to flee the authorities and spent the rest of his life in exile, dying of fever at the age of 39.

Wars of religion

The 17th century was a time of fierce religious debates, quarrels and even wars. In the end, this made the Christian Church split into two. Northern Europe became largely Protestant, while southern Europe remained Catholic. Religious battles had a huge effect on art. Catholic Church leaders encouraged people to use religious images as an aid to prayer. But in Protestant countries this use of art was frowned on and even considered sinful.

Close to Heaven

If religious paintings were to teach people and inspire their devotion, as the Catholic Church wanted, the artists needed to create clear, compelling images. So they used the Baroque techniques of theatrical lighting and dynamic compositions to convey intense spiritual experiences. Many Catholic paintings illustrated dramatic episodes from the lives of the saints, such as someone having a vision, as in the picture on the right, or being martyred (killed for their beliefs). These were extraordinary scenes, but they were often shown in ordinary, domestic settings, to help people feel closer to the saints.

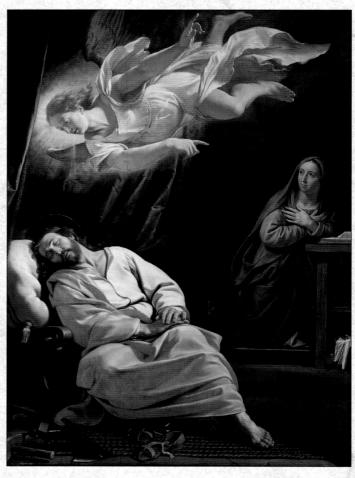

The Vision of St. Joseph (about 1638), by Philippe de Champaigne. The angel is telling Joseph that his wife's baby is the son of God. Notice Joseph's sandals lying discarded on the floor.

Setting a good example

Protestants believed you should only worship God. But the Catholic Church encouraged people to admire the saints, especially the Virgin Mary, and to address their prayers to God through them. So the Virgin Mary is often featured in Catholic art from this period, and artists such as Sassoferrato painted her time and time again.

The Virgin In Prayer shows Mary praying, perhaps for our salvation. Her calm concentration is designed to set a good example, to encourage people to copy her and pray, as she does. The dark setting, strong lighting and close-up view make her a striking figure. The shadows on her face and robes were painted so delicately that, in a dark church lit only by candles, you could almost mistake this image for a real woman.

The VirginIn Prayer (1640-50), by Giovanni Salvi, known as 'Sassoferrato'

Seeing the light

In Protestant countries, like the Dutch Republic, people thought church services should concentrate on religious readings and prayers. They felt that paintings, statues and other church decorations were a distraction. Some even believed that it was wrong to pray in front of a holy picture – just as the iconoclasts had thought (see page 27). So a lot of religious art was destroyed, and church interiors were stripped bare.

This painting of a church in Utrecht, in the Dutch Republic, was painted not long after the church was 'cleansed' of Catholic imagery. The whitewashed columns and arches appear startlingly bright and clear. Sunshine streams through the plain windows, which until recently would have had stained glass. The grand architecture, bathed in a divine light, is meant to make you think about religion and fill you with awe.

The Interior Of The Buurkerk At Utrecht (1644), by Pieter Saenredam

Homely scenes

Although grand altarpieces and large-scale religious paintings were no longer made for Protestant churches, Protestant art-lovers still bought small religious scenes to hang at home. These usually showed Bible stories, as pictures of saints were taboo outside Catholic countries, and tended to be much less dramatic and imposing than Catholic pictures. Rembrandt's *The Adoration Of The Shepherds* is typical of how Dutch artists painted religious subjects. It shows shepherds praying to the newborn Jesus in a Dutch barn, on a dark winter's night. The scene has a homely, intimate feel, in complete contrast to the grand Baroque style of paintings like *The Vision Of St. Joseph* (above left).

The Adoration Of The Shepherds (1646), by Rembrandt van Rijn. Notice how Rembrandt uses light to draw your eye into the picture.

For a link to a website where you can compare paintings by Sassoferrato and Saenredam, go to www.usborne-quicklinks.com

Fit for a king

In the 17th century, kings and queens were much more powerful than today. They lived in grand palaces and paid the best painters to work at their courts. The court painters' main duty was to paint royal portraits. They also created historical and mythological scenes to decorate royal palaces – paintings which were worlds away from the religious images made for the Church.

Spin doctors

Most kings and queens allowed themselves to be painted only by their court painter. Their images were tightly controlled, just as celebrities today try to control how they are portrayed by the media. So court painters were often chosen for their ability to flatter their subjects, as well as their skill in painting – as you can see from the two portraits of kings on this page.

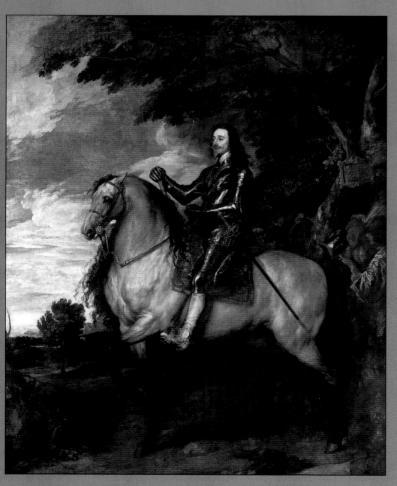

Charles I On Horseback (about 1637-38), by Flemish artist Anthony van Dyck

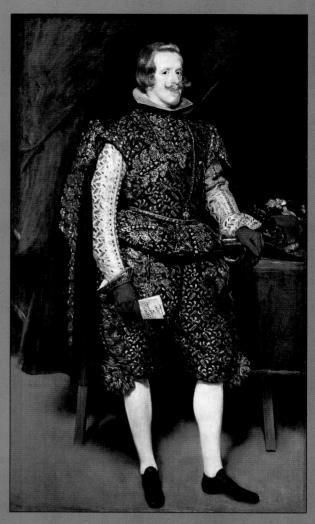

Dress to impress

Diego Velázquez was the court painter of King Philip IV of Spain. In the portrait above, he showed Philip dressed in an impressive, silverembroidered suit. Philip was supposed to have had a large, jutting-out chin. But Velázquez painted him with his head turned slightly away from us, so it doesn't show too much.

Power and glory

Anthony van Dyck was court painter to the English king, Charles I. In the lifesize portrait on the left, he showed Charles on horseback, towering above the landscape – and the viewer. The painting was so big, van Dyck needed scaffolding to complete it. Charles was really a small, thin man with a narrow face. But van Dyck made him look regal and impressive, by showing him so high above us, in shining armor, and drawing his face from the side.

Risky pictures

Members of the royal courts, or courtiers, would buy historical and mythological scenes for decoration. But they also wanted to show how cultured they were, as only people with a good education would

know the stories behind them. The paintings reveal how privileged courtiers were, too. In Spain, the nudity in many of these scenes would simply not have been allowed outside the closed world of the court.

Hidden Venus

The Toilet Of Venus was very unusual, considering when and where it was painted. It shows a female nude – a subject then frowned on by the Spanish Church. Velázquez got away with it because it was made for a royal courtier, but even he probably didn't put it on general display. Nudes were often hung behind curtains and only revealed to select audiences. The winged Cupid identifies the woman as Venus, goddess of love. She is checking her appearance in the mirror – this is the old meaning of 'toilet,' from the French toilette. Velázquez plays a game with the reflection: is Venus looking at her own face, or is she watching us in the mirror, coolly returning our gaze?

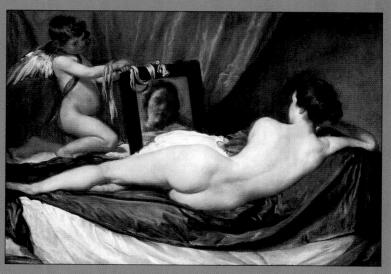

The Toilet Of Venus (1647-51), by Diego Velázquez. This picture had to be mended after a women's rights protester attacked it with a cleaver in 1914.

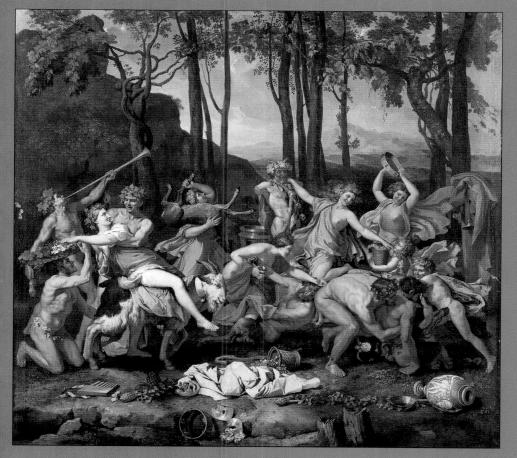

Pan pipes

The Triumph Of Pan, by Nicolas Poussin, reflects the educated tastes of 17th-century nobles. It wasn't commissioned by a king, but by someone almost as powerful - Cardinal Richelieu, chief minister of France. His palace had a room full of mythological paintings from the Renaissance. Poussin created this scene to fit in with them. It shows mythical characters celebrating around a statue of Pan, the god of woods and fields. They look quite frenzied, but Poussin turned their wild movements into a highly ordered picture. You can see how their arms and legs are arranged in neat diagonal lines.

The Triumph Of Pan (1636), by the French artist Nicolas Poussin

Peace And War

The Flemish artist Peter Paul Rubens was an important diplomat as well as a prolific painter. In 1630, the Spanish sent him on a mission to England, to try to secure peace between the two countries. As well as putting his case in words, he gave the English king *Peace And War*, a magnificent painting which was meant to be a graphic illustration of the benefits of peace.

Title: Peace And War (Minerva Protects Pax

From Mars)
Date: 1629-30

Artist: Peter Paul Rubens Materials: oil on canvas Size: 204 x 298cm (80 x 117in)

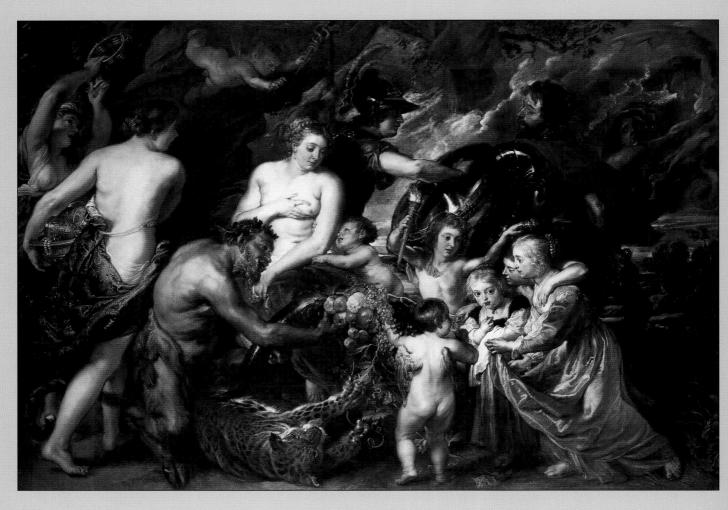

Picture puzzles

This painting is an allegory. This means it holds a hidden message that has to be read by picking up visual clues. The different mythical characters represent abstract ideas. The woman sitting in the middle is Pax, or peace. Around her, everything seems peaceful and contented. But Mars, the god of war, is standing nearby, ready for battle. The painting's structure reinforces the symbolism. It contains three triangles, two bright and happy, the third dark and ominous.

This diagram shows how the picture is made up of triangles. The one on the right has Mars and dark storm clouds; the other two are more colorful. Pax herself sits near the top of the middle one.

Advantages of peace

Around Pax, everything is harmonious. Even the wild creatures have been tamed. The leopard rolls on its back like a kitten. Beside it, there is a satyr – a mythical creature with the body of man and the legs of a goat. Satyrs were meant to be very mischievous, but this one is kindly offering the children fruit from a cornucopia, or horn of plenty. Behind him, there is a woman carrying a basin of gold. The fruit and gold represent the prosperity peace brings. So the children can grow up well-provided-for and happy.

Under threat

But this pleasant scene is threatened. The sky is darkening, and Mars lurks in the background, accompanied by a ghostly Fury, or goddess of vengeance. A woman clad in armor – Minerva, the goddess of wisdom – pushes Mars away. So peace is protected for now. But though Mars is leaving, he is still a threat. He is looking back over his shoulder as if reluctant to depart, and his sword is dangerously close to the girl in the yellow dress.

Reality and myth

The children are actually portraits of the son and daughters of Sir Balthasar Gerbier, the artist's friend and host in London. The boy is dressed as Hymen, the god of marriage, but the two girls are in ordinary

Cherubic mission

The winged cherub hovering above Pax grasps an olive branch, a symbol of peace, in one hand. In the other, he carries a second symbol of peace: a rod with a serpent twined around it. Known as a 'caduceus,' this was supposed to be the staff of Mercury, the messenger of the gods. Perhaps the cherub represents Rubens' own role as a messenger of peace at the English court?

Rubens the diplomat

You can see what Rubens looked like in this self portrait he painted shortly before his death in 1640.

Self Portrait (1638-40), by Peter Paul Rubens

Rubens' mission led England to sign a peace treaty with Spain in 1630. How much this was due to his skill at negotiating, and how much to his talent for painting, it is impossible to say. But the English king, Charles I, was so impressed that he knighted Rubens and commissioned him to paint a ceiling in the royal Banqueting House in London.

Sadly, peace turned out to be short-lived. England and Spain were soon caught up in a long-running European conflict known as the Thirty Years' War. But Rubens was not sent on any more missions. Now in his 50s, he retired to his Flemish country estate, where he devoted himself to painting tranquil scenes of rural life and vast landscapes like the one on page 14.

Rubens' fluid brushwork and strong colors were greatly admired, especially his flesh tones - one critic said they seemed to be painted with milk and blood.

Town and country

Landscapes and townscapes became very popular in the 17th century, as people began to accept they were a suitable subject for paintings. Some artists created beautiful imaginary scenes. But pictures from the newly independent Dutch Republic tended to be about real life instead. The republic's proud citizens wanted paintings that captured the particular character of their countryside and towns.

Heavenly view

French artist Claude was one of the first artists to paint proper landscapes, although they were often disguised as story-telling scenes. This painting is supposed to be about a Biblical character, Hagar, and an angel. But they are just small figures in the foreground. The picture isn't really about them, but the dazzling vista behind them. It's constructed a bit like a theater set: dark trees and shadows neatly frame a sunlit view of a river and hills, which fade into the distance in a dramatic show of aerial perspective (see page 45). The effect is dreamy – quite unlike the down-to-earth Dutch style.

Landscape With Hagar And The Angel (1646), by Claude Gellée, known as Claude Lorrain or Claude

The Avenue at Middelharnis (1689), by Meindert Hobbema

On location

This picture shows a real place: Middelharnis, in southern Holland. It is so accurate that if you went there today, you'd still be able to recognize the spot. As you can see, the land is very flat, but the lines of the trees against the sky give the scene a dramatic perspective. Many Dutch painters paid great attention to skies, because the land was so featureless. The left and right hand sides of the road are very different. On the left, the land is overgrown and wild. But on the right, it has been turned into a neat market garden. This illustrates the Dutch people's success at farming.

Spick and span

The painting on the right, by Dutch artist Pieter de Hooch, shows the courtyard of a house in Delft, a town in Holland where he was living at the time. Later, he moved to Amsterdam and painted pictures of high society, but he is best known for ordinary domestic scenes like this one, which are more typical of Dutch art of the time.

If you look carefully at this picture, you can see how many details de Hooch captured. The inscribed plaque over the doorway still exists today. The patterns created by the tiles and bricks, and the receding view down a corridor inside the house, reveal his skill with perspective. The cleanly swept courtyard and smiling woman and child may be meant to suggest the pleasures of a happy home life.

For a link to a website featuring a Claude glass, and other equipment used by landscape painters, go to www.usborne-quicklinks.com

The Courtyard Of A House In Delft (1658), by Pieter de Hooch

Playing tricks

The painting below shows another Delft scene: a view along a street with a musical instrument stall, church and town hall. But the street bends oddly so that, at first sight, everything seems rather unreal. The artist, Carel Fabritius, was interested in optical

devices such as the camera obscura (see pages 120-121), which could help him draw more accurately. He was also an expert in perspective. So he deliberately distorted the perspective, as an optical trick. To see it without the distortion, you had to use a special box.

A View Of Delft, With A Musical Instrument Seller's Stall (1652), by Dutch painter Carel Fabritius

This picture was meant to be inserted into a 'perspective box' and viewed through a peephole, which corrected the distortion.

Everyday life

The 17th century saw an enormous increase in paintings of ordinary people in everyday settings, particularly in the Dutch Republic. This wasn't the first time artists had painted scenes of everyday life - but, until now, these had usually only formed a small part of paintings on other, grander themes. Now, everyday life became a subject in itself.

To paint a scene like this requires delicate brushwork. In the detail below, you can see how the artist used touches of pure white to add gleaming highlights to the lady's silk dress and pearls. By contrast, her face is very smoothly shaded.

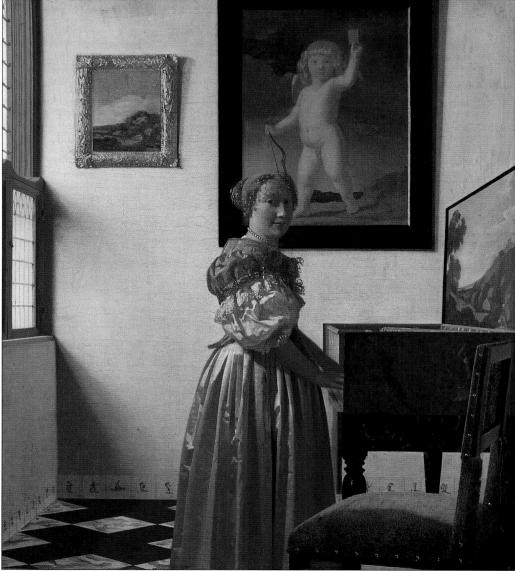

A Young Woman Standing At A Virginal (about 1670), by Jan Vermeer

Musical moments

A Young Woman Standing At A Virginal pictures a calm, sunlit corner of a wealthy Dutch home. There is nothing special going on and no obvious moral tale, only a beautifully dressed woman standing by a virginal, an old-fashioned instrument similar to a piano. It is a quiet interior scene – a deliberate contrast to the grandeur and drama of Baroque-style art.

The painting in the background shows a cupid holding a playing card. This was sometimes used as a symbol of fidelity. The chair by the virginal is turned inwards, away from the viewer - it is not being offered to the onlooker. So the idea behind the picture may be that the woman is faithfully waiting for the return of her lover or husband, and not seeking out other companions.

The moral of the story

At this time, paintings with moral messages were popular, perhaps because buying them was a way for people to show how virtuous they were. So many everyday scenes show good behavior, such as work or study, that viewers were meant to imitate; or bad behavior, such as drinking too much, they had to avoid. But despite the seriousness, these pictures often tried to be funny, too. They poke fun at bad habits instead of condemning them, to try to entertain their audience as well as teach them

Books and toys

The painting on the right, by the Dutch painter Caspar Netscher, uses a quiet family scene to contrast hard work and laziness. In the corner of a room, a mother teaches her daughter to read. But her son ignores his lessons, playing idly with a pet dog and his toys instead.

A Lady Teaching A Child To Read (probably 1670s), by Caspar Netscher

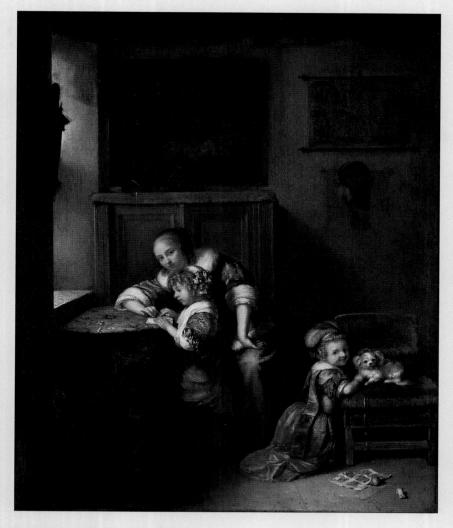

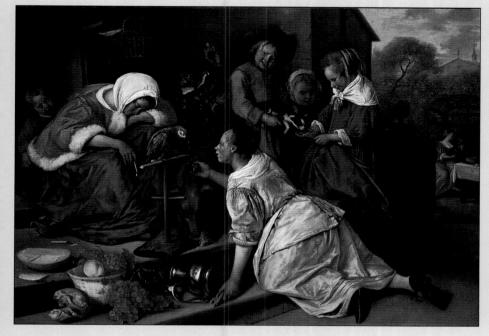

The Effects Of Intemperance (about 1663-65), by Jan Steen

Like many Dutch paintings, this illustrates an old Dutch proverb: 'Wine is a mocker' - meaning that wine makes a mockery of those who drink too much of it.

Drunk and disorderly

The Effects Of Intemperance, by Dutch artist Jan Steen, shows the chaos caused by parents behaving badly. The mother is drunk and asleep, while the father is sitting with another woman in the garden. Unwatched, their children misbehave too. One boy picks his mother's purse while another throws roses at the pig. The children on the right feed their dinner to the cat, and the tipsy maid offers her wine to the parrot. Steen hints at the dire consequences which may follow all this. The basket above the mother's head holds a birch rod used to punish petty criminals, a crutch and a kind of rattle carried by beggars.

Making arrangements

In the 17th century, there was a huge demand for still life paintings of flowers, food and other things, especially in the Dutch Republic. Dutch artists specialized in creating amazingly lifelike still lifes on particular themes. But despite the dazzling technical skill they showed, many people considered them less important than other kinds of paintings, because they seemed only to copy how things looked. But there is often more to them than meets the eye.

Flower power

From the early 17th century, flowers became a hugely popular subject for still lifes. At the time, scholars were beginning to learn much more about plants, and this is reflected in the range of species found in paintings. The vase on the right holds at least 14 different flowers, including tulips, which were then so rare and highly prized that some collectors would exchange their life savings for a single tulip bulb.

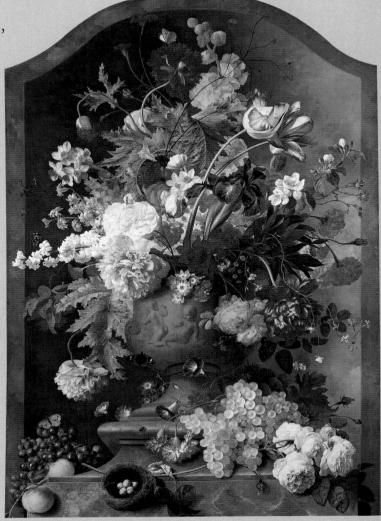

Flowers In A Terracotta Vase (1736), by Dutch painter Jan van Huysum. Look at the insects on the vase: they are so lifelike, they could almost be crawling over the surface of the painting.

Blooming marvellous

Although Flowers In A Terracotta Vase looks extremely lifelike, it isn't as real as it seems. Many of the flowers are larger than life, and the artist, Jan van Huysum, could never have seen them all together like this. Flower artists used to paint one species at a time, as each came into bloom, and gradually build up an imaginary bouquet of flowers from different seasons. Van Huysum took over a year to complete this painting, which includes spring blossom

along with summer roses and

autumnal fruits.

Lap of luxury

Still Life With Drinking Horn
proudly displays the trappings of
a luxurious feast. On a table
draped with an oriental rug there
are glasses of wine, a
magnificent drinking horn and a
whole lobster on a silver platter,
next to a half-peeled lemon. It
might seem casually arranged,
but everything was carefully
chosen to provide contrasting
colors and textures.

This painting, like Van Huysum's Flowers, was designed to show off expensive luxury items. Even the lemon, which might seem ordinary today, would have been a costly item imported all the way from Italy. The Dutch word for 'show off' is pronk. So these arrangements are sometimes called 'pronk' still lifes.

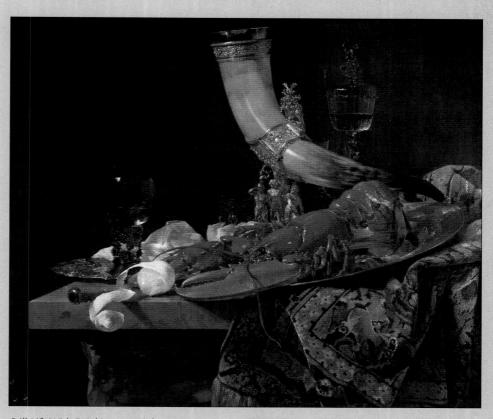

Still Life With Drinking Horn (about 1653), by Willem Kalf. Notice the silver figures supporting the horn. The middle one is St. Sebastian, patron saint of archers - the horn used to belong to an archers' guild.

For a link to a website where you can zoom in on the details of different still lifes, go to www.usborne-quicklinks.com

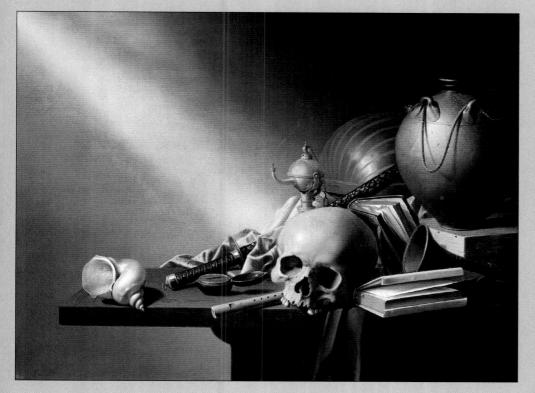

An Allegory Of The Vanities Of Human Life (about 1640), by Dutch painter Harmen Steenwyck. This kind of allegorical still life seems to have been especially popular with scholars, who must have enjoyed deciphering the different symbols.

All in vain

Another popular type of still life was known as a 'vanitas' (vanitas is Latin for 'vanity.') These were meant to stop you from being too proud by reminding you that success is only temporary and everyone dies in the end. In this example, a beam of light points to a skull, an obvious symbol of death. It is surrounded by a rare shell and sword, representing wealth and possessions; books, symbolizing knowledge; and musical instruments, which stand for entertainment. But time passes, as shown by the watch and the dying lamp flame, and the shadow of death hangs over everything.

Flights of fancy

In the early 18th century, an elegant new style of art, known as 'Rococo,' appeared in France. Unlike the dramatic, moralizing art of the previous century, Rococo paintings were just meant to be charming and entertaining. They show graceful figures relaxing in dreamy landscapes – scenes

which can seem a bit light and frothy by today's standards. The new style was hugely popular with the aristocrats of the French court. But it quickly went out of fashion at the end of the century, when the French Revolution brought a bloody and abrupt end to their privileged lifestyle.

Passing the time

Rococo paintings were basically about aristocrats having a good time, reflecting the life of leisure most of them led. So these scenes show gatherings of fashionably dressed people, playing music, dancing, picnicking and generally enjoying themselves.

These scenes of courtly entertainment are sometimes referred to as *fêtes galantes*. But they are far from lifelike. They always take place in idealized, imaginary settings, painted in soft, pretty colors.

The Scale Of Love (1715-18), by Jean-Antoine Watteau

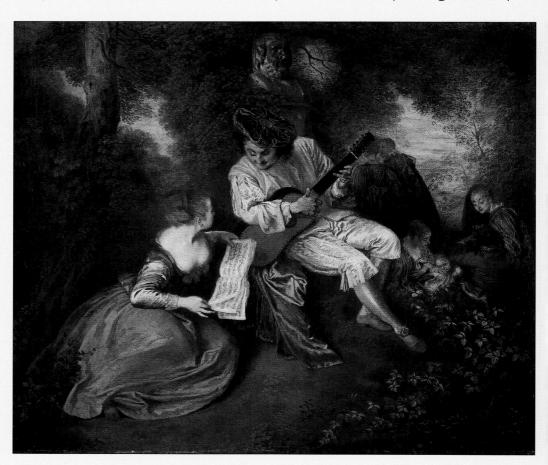

Love and harmony

One of the earliest and most influential Rococo artists was a French painter named Jean-Antoine Watteau. His paintings often deal with the theme of love. *The Scale Of Love* shows a couple sitting in the woods. The man, wearing a theatrical pink costume, is playing a guitar, while the woman holds a book of music. Watteau matches the angle of the man's guitar to the line of the woman's leg beneath her skirt, creating a strong visual link between them. The title of the painting refers to the traditional association between music and love. The harmonies of the music were supposed to reflect the lovers' harmonious feelings.

Feathery brushstrokes create a hazy effect on the sky and trees. This technique was influenced by Rubens' style (see pages 62-63).

An Allegory With Venus And Time has the delicate colors and light touch of the Rococo style, but shows a mythical scene instead of a fête galante. Venus, seated in the heavens, is handing a baby to Old Father Time - you can tell who he is by his hourglass and scythe. The child is Venus' son, Aeneas, who is half human and so must live his life on Earth, subject to the laws of Time.

The painting may have been commissioned to celebrate the birth of a child. It has an unusual shape because it was designed to fit into the ceiling of an Italian palace. As it would have been seen from below, the artist has used aerial perspective to create the impression of looking up to a great height. The tones get lighter and the details become hazier as the things get higher up and farther away, so it is quite hard to make out the faces of the figures at the top.

An Allegory With Venus And Time (1754-58), by Italian artist Giovanni Tiepolo. Notice how the figures are drawn from a steep angle, as if seen from underneath.

For a link to a website where you can visit a virtual exhibition about the Rococo, and see more pictures by Jean-Antoine Watteau, go to www.usborne-quicklinks.com

Coffee break

This painting is by one of the most successful Rococo painters, Nicolas Lancret. It shows a family dressed in elegant 18th-century clothes. But, in the fashion of the time, it is an intimate, relaxed scene, rather than a formal family portrait.

There are lots of small details which emphasize the informality of the scene. The mother is offering a spoonful of coffee to one of her daughters. A doll lies abandoned on the ground, and there is a dog digging in the flowerbed. The painting is sometimes referred to as *The Cup Of Chocolate*, but the servant on the left is holding what is definitely a silver coffee pot.

A Lady In A Garden Taking Coffee (probably 1742), by French painter Nicolas Lancret

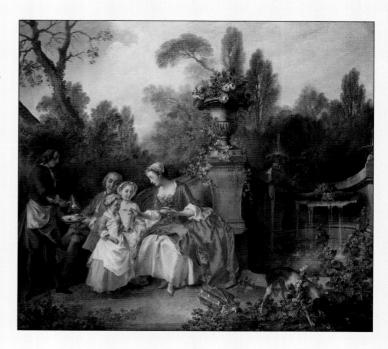

High society

The 18th century was an important time for art in England. More people began taking an interest in artists' work, and new art societies were established, including the Royal Academy of Arts in 1768. The societies

helped artists to study, exhibit and sell their works to a wider public, though many still made their living by painting for rich, upperclass patrons. But there was also a market for satirical pictures criticizing high society.

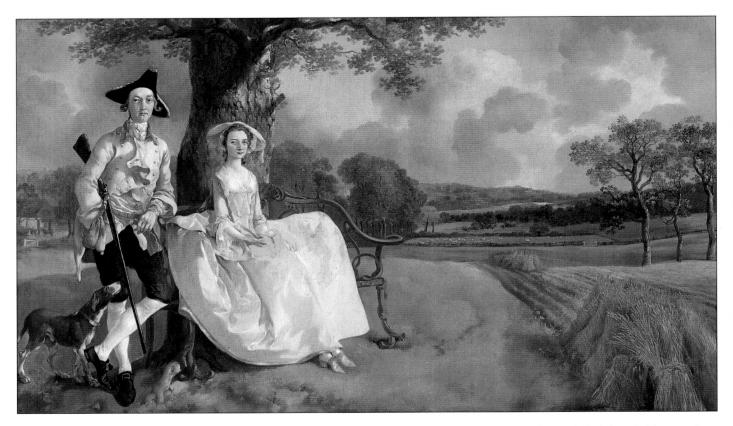

Mr. And Mrs. Andrews (1750), by Thomas Gainsborough. Gainsborough loved painting landscapes and often included them in his portraits.

Artistic rivals

The leading British portrait artists of the day were Thomas Gainsborough and Joshua Reynolds. Both members of the Royal Academy, they were artistic rivals who took very different approaches to painting, though they respected each other's work.

Reynolds studied Classical art and often based his compositions on what he learned from it. He began his paintings by making careful preparatory drawings, and spent a lot of time working on different paint effects. He even tried mixing his paints with wax and vinegar to create texture. By contrast, Gainsborough painted in a livelier, more spontaneous way, and developed a more personal style.

Wealth and weddings

Gainsborough's Mr. And Mrs. Andrews shows a newly wed couple from Suffolk. Robert Andrews, a wealthy landowner, proudly surveys his estate. His wife Frances sits beside him, wearing a fashionable dress with wide skirts. The blank space on her lap was meant to be filled in later, perhaps with a book or an animal. The landscape represents Robert's property, to which his marriage had added. At the time, it was not uncommon for the upper classes to marry for money.

Back in his London studio, Gainsborough painted landscapes from models he made himself, using broccoli for trees and mirrors for lakes.

Fighting man

When he painted people, Reynolds didn't just want to capture how they looked. He also wanted to make his paintings seem important and dignified, to make us take them seriously. So he worked on enormous canvases, and often included allusions to Classical art. For example, the pose of Colonel Banastre Tarleton, the man on the left, was copied from a statue of an ancient Greek god.

Colonel Tarleton commissioned this portrait after fighting in the American War of Independence. It shows him in the middle of a battleground, standing against a cloud of cannon smoke. His pose allowed Reynolds to conceal his fingers, some of which he had lost in battle. But, in spite of his heroic appearance, Tarleton was not a very successful soldier. Some people think Reynolds might have hinted slyly at this in the portrait: amid the debris in the background, there is a cannon aimed at Tarleton's back.

Colonel Banastre Tarleton (1782), by Joshua Reynolds. Notice Tarleton's green coat, the uniform of his cavalry division, which was known as Tarleton's Green Horse.

For a link to a website where you can explore 18th-century London and meet its artists, go to www.usborne-quicklinks.com

Making a mockery

The Marriage Settlement, by William Hogarth, mocks high society and the practice of marrying for money or status. Unlike paintings by Reynolds or Gainsborough, it was designed to be the basis for 'engravings,' or printed copies, which were bought in their hundreds by all kinds of people. It shows the arrangements for a marriage between an impoverished earl's son and a rich merchant's daughter. The fathers negotiate the contract, the merchant with a pile of gold coins, and the earl with a copy of his family tree. The young couple waits helplessly, sitting side-by-side, but turning away from each other. They have been forced together, like the chained dogs in the corner.

The Marriage Settlement (about 1743), by William Hogarth. This is one of a series entitled Fashionable Marriage. A monster's head looms in the oval frame above the young couple, hinting at trouble ahead. The rest of the series illustrates the dire outcome of their marriage.

Vacation snapshots

In the 18th century, it was usual for wealthy gentlemen to complete their education by going on a 'Grand Tour' of Europe, and especially Italy. This was a chance for them to learn about art and culture in other countries, as well as to have some fun away from home. The Tour had a great impact on art. Many 'Grand Tourists' bought paintings and antique sculptures as souvenirs of their travels, creating a profitable line of work for painters and leading to an increased interest in Classical art back home.

Charles Townley's Library At 7, Park Street, Westminster (1782), by Johan Zoffany. This painting shows the extraordinary number of Classical sculptures and replicas collected by one enthusiastic British Grand Tourist, Charles Townley (sitting on the right, wearing a gray jacket), during the course of his travels.

For a link to a website where you can find out more about artists and the Grand Tour, go to www.usborne-quicklinks.com

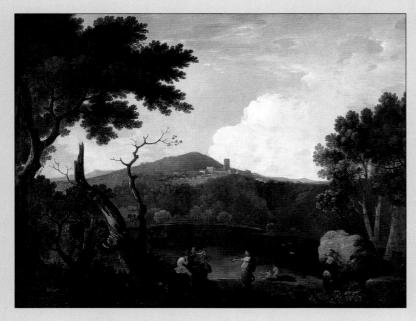

Landscape With Diana And Callisto (about 1757), by Richard Wilson

Humble artists

The Grand Tour was very expensive, so only the wealthiest could afford it. But many artists saw a trip to Rome as an important part of their education. Visiting Rome meant they could study Roman and Italian art, and paint the famous scenery that had inspired Claude, an influential French painter. Many artists found well-paid work there too, making paintings for the Grand Tourists. The painting on the left is a view of Lake Nemi, east of Rome, which the English artist Richard Wilson had visited. The town of Nemi, which you can just see in the distance, was believed to have a shrine to the Roman goddess Diana. Wilson painted Diana and some of her attendants in the foreground.

Interior Of Saint Peter's, Rome (before 1742), by Giovanni Panini

Souvenir scenes

Just as today's tourists buy postcards or take snapshots, 18th-century travelers wanted pictures to remind them of their trip. So some artists specialized in picturesque views of famous sights, like these paintings of Venice and Rome, which they sold to Grand Tourists. The painting on the left shows St. Peter's Basilica, Rome, which would have been on the sightseeing list of any Grand Tourist. The painting below is a view of Venice during a regatta, when there were boat races on the city's canals.

A Regatta On The Grand Canal (about 1740), by Giovanni Canal, or 'Canaletto'

A better view

One Italian painter nicknamed 'Canaletto,' or 'little canal,' became very famous for his detailed scenes of canals in Venice. The picture above is so lifelike, you could almost mistake it for a photo. Canaletto may actually have used a kind of early camera, known as a

'camera obscura,' to help him draw more accurately (see pages 120-121). But he did cheat to improve the scenery, moving buildings to open up the view, and usually showing Venice with sunny skies and sparkling water – just as tourists would want to remember it.

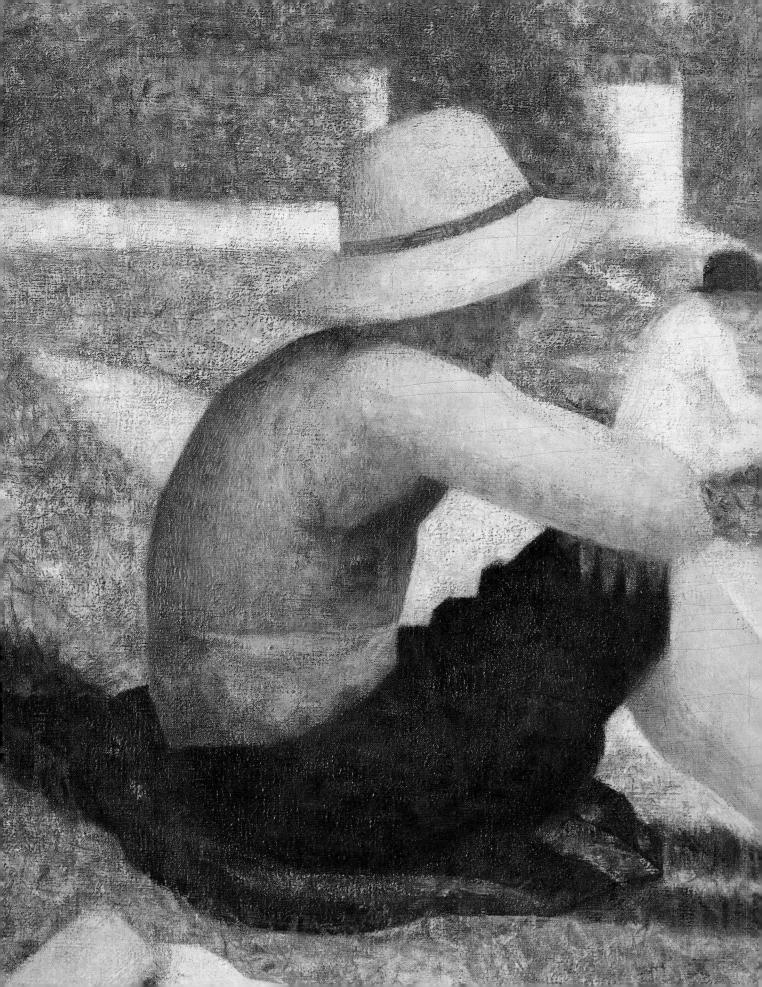

The 19th century was a time when lots of art movements began to appear. These movements were formed when artists began to work together in groups, sharing ideas and often exhibiting their pictures at the same shows. Many artists began to experiment more widely too, taking advantage of new materials and new scientific theories to create radically different ways of painting the world.

Detail from *Bathers At Asnières* (1884), by Georges Seurat. You can see the whole picture on pages 90-91.

Making history

The end of the 18th Century brought troubled times, with wars all over Europe and a bloody revolution in France. Many artists responded by making big, serious pictures of important events and people of the time, or scenes from the past that seemed to relate to them. Often, these paintings were designed to make viewers take a particular political view of events.

The Oath Of The Horatii (1784) by Jacques-Louis David

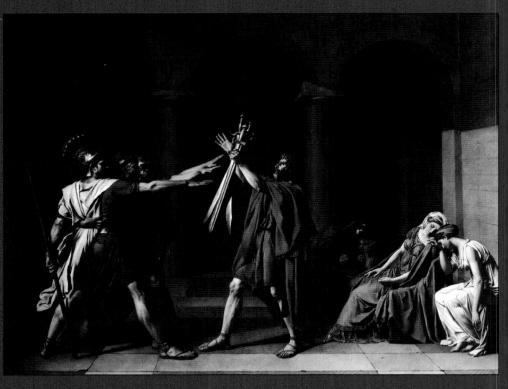

New Classicism :

After excavations began at Pompeii (see page 23) in 1748, there was a renewed interest in Classical 1 history. French artist Jacques-Louis David was particularly inspired by Classical art. His style, with its clearly drawn, smoothly shaded figures, became known as Neoclassicism ('neo' means new.) In choosing austere, Classical subjects, David was

misciously rejecting the more frivolous Rococo style which had

History lessons

David's The Oath Of The Horatii is a history painting (see pages 10-11) in that it illustrates a story. But it was also meant to teach a moral lesson to modern audiences. Set in Roman times, it shows the Horatii brothers swearing loyalty to their father before setting off to battle. Willing to die for the greater good, the brothers represent courage and patriotism - Classical ideals which were very relevant to the artist's own time. This picture was made in 1784, just five years before the violent revolution which overthrew the French king.

David wanted to imitate the polished elegance of Classical sculptures. So he painted very smoothly, hardly leaving any brushmarks that you can see. He also arranged everyone in a row, like the figures in a Classical frieze.

To a link to a website where you can explore a portrait of Napoleon by Jacques-Louis. David, go to www.usborne-quicklinks.com

Horrors of war

This painting, by Spanish artist Francisco Goya, shows French troops shooting unarmed Spanish civilians. Commissioned by the Spanish king, it commemorates a real incident from the 1808-14 war between France and Spain. It is meant to shock us and make us condemn the shootings. But the painting is not just about one event, it also represents the horrors of every war. Unlike David's picture, which makes fighting and sacrifice seem noble and valiant, Goya doesn't shrink from showing the grim reality of killing.

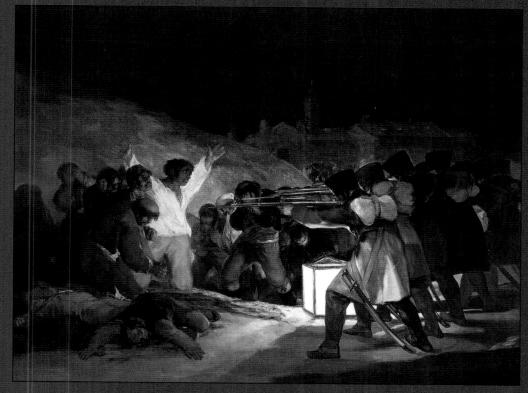

The Third Of May 1808 (Executions) (1814-15), by Francisco Goya. Notice the lantern by the soldiers' feet. Goya uses its light to focus attention on the victims' terrified faces, the harsh lines of the soldiers' guins, and the gruesome puddles of blood on the ground.

Power and glory

Jean-Auguste-Dominique Ingres studied art under David and, like his teacher, became a successful Neoclassicist. By his early twenties, he was regarded as one of the leading artists in France. He painted the French emperor, Napoleon I, several times. This particular portrait was designed to glorify the newly crowned emperor and show just how powerful he was.

To make Napoleon look important, Ingres concentrated on the trappings of state rather than his character. So the emperor's grand, velvet and ermine robes, and his golden crown, chain and scepters, are painted in beautiful detail. But his face is mask-like, revealing little about him as a man.

Napoleon I On His Imperial Throne (* 806), by Ingres. Napoleon's throne, crown, robes and scepters are all traditional symbols of authority. Ingres also added a Roman eagle on the carpet, to make Napoleon seem as mighty as a Roman emperor.

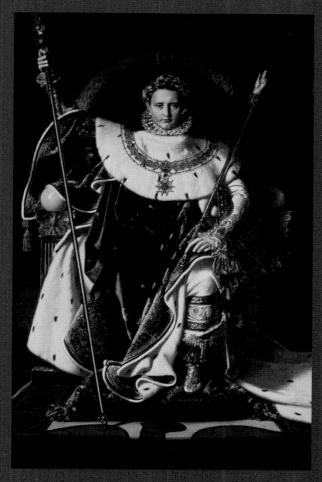

This painting measures a huge 259 x 162cm (102 x 64in). Its vast size was meant to fill you with awe of Napoleon.

In contrast to the size of his portrait, Napoleon was a small man, only 168cm (5ft6in) tall. So the painting is much bigger than lifesize.

Sun and storm

Come 19th-century artists were inspired by the power of Inature, painting wild landscapes beneath moody, dramatic skies. These scenes were meant to have a powerful emotional or spiritual impact when you looked at them. This approach to art became known as Romanticism.

For a link to a website where you can find out more about painting the weather, and see many pictures, go to www.usborne-quicklinks.com

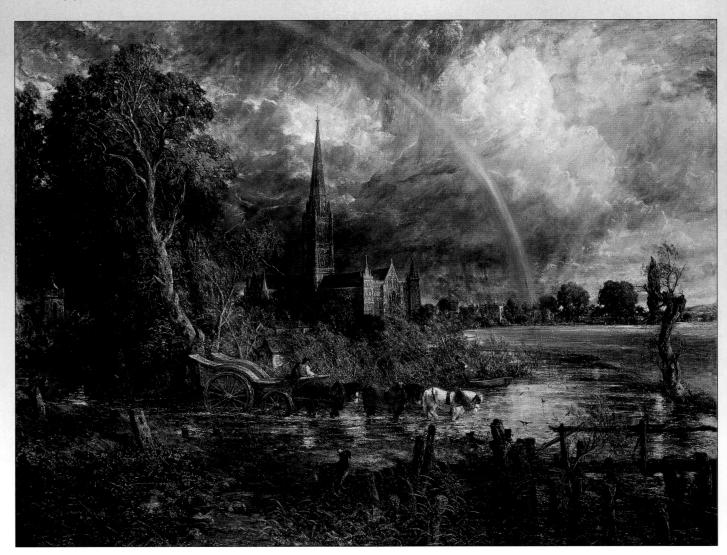

Salisbury Cathedral From The Meadows (1831), by English artist John Constable

Stormy weather

John Constable specialized in painting English landscapes. He created this dramatic scene soon after his wife's death, using the sky - which he described as the 'keynote' of a painting - to set the tone. To the left, it is dark and stormy. But the cathedral's spire rises above the clouds, and the storm is passing, leaving patches of sunlight on the right. The spire may be meant to suggest the consolation of religion,

and the rainbow above it is a traditional symbol of new hope. In this way, Constable made

the picture represent both his grief and his faith in the afterlife

Constable spent months studying clouds, trying to capture their ever-changing appearance in paint.

Snow and salvation

Caspar David Friedrich was the leading German Romantic painter, and his pictures often have a strong religious symbolism. In Winter Landscape, he made a visual link between nature and religion by making the fir trees echo the shape of the distant church. At first sight, the scene seems bleak and cold. But a rosy glow in the sky announces the arrival of a new day. In the foreground, a man has abandoned his crutches and prays in front of a crucifix. The rock he leans on, and the evergreen firs, are meant as symbols of everlasting faith in God.

Winter Landscape (probably 1811), by Caspar David Friedrich. Friedrich based his landscapes on the countryside around Dresden, in northern Germany, where he lived.

Artist in exile

This painting by Eugène Delacroix shows the Roman poet, Ovid, in exile in Scythia, in central Asia. Set apart by his smart, dark blue and white clothes, Ovid watches the Scythians' 'foreign' custom of drinking horses' milk. Delacroix chose this subject because, like

Ovid, he felt himself to be a misunderstood artist, isolated among 'barbarians' (by which he meant unsympathetic art critics.) Delacroix used bright, contrasting colors, such as red and green - he said, "color gives the appearance of life."

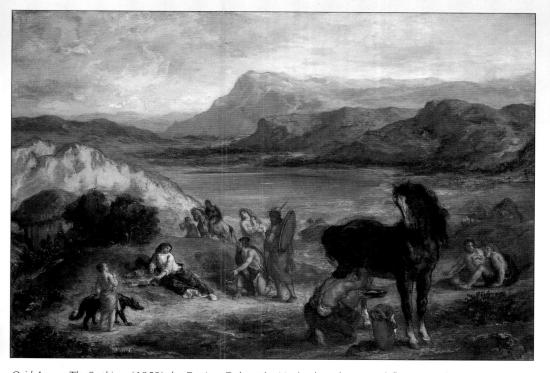

Ovid Among The Scythians (1859), by Eugène Delacroix. Notice how loose and flowing Delacroix's brushwork seems, compared to the painting by Ingres on page 79, which has a much smoother, more even finish.

Fighting it out

Delacroix was the bestknown French Romantic painter, and his vivid, expressive approach is typical of Romanticism. It was very different from the smooth, polished style of the Neoclassicists and Ingres. In the 19th century, art critics argued furiously over the merits of these two styles, often pitting Delacroix's work against that of Ingres. Admirers of Classicism denounced Delacroix's paintings as 'ugly.' But his supporters criticized Ingres' pictures for lacking feeling.

Dreams and legends

Although many 19th-century artists chose to paint the world around them, others found their inspiration elsewhere. Some looked inside their imagination, creating moody, mysterious images of magic and dreams. Others looked back to the past, painting scenes from ancient heroic tales and legends.

Mystery and make-believe

Artists like Gustave Moreau and Odilon Redon in France, and Gustav Klimt in Austria, were preoccupied with dreams and the supernatural, and the mystery of life. But they felt mystery could not be shown directly, so they tried to *suggest* it by using strange, symbolic imagery. This became known as Symbolism. It is hard to say what their symbols mean, they just hint at feelings and impressions.

St. George And The Dragon is Moreau's personal version of the saint's story. Although it is full of details, it is not very realistic. Just look at the way St. George's cloak flies up behind him, defying gravity. Moreau was more interested in exploring his own mind than in creating a lifelike scene, so he painted this picture purely from his imagination. Ideas and feelings were, for him, more important than the world around him – he claimed: "I believe neither in what I touch nor what I see. I only believe... in what I feel."

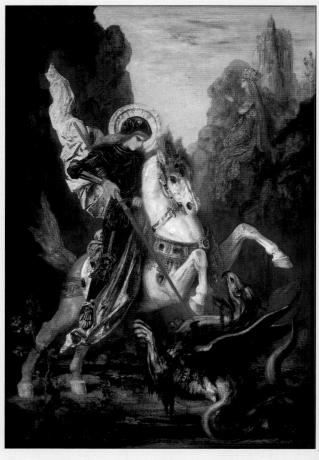

St. George And The Dragon (1889-90), by Gustave Moreau. Notice the saint's halo, copied from earlier religious art.

Flower girl

This pastel drawing by Redon shows a colorful mass of flowers, set against a hazy, mysterious background containing a girl's face. It isn't meant to seem realistic – the girl's features are little more than a blur, and the flowers have oddly blue leaves. Rather, it is a dream-image, more about color and mood than anything else. Redon was said to have been inspired by watching clouds and imagining fantastic figures in the shapes they made.

Ophelia Among The Flowers (about 1905-08), by Odilon Redon

Ophelia (1851-52), by John Everett Millais. Ophelia is surrounded by beautiful plants, all painted from life, many with symbolic meanings. The weeping willow represents sadness, daisies evoke innocence, and poppies and violets are associated with death

Secret society

Another 19th-century development came from a group of young British painters, including Dante Gabriel Rossetti and John Everett Millais. They admired the spirituality and simplicity of medieval art and disliked the influence that Raphael (see page 40) had had on art for centuries. So they formed a secret society, the 'Pre-Raphaelite Brotherhood,' to promote their ideas, and signed their pictures 'PRB.'

The PRB wanted to make art true to nature, so they always worked from life. They drew people in natural poses, with realistic backgrounds. They also prepared their canvases with white, which made the colors on top look brighter. At first, people criticized their work for looking too bright and awkwardly composed. But eventually their style became very popular.

For a link to a website where you can find out more about Millais' Ophelia, go to www.usborne-quicklinks.com

Poetic vision

The Pre-Raphaelites often painted scenes from books, especially the Bible and Shakespeare. The painting above shows the death of Ophelia, from Shakespeare's play *Hamlet*. Mad with grief after her father was killed, Ophelia was supposed to have fallen into a stream while picking flowers and drowned.

Millais spent four months working by a river, plagued by mosquitoes and unfriendly landowners, to make his setting as lifelike as possible. For Ophelia, he got his model, Lizzie Siddal, to pose in a bathtub so he could study the effect of the water – making her catch an awful cold in the process. Lizzie married Millais' friend Rossetti. When she died, Rossetti threw a book of his poems into her grave. But he dug them up again later, so that he could publish them.

City life

The 19th century was a time of great changes and upheavals, some of which, like the explosion of cities, the development of new industries and the introduction of railways, changed forever the way people lived their lives. Some artists responded to this by looking beyond the traditional subjects of art, finding their inspiration instead in the hustle and bustle of modern city life.

Café society

In many ways Paris was at the heart of the new age. The French capital changed rapidly as its old, narrow streets were demolished and replaced by the grand boulevards, designed by Baron Haussmann, that you can see today. New shops, theaters and cafes were built, which form the settings of many paintings by French artists such as Edouard Manet and Edgar Degas, who were born and bred in the city.

Top hats and togas

In painting contemporary scenes, Manet and other artists were influenced by a poet named Charles Baudelaire. He encouraged artists to turn away from the past and paint modern scenes. Top hats, he said, were as interesting as togas, meaning that ordinary modern subjects could be as rewarding as Classical ones. On these two pages you can see examples of some of the kinds of everyday scenes artists chose.

This painting shows a fashionable crowd gathered in a Paris park. The clothes and setting locate the painting firmly in 19th-century Paris. Several of the artist's friends are among the crowd.

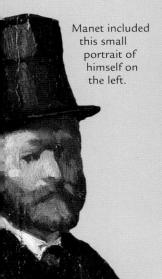

Music In The Tuileries Gardens (1862), by Edouard Manet. Notice how some parts of this scene are more 'finished' than others. Manet wanted to reflect how we see some things more clearly than others.

A modern style

Many artists looked for new ways to capture the experience of modern life. Rather than trying to create balanced compositions and smoothly painted images, they tried to make their pictures seem spontaneous. They often showed scenes from odd angles, as if glimpsed in passing, or cropped like a snapshot, and they used loose, bold brushstrokes.

At the circus

Miss La-La was a famous circus performer. Here, Degas shows her in the middle of a show, performing a feat of strength. In this part of the show, she hung by her teeth from a rope and spun around. The painting is designed to make us feel we are at the show ourselves, watching from below. The scene is drawn in dramatic perspective and lit from beneath, increasing the sensation of height. But Degas didn't paint it in the circus. He made sketches there, but completed the final painting in his studio.

Miss La-La at the Fernando Circus (1879), by Edgar Degas

For a link to a website that features another picture set in Saint Lazare Station, go to www.usborne-quicklinks.com

Saint Lazare Station (1877), by Claude Monet

Light and steam

When Monet painted Saint Lazare Station, trains were still a recent invention. This particular station, which is still a working station today, was then one of the newest and busiest stations in Paris.

Monet spent weeks working on a series of pictures of the station. But he was more interested in the light and colors created by steam from the trains than in the trains themselves. He made friends with the station master, who told the train drivers to let off steam specially when Monet was ready to begin painting.

Rain, Steam And Speed

In 1844, English artist Joseph Turner painted a picture of a steam train crossing a river beneath a stormy sky. At the time, this was a startlingly modern subject – the first ever passenger train had run only 14 years earlier. It was also painted in a very new, blurry and impressionistic style, and created a sensation when it was exhibited.

Title: Rain, Steam And Speed – The Great Western Railway

Date: before 1844

Artist: Joseph Mallord William Turner

Materials: oil on canvas Size: 91 x 122cm (36 x 48in)

Different angles

Turner deliberately contrasted old and new. The train is shown rushing over a modern railroad bridge. To the left, there is an old footbridge. Turner used perspective to emphasize the difference between them. Just compare the lines in the diagram on the right. The old bridge crosses the picture almost horizontally, but the train and the new bridge are drawn at a much steeper angle. It feels as if the train is zooming straight at you.

The shallow angle of the old bridge seems static, while the steep angle of the railroad bridge helps show just how fast the train is moving.

Dashing along

Although it's hard to make out any details, Turner's picture gives a powerful impression of a train racing along. One 19th-century writer was so impressed, he wrote: "there comes a train... really moving at the rate of 50 miles an hour, and which the reader had best make haste to see, lest it should dash out of the picture, and be away... through the wall opposite."

Love and hate

Turner loved to travel on trains, and Rain, Steam And Speed seems to be a celebration of them. But he wasn't always so positive about the new age of steam. The 'Fighting Temeraire,' painted only five years earlier, seems full of nostalgia for the past. It shows a modern tug towing away an old sailing ship for scrap. The setting sun evokes a sense of ending and loss, and the old ship's tall, graceful outline contrasts starkly with the squat modern tug, belching smoke.

The 'Fighting Temeraire' Tugged To Her Last Berth To Be Broken Up, 1838 (1839), by J.M.W. Turner

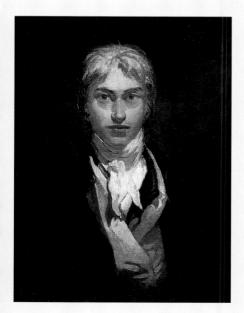

Self Portrait (about 1799), by J.M.W.Turner. This shows Turner in his 20s - by which point he was already a successful artist.

Stormy weather

Turner was famous for painting dramatic skies and atmospheric effects. He set the train against a hazy backdrop of clouds and slanting rain, made up of streaks of white paint smeared across the surface of the picture. One critic dismissed this kind of effect as "soapsuds and whitewash." But it was a good way to convey the power of the rainstorm.

Finishing touches

Turner was a very fast painter. At the time, artists were generally allowed a small amount of time to retouch and varnish paintings after they had been put up in an exhibition. Turner would submit unfinished pictures, then complete them on the spot in front of an admiring audience. He could transform a whole scene with touches of brilliant color, often making paintings nearby look dull and uninteresting by comparison. The artist John Constable once watched

Turner add a patch of red which outshone the reds in his own picture hanging beside it. Constable said, admiringly: "He has been here and fired a gun."

Turner loved watching the weather. He even claimed to have persuaded some sailors to tie him to their ship's mast during a storm, so he could observe its effects.

The great outdoors

In the 1860s-70s, there was a new fashion for painting outdoor scenes outside. Painting outside was not in itself new – many 18th-century artists sketched outside – but now, for the first time, artists were finishing entire paintings out of doors.

Portable paints

One of the things that made painting outdoors possible was the invention of new art equipment in the 1850s. Now, artists could buy ready-to-use paints in portable boxes or resealable metal tubes. So they could take them wherever they wanted.

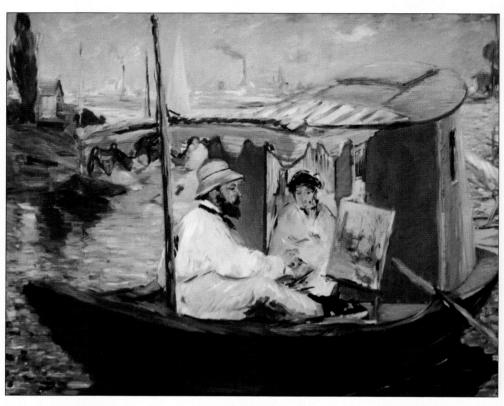

Monet Working On His Boat In Argenteuil (1874), by Edouard Manet. Manet's painting of his friend and fellow-artist, Claude Monet, shows how Monet was prepared to set up studio anywhere.

Fox Hill, Upper Norwood (1870), by Camille Pissarro. Pissarro was interested in the effects of snow. Look at the bright blue he uses in the shadows.

Practical problems

Painting outside brought with it lots of practical problems. It could be bitterly cold, as it was when Camille Pissarro painted Fox Hill. Working on a boat, as Claude Monet is doing above, was rocky and unstable. And, when he painted on a beach, the wind blew sand into his paint. But the artists felt it was all worth it for the sense of immediacy and freshness they achieved by working on the spot.

Monet once arranged for some trees' spring leaves to be removed, so he could finish painting a winter scene.

Bold impressions

The new outdoor paintings showed modern subjects in strong colors, with broken brushstrokes leaving an uneven, 'sketchy' finish. Even where artists had worked on paintings for a long time, they wanted them to seem spontaneous, to capture the fleeting effects of sunlight and shadows.

At the time, critics attacked the new style for being 'impressionistic' and crude. Their insults gave rise to the name by which it is now known: 'Impressionism.' Many Impressionist artists went on to be enormously successful, including Auguste Renoir, Berthe Morisot and Alfred Sisley, as well as Monet and Pisarro. But, when they first started, their work was rejected by official exhibitions.

For a link to a web site where you can find out all about Impressionism, go to www.usborne-quicklinks.com

The Beach At Trouville (1870), by Claude Monet. Monet painted this while on holiday in northern France. The woman on the left is his wife, Camille.

If you look at this detail, you can see grains of sand got stuck to the wet paint - which Monet applied using big, broad brushstrokes.

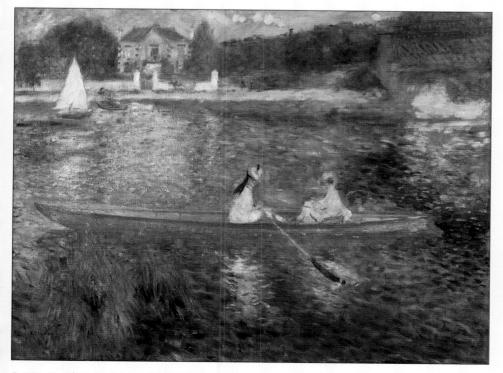

Boating On The Seine (about 1879-80), by Auguste Renoir

Bright and sunny

In Boating On The Seine, Renoir used bright colors to create the impression of a landscape drenched in sunshine. The effect is exaggerated because he put complementary colors (colors that stand out against each other) together. For example, painting the boat orange made the blue water around it look even brighter.

Blue stands out strongly against orange, its complementary color.

Against other colors, the blue water seems less bright.

Bathers At Asnières

This huge canvas was Georges Seurat's first large-scale painting, made at the age of 24. It may look like an inoffensive scene to us, but for Seurat and his contemporaries it was a daring work of art, and it was rejected by all the official exhibitions.

Title: Bathers At Asnières
Date: 1884
Artist: Georges Seurat
Materials: oil on canvas

Size: 201 x 300cm (79 x 118in)

Work and play

At first glance, the picture looks like a peaceful scene of people relaxing by the river at Asnières, on the outskirts of Paris. On the right is the island of La Grande Jatte, a popular weekend destination for Parisians. (This is where the rowboat is heading.) But work is not far away. In the distance, you can see smoky factories and a railroad bridge, and the people on the bank have ordinary workers' clothes.

The big picture

Many people found *Bathers At Asnières* shocking because of its size. At the time, big canvases were usually kept for important historical subjects. It was almost unheard of for an artist to create such a large picture of ordinary, working-class people. But Seurat painted these workers on a vast scale. He wanted to make them look as dignified and important as the people in grand history paintings. So this combination of subject matter and size was a radical step.

Connect the dots

The picture's colors also caused a stir. Seurat was interested in scientific theories about color. He thought colors looked fresher and brighter if they were mixed in the viewer's eye, rather than on the artist's palette. So he used strokes of pure, contrasting colors to build up the effect that he wanted.

The 'green' grass actually contains pink, yellow, blue and orange.

Seurat went on to develop a style known as Pointillism (see page 92), which uses tiny dots of pure colors, painted with just the tip of the brush, rather than whole brushstrokes. Later, he added dots to parts of his *Bathers* picture – for example, there are dots of yellow and blue on the orangeyred hat of the boy on the right. But this did not turn it into a Pointillist painting. Most of it was painted in fairly broad brushstrokes, which did not get covered in dots.

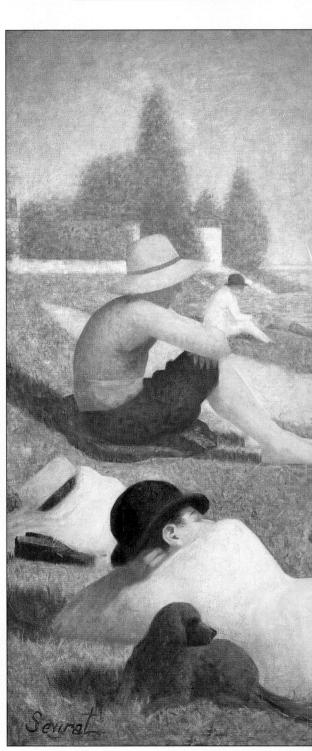

Golden rules

Seurat composed his picture very carefully. He made lots of preparatory sketches, both on location and in his studio, and arranged the scene according to a geometrical rule known as the golden section. This determines the proportions of the shapes in the picture, and is meant to create a balanced, orderly composition.

This diagram shows how the picture can be divided according to the golden section. This means that the ratio of A to B is the same as that of B to C, and the ratio of D to E is the same as that of E to F.

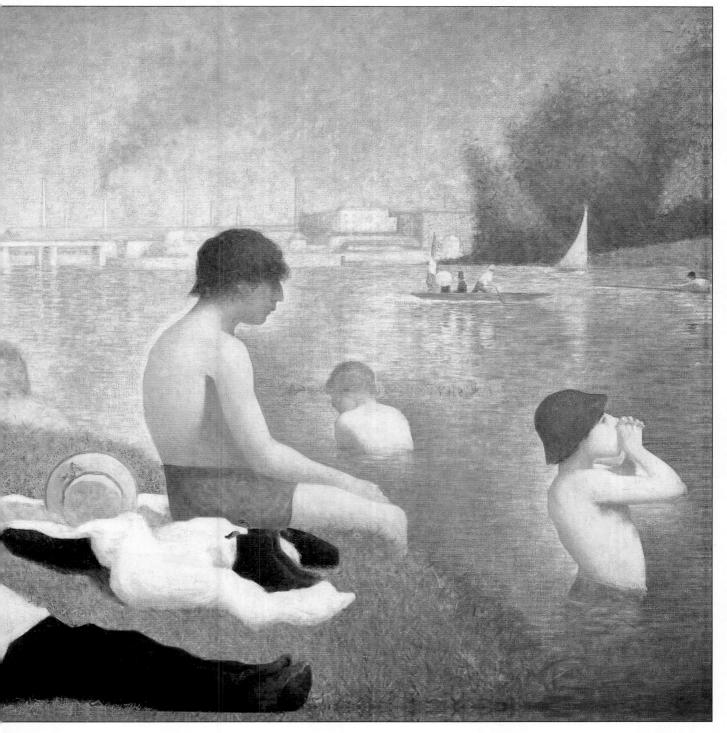

Colorful ideas

Toward the end of the 19th century, some artists developed radical new ways of using color. Rather than just painting colors as they saw them, they began to look at them scientifically and break them up into component parts – or even, rather less scientifically, to use them to convey feelings.

Going dotty

One of the first artists to experiment seriously with color was Georges Seurat. In the 1880s, he invented a technique known as 'Pointillism,' using hundreds of tiny dots of pure, unmixed colors. When you see the dots from a distance, they mingle together, creating the effect of blended colors. Seurat thought that letting colors mix like this made them appear richer and more intense. Another artist, Paul Signac, described it as painting "with jewels."

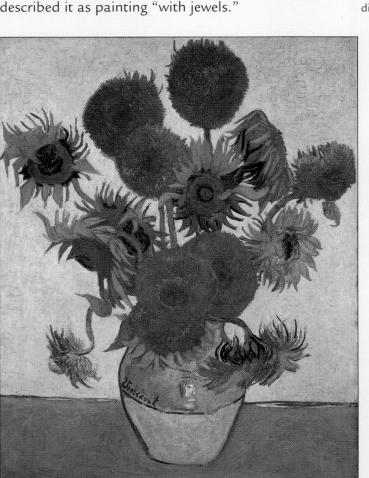

Sunflowers (1888), by Vincent van Gogh

Le Bec Du Hoc (1888), by Georges Seurat. Close up, you can see the grass contains dots of blue, orange, pink and green. (These are clearer in the enlarged detail on the right.) But, from a distance, these all blend together to look green.

Expressive color

Other artists believed that colors had particular emotional values. Vincent van Gogh wrote: "instead of trying to reproduce exactly what I have before my eyes, I use color arbitrarily, in order to express myself more forcibly."

Van Gogh liked to work in strong colors, applying paint thickly, often straight from the tube. For him, colors had symbolic meanings. For example, in *Sunflowers*, which he painted for his friend Paul Gauguin, he used 'harmonizing' oranges and yellows (see below) to express his feelings of friendship and artistic partnership.

Color theory

Artists sometimes use a 'color wheel' to work with colors. In the wheel, each color lies opposite its complementary color, the color it contrasts with most intensely. It sits next to its harmonizing colors – the colors most similar to it.

The color wheel contains the primary colors red, yellow and blue, and the secondary colors (green, orange and purple) you get by mixing them.

Flat shapes

Like van Gogh, Gauguin worked in strong, bright colors. He, too, chose colors because he liked them, rather than because they looked realistic. But, in practice, the two artists painted very differently.

Van Gogh used very thick layers of paint, known as 'impasto,' and left his brushmarks showing, making the surface look bumpy. But Gauguin's pictures are much smoother. He tended to simplify shapes and create flat areas of color, as in the scene on the right.

Harvest At Le Pouldu (1890), by Paul Gauguin. Notice how the red dog stands out against the green grass.

The bluest blue

Many young artists, including Paul Sérusier, Maurice Denis, Pierre Bonnard and Edouard Vuillard, were greatly influenced by Gauguin. Like him, they believed color was the most important part of a painting. Sérusier painted *The Talisman* following Gauguin's advice to use "the most beautiful green" and "the bluest blue possible."

Sérusier and the others formed a group known as the 'Nabis' (Hebrew for 'prophets,') who held several exhibitions together in the 1890s. They believed color should be an artist's first consideration, even before creating a good likeness. According to Denis: "A painting, before it's a picture of a battle horse or a nude woman or some kind of anecdote, is essentially a flat surface with colors organized in a certain order."

The Talisman (1888), by Paul Sérusier. This painting was inspired by a wooded landscape, although the colors and shapes have been altered so much, it is difficult to make out what anything is – but Sérusier didn't think this mattered.

Getting away from it all

Although some 19th-century artists were inspired by cities, others rejected city life. They longed for a simpler, more traditional kind of existence - a longing reflected in their paintings, which often show perfect imaginary landscapes or scenes from nature.

Southern sun

Vincent van Gogh was born in Holland but moved to France, living first in Paris and then Arles, a small town in the of the climate. The strong southern sun made colors appear bright and vibrant which was just how he wanted them to look in his paintings.

Wheatfield With Cypresses (1889), by Vincent van Gogh. Van Gogh used a bright, golden yellow to show the wheat catching the light, even under a cloudy sky. For more about van Gogh's use of colors, see page 92.

Island paradise

Van Gogh's friend Paul Gauguin also left Paris for rural France, staying first in the village of Pont-Aven, then with van Gogh in Arles - until the two friends fell out so violently that van Gogh, who suffered from mental illness, cut off part of his own ear. Later, Gauguin moved to Tahiti in the South Pacific, in search of an earthly paradise. Away from city influences, he developed a deliberately crude style inspired by traditional Pacific art. He simplified shapes, flattened perspective and exaggerated colors, as you can see in Faa Iheihe. Like many of his pictures, it is meant to show people in harmony with nature.

Faa Iheihe (1898), by Paul Gauguin. The name of this picture probably means 'to beautify, adorn or embellish,' in the sense of getting dressed up for a special occasion.

Imaginary voyages

Henri Rousseau was a French customs officer who painted in his spare time. Although he led a quiet life, never traveling far from home, he made imaginary voyages, creating wild scenes based on plants and animals he saw in parks and zoos, or read about in books.

Perhaps because they are imaginary, Rousseau's pictures often have a strange, dreamlike quality. Art critics at the time laughed at his simple, self-taught style, and dismissed him as an 'amateur.' But several artists came to admire him, including the Surrealists (see pages 106-107) and Pablo Picasso (see page 97,) who organized a grand dinner in his honor.

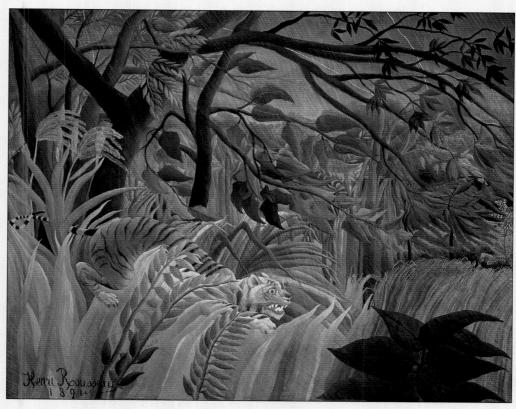

Tiger In A Tropical Storm – Surprised! (1891), by Henri Rousseau, nicknamed 'Douanier' Rousseau (douanier is French for 'customs officer.')

The plants at the bottom of this picture were based on ornamental houseplants. But Rousseau made them much bigger, so they look like exotic jungle plants.

For links to websites where you can find out more about van Gogh and Gauguin, and escape from inside a famous painting in an interactive game, go to www.usborne-quicklinks.com

Gauguin loved traditional art, and the shape of this picture was inspired by the sculpted friezes traditionally produced in the Pacific islands. Some of the figures were copied from friezes, too.

Gauguin used natural, locally available materials for his paintings.

He used pigments like these, made by grinding up dried dirt, to mix his earthy colors.

He painted on rough cloth, or 'hessian,' which was made in Tahiti.

Breaking the window

From the Renaissance until the 20th century, virtually all artists shared one basic belief: that a flat, 2-D painting should create an illusion of 3-D space, as if it were a window opening onto a real-life scene.

But, in the 1880s, a French artist named Paul Cézanne began to experiment with different ways of representing space - so paving the way for a radically new approach to painting.

Hillside In Provence (probably late 1880s), by Paul Cézanne. Cézanne loved the Provençal countryside, and painted it over and over again.

Patchwork

Saying he saw nature in terms of "the cylinder, sphere and cone," Cézanne tried to create solid, substantial landscapes, built up from geometric shapes. But instead of using light and shade to give the impression of depth, he did it by placing patches of different colors side by side, as in *Hillside In Provence*.

Distorted views

Cézanne also painted things from different viewpoints, distorting true 'unified' perspective (see page 38). This is most obvious in his still lifes, where he might show the top of a pot or bottle from above, then paint its body from the side. But the distortions are subtle, so you don't always notice them at first.

No illusions

In 1907, a big exhibition in Paris introduced Cézanne's work to a younger generation of artists, including Pablo Picasso and Georges Braque. It had a huge influence on them. But they took Cézanne's experiments even farther – working together so closely that, at times, it is almost impossible to tell their pictures apart.

Cézanne distorted space, but Picasso and Braque abandoned the illusion of space altogether. They rejected traditional perspective, where everything is shown from one viewpoint. Instead, they combined details seen from various viewpoints, at different times. And rather than treating the surface of the picture like a see-through window, they drew attention to it by breaking it up with angular shapes and lines. When a critic said Braque's painting *Houses In L'Estaque* looked like "a pile of little cubes," the style found its name: Cubism. It turned out to be one of the most ground-breaking developments in the history of art.

Houses In L'Estaque (1908), by Georges Braque

Bits and pieces

The Cubist picture on the left, by Picasso, shows an arrangement of objects on a table: a dish of fruit, a violin, a wine glass and a newspaper. In the bottom left-hand corner, you can see the back of a chair.

The image combines several viewpoints. It's as if Picasso walked around the table while painting it, noticing something different each time. The result is an assortment of pieces that don't join up. And it looks even more broken up because of the colored shapes which divide the picture surface. The Cubists felt these fragmented, multiple views were the best way to capture the true nature of things.

Still Life With Violin And Fruit (1912), by Pablo Picasso. Instead of painting the newspaper, Picasso stuck real newspaper onto his painting – you can see part of the word *journal*, which is French for 'newspaper.' This technique is known as collage, and Picasso used it again in other pictures, sticking on anything from rope to wallpaper.

For links to websites where you can find out more about Picasso, view hundreds of his pictures, and color in a Picasso painting online, go to www.usborne-quicklinks.com

New perspectives

The 20th century brought huge changes to people's lives, as new machines revolutionized how people lived, worked and traveled. Many artists reacted by painting pictures about speed, movement

and machines. Continuing the Cubist experiments of Picasso and Braque, these artists used fragmented images and multiple viewpoints to try to capture their new experiences.

Abstract Speed - The Car Has Passed (1913), by Futurist artist Giacomo Balla. This uses geometric shapes to convey the blur of a speeding car.

Into the future

In the early years of the 20th century, a group of Italian artists calling themselves 'Futurists' set out to create a new art for a new era. They rejected the past, dismissing museums as 'cemeteries.' One group even set out – unsuccessfully – to burn down the Louvre museum in Paris. They wanted to enjoy the present, especially the power and speed made possible by

machines. This didn't just mean painting fast cars and planes. They actually tried to capture the *experience* of speed, using new techniques which influenced avantgarde artists across Europe. In 1909, they published a statement of their goals called the Futurist Manifesto, in which they said: "We declare that the world's splendor has been enriched by a new beauty, the beauty of speed."

City slickers

Many artists developed Cubist and Futurist techniques to explore the hectic experience of modern life. If you compare the works by two French artists, Fernand Leger and Robert Delaunay, on this page, you can see how different the results could be.

Modern life

Delaunay lived and worked in Paris for years, creating many paintings of modern life in the city. Often, these pictures include symbols of modernity, such as planes or the Eiffel Tower, the tallest building in the world at the time.

The Red Tower shows the Eiffel Tower between tall buildings, as if glimpsed from the street. In fact, it is more like a series of glimpses than one clear view. Delaunay has used multiple viewpoints to make it seem as if we – or the scene – are shifting, caught up in the speed and movement of city life.

For a link to a website showing more paintings by Robert Delaunay, go to www.usborne-quicklinks.com

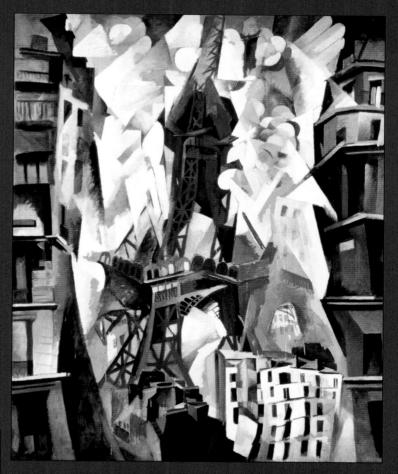

The Red Tower (1911-12), by Robert Delaunay

The City (1919), by Fernand Leger. Notice how Leger works in letters from posters and signs.

Man and machine

Leger made many paintings of urban scenes and strange, imaginary machines. He developed his own form of Cubism, creating bold geometric structures using strong outlines and pure colors.

The City is a celebration of modern city life. Different elements of the city are jumbled together in a chaotic arrangement of flattened, brightly colored shapes. See if you can make out buildings, billboards, scaffolding and steps. The people look like robots. Even the painting itself looks as if it might have been made by machine, with its clean lines and smooth shading.

Art and emotion

Around the turn of the 20th century, many artists became interested in finding ways to convey their feelings through art. Instead of painting what they could see, they used distorted shapes and heightened colors to express strong emotions. This approach became known as Expressionism.

It's a scream

Expressionism was inspired by the work of two artists, Vincent van Gogh and Norwegian Edvard Munch. Van Gogh believed he could communicate feelings through color (see page 92.) Munch had led an unhappy life. His beloved mother and older sister died of tuberculosis during his childhood, and he himself was often ill. He said he wanted his paintings to show "living beings who breathe and feel and love and suffer," as he must have done.

The Scream (1893), by Edvard Munch. This is a powerful image of anguish and pain. The skin is stretched so tight over the screaming face, it looks like a skull.

Wild beasts

Some Expressionist artists wanted to convey happier feelings. Henri Matisse, for example, painted idyllic landscapes and colorful portraits of his family and friends. But people still found his pictures shocking because of his bold, experimental use of color. He chose vibrant colors which don't look natural, but seem full of light, as you can see in this portrait of his wife, Amélie. In fact, people thought Matisse's colors were so wild that they called him - and other artists who used colors in the same way - Fauves, which means 'wild beasts' in French.

Madame Matisse (1905), by Henri Matisse. Even the shadows in this painting are full of color, painted in green and purple.

The three main pairs of complementary colors are: red/green, orange/blue and purple/yellow. The Fauves created wild, vibrant effects by putting these complementary colors together, rather than using real-life colors.

The Bridge

In 1905 in Germany, some young artists formed a group they called *Die Brücke* ('The Bridge' in German.) They chose their name because they wanted to create a bridge to the future, to a new kind of art. Among them were Ernst Kirchner, Erich Heckel and Karl Schmidt-Rottluff. They worked together first in Dresden, then in Berlin.

Dissatisfied with contemporary German art, the Bridge artists turned to the arts of Africa and medieval Europe. You can see these influences in the angular shapes and artificial colors in this picture by Kirchner. Many Bridge pictures dealt with modern concerns: country scenes filled with nostalgia for simpler times, and urban scenes like Kirchner's, reflecting the tensions of city life. To research his painting, Kirchner went sketching in the most disreputable areas of Berlin he could find.

Street Scene In Berlin (1913), by Ernst Ludwig Kirchner. Distorted shapes and jarring colors make an everyday scene seem unfamiliar and uncomfortable. The roughly drawn faces look like masks.

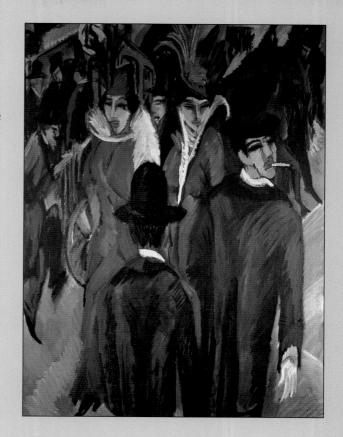

The Blue Rider and their blue horses

Another German group, *Der Blaue Reiter* ('The Blue Rider,') was founded in 1911. They were led by Vassily Kandinsky and Franz Marc, who chose the group's name because they liked blue and horses. The Blue Rider artists thought art should express spiritual themes. Marc loved to paint animals

because he believed they led a more noble and natural existence than people. His paintings of horses, for example, were meant to represent a purity and innocence people had lost, especially in the troubled years leading up to the First World War. Tragically, Marc died fighting in the war.

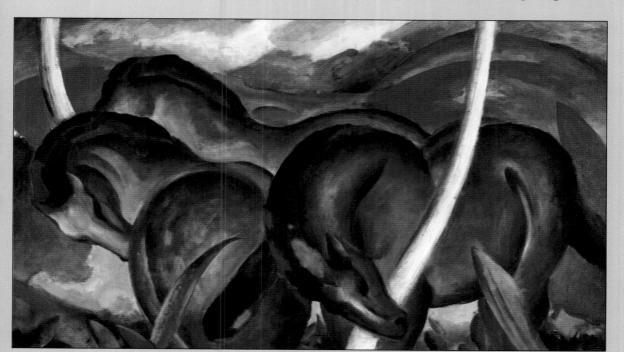

The Large Blue Horses (1911), by Franz Marc.

The horses' bodies have been simplified into bold, round shapes. Their curved backs are echoed by the curving hills in the distance.

Less is more

Around 1910, artists began to paint pictures that were not meant to be pictures of things, but things in their own right. Instead of showing recognizable

scenes, these paintings used combinations of colors, lines and shapes, put together in expressive or decorative ways. This kind of art is called abstract art.

Pioneering art

One of the earliest pioneers of abstract art was Vassily Kandinsky (who also founded 'The Blue Rider,' see page 103.) Cossacks, for example, was based on a battle scene, but it has been distorted almost beyond recognition. The shapes and colors suggest the commotion of battle. But when you look at the painting, you see them as separate elements, rather than as parts of a scene.

Kandinsky said he was inspired to make abstract art by seeing a painting lying on its side. He thought the shapes in it looked more interesting upside down.

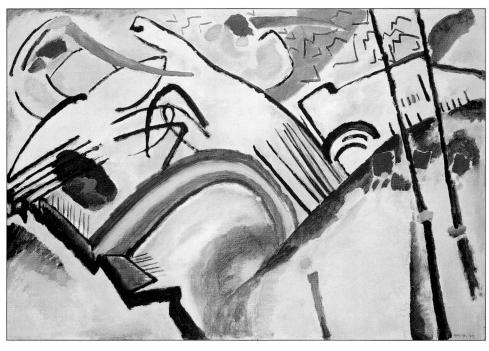

Cossacks (1910-1911), by Russian artist Vassily Kandinsky. The three red squares on the right represent Cossack soldiers, who wore red hats. Two of them are holding lances. On the left, two more red-hatted Cossacks fight on horseback. In the background, there is a fort with birds flying overhead.

Supreme art

At about the same time. Russian artist Kasimir Malevich began painting abstract, geometric compositions. Unlike Kandinsky, Malevich used very few colors. Influenced by Cubism, his pictures were made up of simple shapes: squares, rectangles, circles and triangles. Malevich believed abstract art was purer and better at expressing spiritual ideas than art that had an obvious subject. He called his works 'Suprematist,' from the Latin supremus, meaning 'of the highest order.'

Describing the goals of his work, Malevich wrote:
"... trying desperately to free art from the dead weight of the real world, I took refuge in the form of the square... Art wants to have nothing further to do with the object, as such, and believes that it can exist in and for itself."

Black Circle (1913), by Kasimir Malevich. The plain, square background is typical of Malevich's Suprematist paintings.

All in order

In the years following the First World War, Dutch artist Piet Mondrian developed an abstract art based on strict geometry and color. He drew up a list of rules for himself, declaring that he would use only pure black, white, red, yellow and blue; that he would draw only straight horizontal or vertical lines; that he would paint only squares and rectangles; and that he would create no illusion of space. Following these rules, he designed compositions which have a special sense of order, balance and harmony – ideals which seemed especially valuable after the horrors of war. His work formed an influential part of an art and design movement known as *De Stijl* (Dutch for 'The Style.') But he left the movement after another De Stijl artist dared to introduce diagonal lines.

For a link to a website where you can find out more about paintings by Vassily Kandinsky and Mark Rothko, go to www.usborne-quicklinks.com

Composition In Red, Yellow And Blue (1927), by Piet Mondrian

Abstract emotions

In the 1950s, a group of New York artists began making abstract paintings which were meant to express feelings. This came to be known as Abstract Expressionism. The group's most famous artists were Mark Rothko and Jackson Pollock. Rothko painted large, hazy blocks of color, while Pollock covered his canvases with drips and splatters of paint. When you look at their work, it absorbs you in colors, shapes and textures. And, by leaving obvious brushmarks or splatter patterns, both artists drew attention to the actual process of painting.

Rothko hated the label 'Abstract Expressionism.' But he did admit he wanted his work to have an emotional or spiritual effect on people. He said: "I'm interested only in expressing basic human emotions... The people who weep before my pictures are having the same religious experience I had when I painted them."

Untitled (about 1955), by Mark Rothko. Here, the blocks have such soft, feathery edges, they look as if they are floating. And the colors are muted, so they seem calming rather than overpowering.

Fantastic art

As the 20th century went on, extraordinary new ideas about art began to emerge. Disillusioned with the state of the world, many artists rejected the traditions and values of the past. Instead, they turned to unconventional materials and imagery to create fantastic, bizarre, and sometimes shocking, works of art.

Stuff and nonsense

During the First World War, a group of artists founded a movement known as Dada. The name (a French word for 'hobby-horse') was deliberately nonsensical, chosen at random from a dictionary. Dada artists relied more on chance than on traditional skills like drawing and painting.

Dada art was meant to shock. Although it might not seem very 'artistic,' it was meant to question our ideas about art, making us rethink what art is and why we value it. So Marcel Duchamp's *Fountain* – a urinal laid on its back – challenged the idea that a work of art should be unique and created by a skilled artist.

Fountain (1917), by French artist Marcel Duchamp. The signature 'R. Mutt' (added by Duchamp) is the name of a toilet manufacturer.

For Duchamp, an artist's ideas mattered more than his actual art. He said: "Whether Mr. Mutt has made the fountain with his own hands or not is without importance. He chose it... he created a new thought for this object."

Soft Watch At Moment Of First Explosion (1954), by Salvador Dalí. Dalí included melted, broken watches in many paintings, reflecting his obsession with time and how we experience it.

More than real

Many Dada artists went on to found another movement, called Surrealism. Surrealist art is known for its bizarre imagery, such as the exploding watch on the left. However, it was not meant to be *un*-real, but *more than* real, or *sur*-real (*sur* is French for 'above.')

The Surrealists were inspired by the workings of the mind, especially the unconscious and dreams. In this, they were greatly influenced by the theories of the famous psychiatrist Sigmund Freud (published in a book called The Interpretation Of Dreams.) Freud believed that much of what people do is triggered by unconscious thoughts and desires, and that these can be revealed in dreams.

Tales of the unexpected

Surrealist works often combined elements that seem quite unrelated, like the bowler-hatted figures and empty landscape in the picture on the right. Perhaps it represents how we can be carried away by talking? As in *Soft Watch...*, the strange, dreamlike quality of this imaginary scene contrasts with the realistic way it has been painted.

The Surrealists loved unexpected combinations, finding beauty in images such as "the chance encounter of an umbrella and a sewing machine on an operating table." They thought these combinations reflected the way the unconscious mind could form associations and bring unconnected things together, which sometimes happens in dreams.

For links to websites where you can find out more about Salvador Dalí and Marcel Duchamp, and see many more of their artworks, go to www.usborne-quicklinks.com

The Art Of Conversation (about 1963), by Belgian painter Réné Magritte

Automatic art

Another way the Surrealists tried to explore the unconscious mind was through 'automatic' drawing. This was a technique where they tried to draw without thinking, letting images emerge by chance – a bit like what can happen if you doodle while talking on the phone. The strange, doodle-like shapes on the left were created in this way. The Surrealists believed that these images were really shaped by the artist's unconscious thoughts and impulses.

Carnival Of Harlequin (1924-25), by Spanish artist Joan Miró

War and propaganda

The 20th century was torn apart by military and political strife. Millions died in two world wars, whose horrific effects were portrayed by many artists - often from

their own first-hand experience. At the same time, politicians struggled to win people's minds, turning to art of a different kind - propaganda paintings - for help.

A Battery Shelled (1919), by Percy Wyndham Lewis. Lewis was a British gunner and an official War Artist for the British government during the First World War. He made this painting after the war, for a Hall of Remembrance commemorating dead soldiers.

World at war

A Battery Shelled combines angular, mechanical figures with more natural-looking ones. It avoids a bloodand-guts view of fighting, showing only soldiers cleaning up after their battery, or arms store, has been hit by a shell. Three officers survey their work without emotion. But the bleak landscape starkly reveals the devastation of war. And the robot-like appearance of the distant soldiers may be meant to show how war can dehumanize people.

War of ideas

In 1917, Communist forces seized power in Russia, leading to a civil war between the Communist 'Reds' and non-Communist 'Whites.' Artists joined in the struggle by creating propaganda images such as the pro-Communist *Beat The Whites*, by Constructivist artist El Lissitzky.

The Constructivists were greatly influenced by Communist ideas. They believed art should be useful, and chose abstract, geometric forms because they thought everyone could understand them. But, after the civil war, their style fell out of fashion. The leaders of the new Communist regime preferred propaganda images of heroic workers, in a style which became known as Socialist Realism.

Beat The Whites With The Red Wedge (1919-20), by El Lissitzky. This image shows the red wedge of Communism breaking into the circle of white, non-Communist Russia.

Art attacks

Artists have often used art to attack governments and expose social problems - sometimes so successfully that their work was banned. In the 1920s, several German artists, including George Grosz and Otto Dix, began to make work that

fiercely criticized their country. For example, Grosz's *Pillars Of Society* satirized leading Germans by making them look ridiculous or evil. He was persecuted for making art like this, until he finally left Germany in 1933.

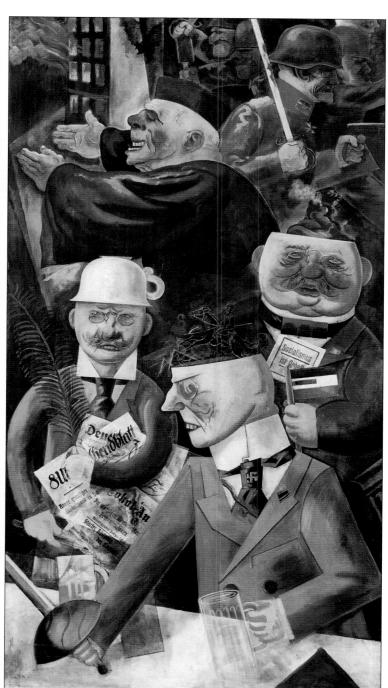

Pillars Of Society (1926), by George Grosz. Brutal soldiers march across the background, while a clergyman stupidly blesses everything in sight. A flagwaving politician reveals a head filled with excrement, a press baron wears a chamberpot on his head and a drunken Nazi brandishes his sword.

Degenerate art

In the 1930s, the Nazi party came to power in Germany. The Nazis believed modern art was degenerate, or corrupt. In 1937, they put on a 'Degenerate Art Exhibition' in Munich, mocking Grosz, Picasso, Kandinsky and many others, by displaying their art with labels describing it as deranged. The Nazis preferred traditional paintings of idealized blonde Germans, which they used as propaganda.

Life and death

The Second World War saw ruthless fighting and bombing campaigns, and the systematic slaughter of millions in Nazi concentration camps. After it was over, many people found it difficult to come to terms with the horror of what had happened, and this was reflected in the art of the time.

Swiss artist Alberto Giacometti drew and sculpted skeleton-like men and women, standing alone in space. He described this as "rendering my vision." His fragile, isolated figures expressed the anguish and uncertainty of the post-war period. Their thinness also evoked the suffering of the concentration camp victims, many of whom had starved to death.

Large Woman Upright IV (1960), by Alberto Giacometti. This bronze figure is a late example of the style Giacometti developed after the war.

Guernica

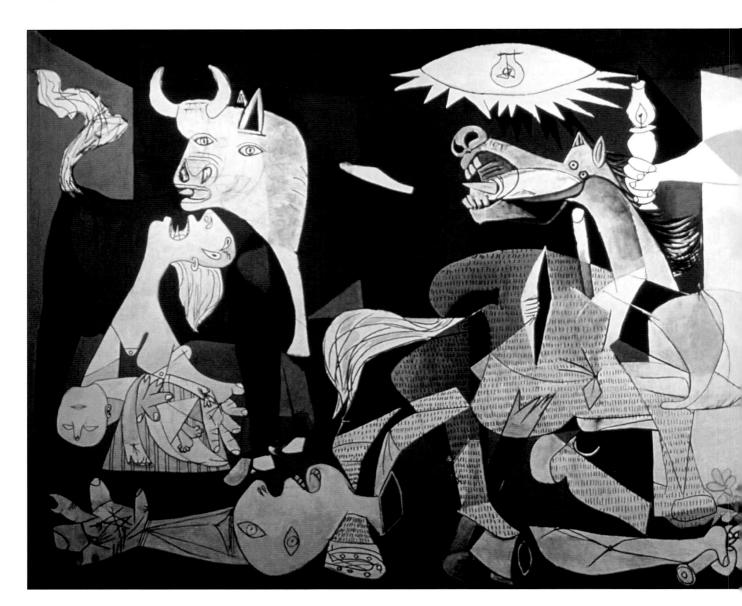

Guernica, by Spanish artist Pablo Picasso, is a very powerful anti-war statement. In 1936, civil war broke out in Spain when extreme right-wing Nationalists, supported by Nazi Germany, attacked the left-wing Republican government. Picasso was inspired to paint this huge, shocking scene of death and destruction after Nazi planes bombed the pro-Republican town of Guernica in 1937, killing hundreds of civilians.

Title: Guernica Artist: Pablo Picasso

Artist: Pablo Picasso Date: 1937 Materials: oil on canvas Size: 349 x 777

Size: 349 x 777cm (138 x 306in)

Exhibitions and old boots

The Republican government had invited Picasso to make a mural for a big exhibition in Paris. At first, he didn't know what to paint But, after the bombing, he created *Guernica* in just five weeks. The painting got a mixed reception in Paris, and was criticized for being hard to understand. Later, the Republicans sent it on tour to promote their cause. In England, people paid to see it with old boots, to help outfit Republican troops.

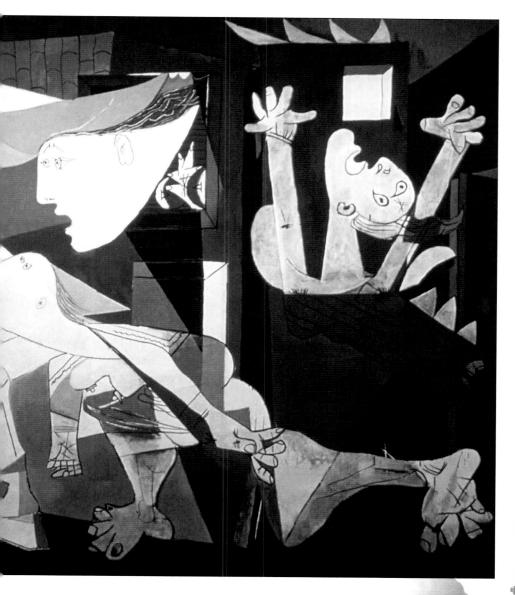

Picasso thought art could have a real impact on events. In 1945, he said: "Painting is not done to decorate apartments. It is an instrument of war for attack and defense against the enemy."

Guernica is full of figures and objects with symbolic meanings. Picasso didn't want the meanings to be clear or straightforward, and didn't like explaining them. But he did say: "The horse represents the people, and the bull brutality and darkness."

On the left, you can see the bull watching, unharmed, as a wailing woman clutches her dead child. A soldier lies dead on the ground and, above him, the horse has been hit by a spear.

On the right, a horrified face looks out of a window. One woman tries to run away while another falls, screaming, from a burning house.

Look at all the sharp, angular shapes in the picture. They emphasize the destruction by making things appear disjointed or broken. The people's faces are distorted, too, in a way that shows how much they are suffering.

Notice the abrupt changes between light and dark. These suggest the flashes of explosions. Lack of color makes the picture bleaker and recalls newspaper photographs of the event, which Picasso would have seen.

For a link to a website where you can see Picasso's sketches for *Guernica*, and photos of the work in progress, go to www.usborne-quicklinks.com

Fighting back

Before the bombing, Picasso claimed he wasn't a political artist. But, after it, he seemed to change his mind. He claimed there was "a deliberate appeal to people, a deliberate sense of propaganda" in Guernica. Its huge size – the canvas was so big it barely fit in his studio – and tortured figures were designed to have a powerful impact. Despite widespread support, the Republicans lost the war and Spain became a dictatorship. Picasso wanted Guernica to be displayed in Spain when democracy was restored. This finally happened in 1975 and, today, his painting hangs in Madrid.

A photograph of Guernica after the bombing in 1937

Pop and Performance

The post-war years saw A a huge boom in massproduced goods and mass entertainment. This gave rise to a new popular - or 'pop' - culture. Many artists responded by borrowing elements of this culture to create 'Pop' art. Other artists began to stage performances instead, creating works which could not be bought and sold, in defiance of the way buying things had come to dominate people's lives.

For links to websites where you can find out more about the lives and art of Pop artists Andy Warhol and Roy Lichtenstein, go to www.usborne-quicklinks.com

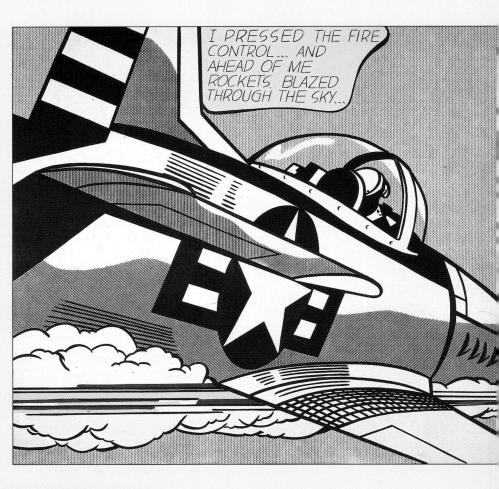

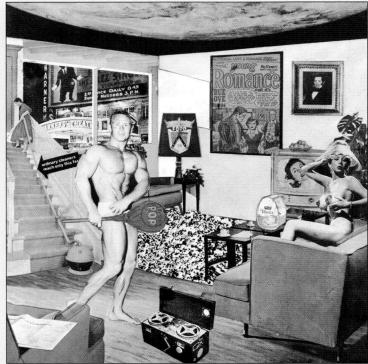

High and low

Pop art first emerged in London in the 1950s, in the work of Richard Hamilton, Peter Blake, David Hockney and others. They celebrated the vitality of pop culture and satirized the relentless consumption of manufactured goods. You can see this in Hamilton's *Just What Is It...*, sometimes called the first Pop picture.

People often distinguish 'high culture,' such as paintings - which are expensive and often seen only by a select few - from pop culture, which is available to everyone. But Pop art blurred this distinction by using images from magazines, television and other mass media, and copying commercial mass-production techniques.

Just What Is It That Makes Today's Homes So Different, So Appealing? (1956), by Richard Hamilton. This collage of cuttings from magazines and catalogs is meant to parody advertising images.

Comic strip art

Warhol went a step further and made actual prints, creating series of bright, repeated images of everything from film stars to soup cans. By specializing in printing, he moved away from the idea of art as a unique creation. He even called his studio 'The Factory,' to encourage people to compare his work to manufacturing.

Whaam! (1963), by Roy Lichtenstein. This image is made up of hand-painted dots.

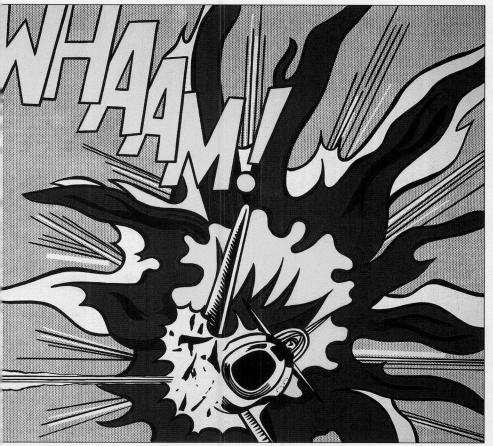

Performance art

Many 1960s artists staged 'performances' - works that were meant to be experienced, rather than collected. In one series of performances known as

'Anthropometries,' a French artist named Yves Klein got models to smear themselves with paint and roll on paper in front of an audience. Though the finished 'paintings' were mounted and framed, the process of creating them was as important as the end result.

Strange ideas

Some artists improvised bizarre, unscripted performances. These events, or 'happenings,' were meant to blur the boundaries between art, theater and real life. In one 1965 happening, German artist Joseph Beuys stuck honey and gold leaf on his head, put on one ski, and went around explaining the pictures in a Düsseldorf gallery to a dead hare.

Although Beuys must have looked very odd, he wouldn't have minded. He believed the idea, or concept, behind a work of art was the important thing. This kind of art is known as conceptual art. To him, the happening was "about the problems of thought [and] consciousness." To act it out, he had to express his thoughts – but as the hare could not listen or understand, he also showed how we may fail to communicate our thoughts to others.

Art today

Art now is amazingly diverse. Although this book is mainly about paintings, artists today work with anything - from traditional oil paints to video recordings

Out in the open

A lot of modern art takes art away from galleries into spaces not traditionally associated with it. Since the 1970s, many artists have dealt with landscapes not as paintings but as real places, creating works out in the open and then documenting them. This approach is known as 'Land' art.

Like traditional landscape painters, the British artist Andy Goldsworthy explores the relationship between people and the world around them. He works in specific locations, creating pieces that interact with their settings. He takes natural materials, such as stones or leaves, and arranges them in simple shapes. These are often designed to be temporary, reflecting the changes that occur in nature.

Icicle Star (1987), by Andy Goldsworthy, a sculpture made of ice. It has long since melted and now exists only in photographs.

and even dead animals. But, strange as these works can seem, they still explore many of the same themes and ideas as paintings have always done.

Bride (1994), by Portuguese artist Paula Rego. Rego got her daughter to model for this drawing. The picture formed part of a series, entitled 'Dog women,' which Rego said explored the animal side of women's nature.

Here comes the bride

Paula Rego's works follow in a long tradition of lifelike pictures of people, such as this pastel drawing of a young woman in a silk wedding gown. But while traditional images of women emphasize their beauty and grace, Rego does nothing of the kind. She shows her model in an awkward pose, staring directly at us with an ambiguous, unsmiling expression. Rego said she based the model's pose on the way dogs roll over to surrender. It is a vulnerable position - and the woman is clearly dressed as a bride. So perhaps Rego meant to criticize the submissive role of some women within marriage?

Nantes Triptych (1992), by Bill Viola

Video games

Many contemporary artists have taken advantage of the possibilities offered by modern technology, using photographs, videos and computer-generated images in their work. The American artist Bill Viola's *Nantes Triptych* deals with the cycle of life. He uses the traditional format of the triptych (see page 28) to present three videos at the same time.

present three videos at the same time.

Dead or alive

British artist Damien Hirst is known for his ability to shock - not least with his controversial pieces using dead animals preserved in formaldehyde. The Physical Impossibility Of Death In The Mind Of

Someone Living is a tank containing a dead tiger shark. But, like Viola's triptych, it shows how contemporary art returns to age-old themes like life and death.

From Egyptian tomb
paintings to Renaissance
portraits, art has always
been a way of
commemorating the
dead. Though Hirst's work
features an animal rather than a person,
it too deals with death. The shark's preserved body is
meant to make us think about life and death. But it almost looks
alive. It floats in the tank as if it is swimming. This makes it hard to
accept it is really dead, demonstrating the "impossibility of death in

the mind of someone living."

The screen on the left shows a baby being born. On the right, a woman lies dying. In the center, there is a man plunging into water. Perhaps he is meant to represent life itself? The triptych works like an altarpiece. Although it depicts fundamental life experiences rather than religious scenes, it was originally made for a chapel in Nantes, in France.

For a link to a website where you can see more art by Andy Goldsworthy, go to www.usborne-quicklinks.com

The Physical Impossibility Of Death In The Mind Of Someone Living (1991), by Damien Hirst

BEHIND THE SCENES

This section explains some of what happens behind the scenes in artists' studios and art museums. You can find out how paintings are made, including artists' materials, technical tricks and famous forgeries, and discover how museums preserve old, fragile pictures. At the end, there is a reference section with a timeline, artists' biographies and a glossary explaining useful art terms.

These pages show a sample of acrylic paintwork, produced for this book by Antonia Miller.

Artists' materials

Artists' materials and techniques have changed greatly over the centuries, from laboriously hand-prepared colors to modern paints squeezed straight from a tube. These pages look at the most common methods of painting, from egg tempera to modern acrylics.

Breaking eggs

In the Middle Ages, most paintings were produced by large workshops. The head of the workshop would design each picture and oversee its production. The paint used was known as egg tempera, a fast-drying mixture of colored pigments and egg, which had to be applied very carefully and methodically in stages.

1. A panel was cut and shaped from wood. This was then covered in 'gesso,' a chalky paste which created a smooth surface for painting on.

2. Any gilded areas were painted red and then covered in a thin layer of gold leaf. The gold was polished and, sometimes, patterns were scratched into it.

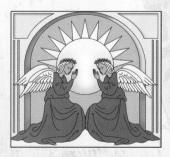

3. The 'underpainting,' or first layer of colors, was applied next. Some surprising colors were used. Skin was painted green, to balance the pink used later.

4. The top layers of paint were filled in slowly. Artists had to mix their paint in small amounts and use tiny brushstrokes, as egg tempera dries so fast.

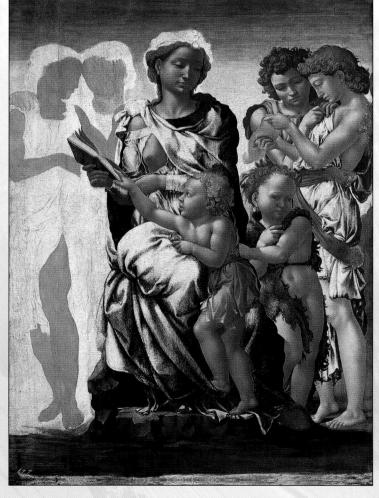

The Virgin And Child With St. John And Angels (probably about 1495), by Michelangelo Buonarroti, usually known just as 'Michelangelo.' This egg tempera painting was never completed. You can see the grayish-green underpainting on the unfinished figures.

Oil and canvas

During the Renaissance, artists began to experiment with oil paints - mixtures of pigments and oil that dried much more slowly than egg tempera. Soon, most people were working in oils. At first, oil paintings were done on wood. But, from the early 16th century, artists began painting on canvas. Unlike wood, canvases don't split, they are easier to join together for large

> Modern oil paints in tubes, along with the artist's palette, palette knife and brushes used for mixing and applying them

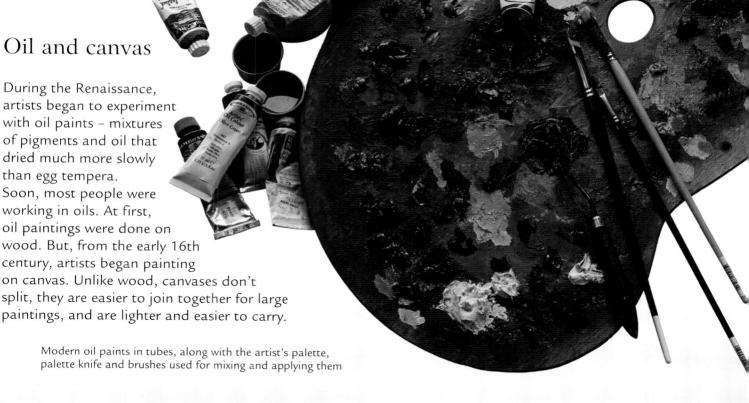

1. Canvas is stretched over a wooden frame, or 'stretcher,' and tacked into place. Nowadays, many artists buy their canvases ready-stretched.

2. The canvas is 'primed,' or coated with a plain layer of paint. This is usually white, but other colors can be used to give different tones to the final picture.

4. Oil paint can be applied smoothly, or thickly so that it retains visible brushmarks. It holds its shape so well, you can even scrape patterns into it.

In the 19th century, developments in the chemical industry gave rise to brighter, more varied colors based on chemical, rather than natural. pigments. Ready-made canvases, ready-mixed paints and new kinds of brushes also became available. In the past, most brushes had been bunched and tied with thread. But the new brushes were bound with metal, so they could have flat tips, which made flatter, squarer marks.

Lots of new techniques have been developed in the last hundred years. Collage, where fabric, newspaper and other materials are stuck onto pictures, was introduced in the early 20th century. Then a completely new kind of paint, acrylic, was invented in the 1950s. Acrylic paintings look similar to oils, but dry much faster. Today, artists continue to experiment, using everything from fluorescent lights and film to waste paper and elephant dung.

3. Some artists sketch in their design. Then they apply the paint. Oil paints are slow-drying and translucent, so colors can be built up gradually, in layers.

Tricks of the trade

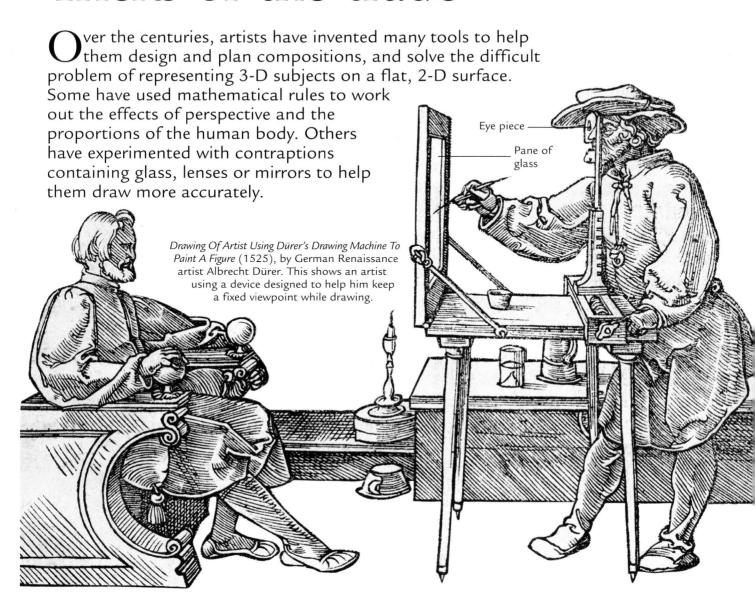

Keeping an eye on things

The most lifelike way of drawing a 3-D scene is to show it from one particular viewpoint, at one particular moment, like a snapshot. So the artist and subject have to stay very still – which is difficult when the artist is constantly glancing between the subject and his sketch.

The illustration above shows a 'drawing machine' designed to help. The machine is made up of

a fixed eyepiece and a sheet of glass. The eyepiece keeps one of the artist's eyes steady at a fixed point. (His other eye is closed, as it will have a slightly different viewpoint.) He can see his model through the glass, so he can trace the model's outlines without having to move his head. But to turn the sketch into a finished painting, the artist would still have to transfer it to canvas and fill in all the details.

Mirrors and magic

16th-century artists such as Dürer were happy to publish pictures of simple optical aids to help their fellow artists. But they were very secretive about more complex instruments involving lenses and mirrors. These had been invented by this time, but many people believed they worked by witchcraft, which was punishable by death. So anyone using them had to keep very quiet, and we don't know how many artists had them.

Drawing in the dark

One complex device which artists did use is known as a camera obscura, which is Latin for 'dark room.' At first, it really was a darkened room, with a tiny hole in one wall. The hole let a small beam of light inside. When the beam fell on a flat surface, it projected an image of whatever was outside in the light. Inside the dark room,

the artist placed a piece of paper in the beam and traced the projected image. Lenses could be used to make the image stronger and sharper. Over time, people realized they could make the device much smaller. Eventually, it became a small viewing box, rather like a modern camera.

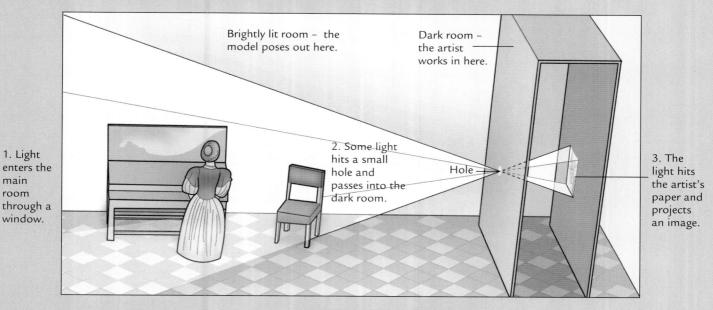

This diagram shows how an artist could set up an early camera obscura.

Who used cameras?

There is a lot of evidence to suggest that two of the artists in this book, Jan Vermeer (see page 66) and Canaletto (see page 75), sketched scenes with the aid of a camera obscura. Joshua Reynolds (see pages 72-73) also owned a portable version, which could be

folded away into a case designed to look like a large, leather-bound book. Reynolds may have wanted to hide the fact that he used a drawing aid. Other artists may have had similar contraptions, but the evidence is often very controversial.

Trickery or talent?

A camera obscura helped artists translate 3-D scenes into 2-D pictures more accurately. But it had many disadvantages. The early, room-sized version was awkward to set up. The image it projected was upside down, so the artist had to right it by tracing it or using complex arrangements of mirrors. And it was too dark to see colors properly inside the camera, so it could only be used for initial sketches. Mirrors and lenses could help improve the projected image, but they were expensive and difficult to make. And even then the apparatus could distort things, for example by blurring bright highlights. So artists still needed a huge amount of skill to paint a convincing image.

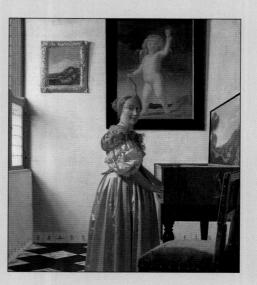

A Young Woman Standing At A Virginal (about 1670), by Jan Vermeer. You can see a larger reproduction on page 66.

This painting is so accurate, it is possible to reconstruct the room it shows exactly. A 3-D model of the room was used to draw the diagram above.

Preserving pictures

Most things deteriorate gradually with age, and paintings are no exception. The materials they are made from can warp, crack and discolor, completely changing how the paintings look, and eventually destroying them. So museums and galleries have 'conservators,' who look after paintings. They use the latest techniques to preserve and repair pictures and their frames – sometimes making some surprising discoveries in the process.

Changing tastes

Ideas about how paintings should look have changed over time. Nowadays, conservators try to keep pictures as the artists intended. But, in the past, restorers would sometimes paint over part of a picture, if it was damaged, or if they thought their changes would 'improve' it. They even covered paintings in brown varnish, to tone down colors they thought looked too bright.

Now, when a picture is restored, this kind of overpainting and varnish are usually removed, revealing how the picture was originally meant to look. But occasionally old repainting work is

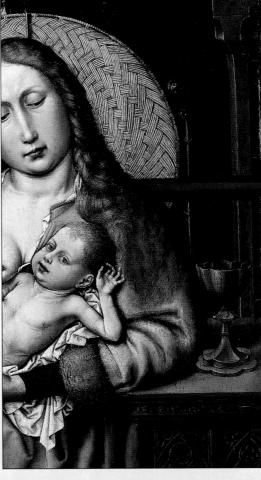

The Virgin And Child Before A Firescreen (see page 37) dates from the 15th century. But a large strip on the right, including the goblet and Mary's elbow, was actually painted in the 19th century, when restorers reconstructed a missing section. Look for where the varnish changes color – this marks the join.

In the frame

Many pictures have elaborate frames which also need looking after. Often, these have ornate carvings covered in gold leaf, or paper-thin pieces of real gold. Conservators repair damaged sections of frames and, if necessary, replace parts with carefully matched carvings. These are then gilded (coated with gold) by hand, as shown here.

A conservator working on a gilded frame. It can take weeks to restore a large frame like this.

True colors

Over centuries, paintings become very dirty, particularly if they have spent years in smoky, candlelit churches. Some old paintings were varnished to protect them, but varnish turns yellow over time. Conservators can clean off dirt and old varnish to reveal a picture's true colors. But this has to be done very gently, with mild solvents, so as not to damage the paint underneath. Often, old paint

A badly discolored painting, before restoration

These details from Titian's *Bacchus And Ariadne* (see page 47) show the startling difference cleaning and repairs can make. After this picture was cleaned in the 1960s, some people complained that the

cracks, blisters or flakes away, especially if the wood or canvas behind it has warped. Loose flakes of paint are stuck down with special glues and, sometimes, small areas are repaired with touches of carefully matched paint (see below). If the wood or canvas is very warped, conservators can even separate the whole painted layer and attach it to a new backing – a painstaking process that may take years.

The same painting, after restoration

colors revealed by the process were too bright. But experts today say that these are the original colors and that they match recent discoveries about Titian's techniques and use of pigments.

Making a match

Before repairing damaged paint, conservators examine paint samples and analyze pigments. They try to match an artist's original materials and techniques as closely as possible, to make their repairs blend in.

A conservator repairs damage on Holbein's *The Ambassadors*. You can see the fully restored painting on page 41.

Air-conditioning

Conservators also work to prevent more damage from happening. Warping is caused by heat and dampness, and strong light and air pollution make certain pigments fade or change color. So, in museums and galleries, light levels are controlled and air quality is monitored. Especially fragile pictures can be put behind glass or 'lined' – given extra backing to strengthen them.

Faking it

There is a lot of money in art. Paintings by famous artists regularly fetch millions at auction. The most ever paid was about \$82.5 million for a portrait by Vincent van Gogh. With wealthy art lovers willing to pay such vast sums, it is hardly surprising some unscrupulous painters have been tempted to produce fakes. These two pages describe some of the most notorious cases, but there must be hundreds more – many still undiscovered.

Portrait Of Dr. Gachet (1890), by Vincent van Gogh. In 1990, this painting - a genuine van Gogh - sold for a record-breaking sum. But experts say up to 100 drawings and paintings, supposedly by the artist, may in fact be fakes. Limited sales records (van Gogh sold only one painting in his lifetime) and his habit of making copies of his own work make it hard to check the origin of his pictures.

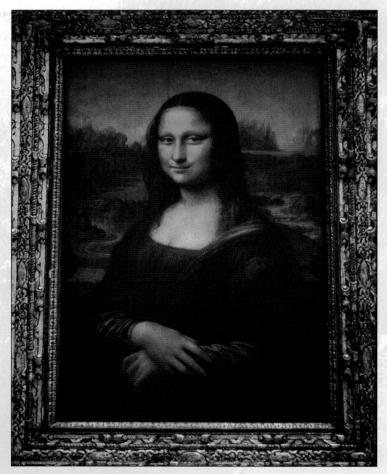

Mona Lisa (1505-14), by Italian artist Leonardo da Vinci. This picture was stolen and its whereabouts unknown for two years. When it was finally recovered, experts examined the pattern of cracks in the varnish and other tiny details to check it was the genuine painting, not a forgery.

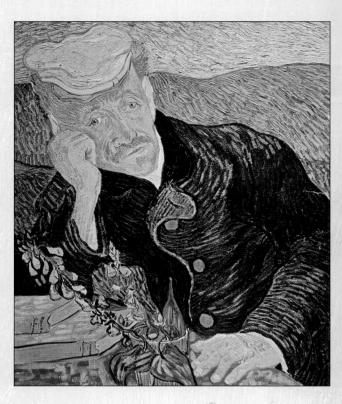

MONA LISA GONE! Daring theft of famous painting

One of the most daring art crimes involved the *Mona Lisa* portrait. For years it hung in the Louvre Museum, Paris. But on August 21, 1911, while the Louvre was shut, a workman took it down and quietly disappeared. The police searched the country in vain. Meanwhile, six wealthy Americans were fooled into paying about \$300,000 each for fake *Mona Lisas*, in a scam which may have been the real reason for the theft.

Then, in 1913, Vincenzo Perugia told a Florentine antique dealer that he had the real *Mona Lisa*. Doubtful, the dealer asked to see it. So Perugia took him to a hotel and showed him the painting, hidden in a secret compartment in his trunk. The dealer alerted the police and Perugia, who had been hoping for a reward, was arrested. He admitted stealing the portrait after working at the Louvre. But he got off lightly, claiming he had only wanted to return it to Italy. He was given the minimum sentence. As for the painting, it was returned to the Louvre, where it still hangs today.

"I made it!

Dealer's astonishing claim about valuable Vermeer

After the end of World War Two, a Dutch art dealer named Han van Meegeren was put on trial for collaborating with the Nazis. His crime? Selling them a prized painting by 17th-century Dutch artist, Jan Vermeer. To defend himself, van Meegeren made a startling confession: he had painted the picture himself. To prove it, he created another 'Vermeer' in front of witnesses, completing it in just two months.

As it turned out, van Meegeren had been forging pictures for years.

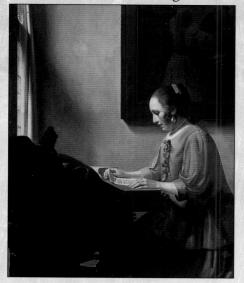

He had fooled experts by using real 17th-century canvases and carefully replicating old pigments. He had also developed a way of baking his pictures, to 'age' them. But, perhaps most importantly, he was a gifted painter. His fakes were much admired before the con was revealed. At the end of the trial, he was acquitted of collaboration. But he was given a prison sentence for forgery.

Woman Reading A Letter (1935-36), a 'Vermeer' fake by Han van Meegeren. (You can see a genuine Vermeer on page 66.)

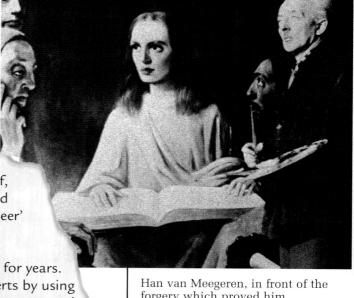

forgery which proved him innocent of Nazi collaboration

Speaking at his trial, Han van Meegeren said:

"Yesterday this picture was worth millions... experts and art lovers would come from all over the world and pay money to see it. Today, it is worth nothing, and nobody would cross the street to see it for free. But the picture has not changed. What has?"

Pictures and their provenances

To check if a painting is genuine, collectors don't just look at the picture itself. They also check its history or 'provenance,' inspecting details of former owners and sales. One of the most successful art crimes of recent times depended on the forgery, not of paintings, but of their provenances.

Together, John Myatt and John Drewe passed off more than 200 pictures in various styles before they were caught and sent to prison. Less than half of these

have been recovered. Myatt forged paintings by several artists, including Georges Braque and Henri Matisse. Technically, the fakes weren't very good. Myatt used a mixture of decorator's paint and lubricant gel quite unlike the real artists' paints. But many people were taken in because Drewe, an accomplished document forger, provided them with false sales receipts, and stamps and certificates of authenticity. He even doctored museum records of artists' works.

Passing judgment

Fakes are often interesting pictures in their own right. Forgers might start out copying others, but some build up reputations of their own. For example, Hungarian forger Elmyr de Hory is so well known, other forgers now sign his name on their fakes. So does it matter who made a picture? Many early artists didn't sign their work, and would not have understood our idea of a 'fake.' They judged a picture on its own merits, rather than the fame of the artist. Perhaps collectors today should do the same?

Timeline

These two pages list many of the important dates in history, and in the history of art, so you can compare what happened when.

For links to websites where you can see timelines of the history of art, and find out more about different periods and styles, go to www.usborne-quicklinks.com

Pre-1400: ancient and medieval times

ABOUT 35,000BC earliest cave paintings made in France and Spain

FROM 2628BC pharaohs rule Egypt; great pyramids built in Giza

ABOUT 2000-1450BC Minoan civilization on Crete

ABOUT 1600-1200BC Mycenaeans dominate Greece

ABOUT 1350BC hunting scene painted in nobleman's tomb in Thebes, Egypt

ABOUT 1000BC Rome founded

ABOUT 500-338BCClassical age of Greek culture

Roman copy of a 5thcentury BC statue

146BC Romans conquer Greece

ABOUT 100BC paper invented in China

AD79 Pompeii in Italy buried

FROM 312 rise of Christianity in Europe

395 Roman empire is split into two: the eastern Byzantine empire and a western empire centered on Rome

476 western Roman empire collapses

726-843 controversy over religious art: 'iconoclasts' destroy pictures, and new religious icons are banned for years

800 Charlemagne crowned emperor of much of Europe

ABOUT 800 Book Of Kells illuminated

ABOUT 1150 first European papermill set up in Spain

1200s Gothic art and architecture flourishes across Europe

ABOUT 1395-99 Wilton Diptych painted

About 1400: the Renaissance

ABOUT 1390-1441 life of Jan van Eyck

1400s oil paints pioneered in northern Europe

1401-ABOUT 1428 life of Masaccio

1404-72 life of Leon Battista Alberti

1410-16 the Limbourg brothers make *The Very Rich Hours* for the Duke of Berry

1434-1737 Medici family control Florence, Italy

1434 Van Eyck paints the *Arnolfini Portrait* using oil paints

1436 Alberti publishes On Painting

1446-1510 life of Sandro Botticelli

1450 beginning of book printing in Europe; paper widely used

1452-1519 life of Leonardo da Vinci

1453 Byzantine empire collapses

1475-1564 life of Michelangelo

ABOUT 1478-1510 life of Giorgione

1483-1520 life of Raphael

ABOUT 1485 Botticelli paints *Venus And Mars*

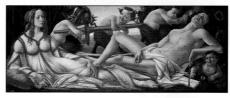

Venus And Mars

ABOUT 1487-1576 life of Titian

ABOUT 1505-14 Leonardo paints the *Mona Lisa* portrait

1508-12 Michelangelo paints the Sistine Chapel ceiling

1517 Martin Luther proposes changes to Catholic church, eventually leading to the creation of Protestant religions

1533 Hans Holbein the Younger paints *The Ambassadors*

1571-1610 life of Caravaggio

1577-1640 life of Peter Paul Rubens

1599-1660 life of Velázquez

About 1600: start of the Baroque period

1600-82 life of Claude Lorrain

1601 Caravaggio paints *The Supper At Emmaus*

1606-69 life of Rembrandt van Rijn

1618-48 Thirty Years' War in Europe

1629-30 Rubens paints *Peace And War*, to show the benefits of peace

Peace And War

1632-75 life of Jan Vermeer

1648 Dutch Republic founded – a rich trading nation

1650s camera obscura in use in Europe

1684-1721 life of Jean-Antoine Watteau

1697-1768 life of Canaletto

ABOUT 1700-1800 Grand Tour of Europe at its most popular

1715-18 Watteau paints The Scale Of Love

1723-92 life of Joshua Reynolds

1727-88 life of Thomas Gainsborough

ABOUT 1730 height of popularity of ornate Rococo art in Europe

1748 excavations begin at Pompeii

1748-1825 life of Jacques-Louis David

1754-58 Giovanni Tiepolo paints An Allegory With Venus And Time

An Allegory With Venus And Time

1775-83 American War of Independence

1775-1851 life of Joseph Turner

1776-1837 life of John Constable

1777 Scottish engineer James Watt designs a successful steam engine

1780-1867 life of Jean-Auguste-Dominique Ingres

1789 an angry mob storms the Bastille Prison in Paris, sparking off the French Revolution

1791-1824 life of Théodore Géricault

1798-1863 life of Eugène Delacroix

About 1800 on: era of revolutions

1804-15 Napoleon Bonaparte rules France

1808-14 'Peninsular War' between France and Spain; in 1814-15 Francisco Goya paints The Third Of May 1808 (Executions) showing French soldiers shooting unarmed Spanish civilians

1825 first passenger railroad opens in northern England

1826-98 life of Gustave Moreau

1832-83 life of Edouard Manet

1834-1917 life of Edgar Degas

1838 Louis Daguerre invents early photographs, or 'daguerreotypes'

1839-1906 life of Paul Cézanne

1840-1926 life of Claude Monet

1841 John Rand patents the collapsible metal paint tube

1841-1919 life of Auguste Renoir

1844 Turner paints Rain, Steam And Speed

1848 the Pre-Raphaelite Brotherhood is founded; 'Year of Revolution' sees uprisings across Europe; the Communist Manifesto is published

1848-1903 life of Paul Gauguin

1853 Baron Haussman starts building the Paris boulevards

1853-90 life of Vincent van Gogh

1859-91 life of Georges Seurat

1863-1944 life of Edvard Munch

1869-1954 life of Henri Matisse

1870 Monet paints The Beach At Trouville

The Beach At Trouville

1871-1958 life of Giacomo Balla

1874 first Impressionist exhibition held

1878 'Whistler v. Ruskin' trial – James Whistler sues critic John Ruskin for libel over comments on *Nocturne In Black And Gold* (1875)

1880s Cézanne experiments with perspective

1880-1938 life of Ernst Ludwig Kirchner

1881-1973 life of Pablo Picasso

1882-1963 life of Georges Braque

1884 Seurat paints Bathers at Asnières

1885 German Karl Benz builds the first motor car

1886-1944 life of Vassily Kandinsky

1887-1968 life of Marcel Duchamp

1888 George Eastman mass markets 'Kodak' cameras

1889 Eiffel Tower built in Paris

1895 Psychoanalyst Sigmund Freud publishes 'The Interpretation Of Dreams' — his theories about the unconscious later inspire the Surrealists

1900 on: beginning of the modern age

1903 Wright brothers make the first successful powered flight in America

1904-89 life of Salvador Dalí

1905 *Die Brücke* art movement formed in Germany

1906 Cézanne memorial exhibition in Paris

1907 on Picasso and Braque begin to develop Cubism

1909 First Futurist Manifesto issued

1910 Kandinsky begins experimenting with abstract art

1911 Kandinsky and Marc found *Der Blaue Reiter* movement

1914-18 World War One – 17 million die during the conflict

1916 Dada movement founded

1917 Russian Revolution

1929 start of the Great Depression – many countries undergo economic crisis

1933 Nazi leader Adolf Hitler comes to power in Germany

1936-39 Spanish Civil War – Fascist General Franco seizes power; in 1937, Picasso paints Guernica in response to bombing of civilians by Franco's allies

1937 Nazi exhibition of 'degenerate' art in Munich

1939-45 World War Two

1950s acrylic paints invented

1961 Russian Yuri Gagarin is first man in space

1965 Joseph Beuys performs *How to explain paintings to a dead hare*

1967 Pop artist Peter Blake designs cover for Beatles' *Sgt. Pepper* album

1969 US astronaut Neil Armstrong walks on the moon

1991 Damien Hirst makes *The Impossibility Of Death...* leading him to be nominated for art's prestigious Turner Prize in 1992 (he goes on to win the prize in 1995)

The Impossibility Of Death In The Mind Of Someone Living

About the artists

If you want to find out more about the artists in this book, you can read short biographies of them here.

For even more information, go to **www.usborne-quicklinks.com**, where you will find links to some useful websites.

Leon Battista
ALBERTI (1404-72)
Italian artist, architect
and writer. He wrote
On Painting (1436),
describing how to

use light, color and perspective to make pictures look more realistic.

Alesso BALDOVINETTI (about 1426-99) Italian painter. Also made stained glass and mosaics. Studied in Florence.

Giacomo BALLA (1871-1958) Italian artist. First worked as an illustrator, caricaturist and portrait painter. A founder of Futurism, he also designed Futurist furniture and clothing.

Giovanni BELLINI (about 1430-1516) Italian painter. His father and brother were also artists. Worked in oil paint, then more common in the Netherlands, and developed techniques which revolutionized Venetian painting. Influenced Giorgione and Titian.

Bartolomé BERMEJO (worked 1460-98) Spanish painter. Known for his religious scenes. Influenced by Netherlandish art.

Gian Lorenzo BERNINI (1598-1680) Italian sculptor and architect. Helped establish the Baroque style. Designed many large buildings in Rome, including the square and buildings in front of St. Peter's. Made busts of important people.

Joseph BEUYS (1921-86)

German artist. Studied medicine, then joined the air force in 1940. After WWII, dedicated his life to art. Made professor of sculpture at Düsseldorf art academy in 1961. Dismissed for allowing 50 rejected students to attend class. Became more and more involved in politics.

Peter BLAKE (born 1932)
British artist. Member of the
Pop Art movement. Uses comics and
magazines to make collages, often

showing cult figures such as Marilyn Monroe.

Pierre BONNARD (1867-1947)

French artist. Gave up law to become a painter. Joined the Nabis in 1889. Shared a studio with **Vuillard** and **Denis**. Also made posters and prints.

Sandro BOTTICELLI (about 1445-1510) Italian painter. Real name Alessandro Filipepi. Born in Florence. Renowned for his paintings of classical myths such as *Venus And Mars* and *The Birth Of Venus*. Also made just as many religious works.

Georges BRAQUE (1882-1963)
French artist. Was a decorator before studying art in Paris. Influenced by the Impressionists and Fauves. From 1907-14 (when he was called up), worked closely with **Picasso** developing Cubism.

Pieter BRUEGEL (1564-1638) Flemish artist. His sons and grandsons also became painters. Became known for his landscapes and often humorous scenes of country life.

Filippo BRUNELLESCHI (1377-1446) Italian sculptor and architect. Trained as a goldsmith. Designed many buildings in Florence, including the cathedral dome.

Robert CAMPIN (about 1378-1444) Dutch painter. Also known as the Master of Flémalle. Painted religious works in a natural-looking way.

CANALETTO (1697-1768)

Italian painter. Real name Giovanni Antonio Canal. 'Canaletto' means 'little canal' in Italian. Famous for his paintings of Venice, which he sold to tourists. Came to London in the 1740s, but his paintings of English scenes were less popular.

CARAVAGGIO (1571-1610) Italian painter. Real name Michelangelo Merisi, or Amerighi. Known as 'Caravaggio' after his birthplace. His work was sensational and innovative, breaking from tradition by showing religious figures as ordinary people. Helped develop the dramatic Baroque style, specializing in light and shade. Had many fights and had to flee Rome after killing a man.

Paul CEZANNE (1839-1906)

French painter. Abandoned legal studies to become a painter. Worked in Paris where he met **Pissarro**, **Monet** and **Renoir**. Then moved back to southern France and turned his attention to landscapes, developing an almost geometrical way of working. Greatly influenced the Cubists.

Philippe de CHAMPAIGNE (1602-74) Flemish painter. Worked in Paris. Trained as a landscape artist, but made his name painting portraits and religious subjects.

Jean Baptiste Siméon CHARDIN (1699-1779)

French painter. Son of a craftsman. Worked as a restorer. Became known for his still lifes and scenes of everyday life, though these were not fashionable subjects at the time. Later became president of the French Academy of Arts. Influenced **Manet**.

Jacopo di CIONE (about 1325-99) Italian painter. The youngest of four brothers, all artists. Completed many large commissions in Florence.

CLAUDE Lorrain (1600-82)

French painter (actually born in the independent Duchy of Lorraine). Real name Claude Gellée. May have begun his career as a pastry cook in Rome. Painted atmospheric landscapes, often with biblical or mythological themes. Recorded all his drawings in a portfolio, the *Liber Veritatis*, to prevent forgeries.

John CONSTABLE (1776-1837) British painter. Worked in his father's

windmills in Suffolk, where he said he learned to study the sky. Then went to London to become a painter. Did portraits before committing himself to landscapes. Taught himself to reproduce the effects of light and weather. Was often

compared to
Turner (whose
work was more
popular at the
time in England).
Much admired in

France and influenced Delacroix.

Lucas CRANACH (1472-1553)

German painter, engraver and illustrator. A Protestant, and friend of the religious reformer Martin Luther. Made pro-Protestant woodcuts. Known for his portraits and scenes with the Virgin Mary.

Carlo CRIVELLI (about 1430-94) Italian painter. Developed a decorative style using gold leaf. Very skilled in the use of perspective. Made many religious works, including *The Annunciation* (1486).

Salvador DALI (1904-89)

Spanish artist, designer and writer. Expelled from the Madrid Academy of Art. Moved to Paris and met **Picasso** and **Miró**. Became a leading Surrealist, making films and paintings illustrating the world of the unconscious. Went to the U.S. to avoid WWII. Flamboyant and eccentric, he once gave a lecture in an old-fashioned diving suit, accompanied by two wolf hounds.

Jaques-Louis DAVID (1748-1825)
French painter. Leading figure of
Neoclassical painting. Dominated art in
France from the outbreak of the French
Payolution to the fall of Nanalessa

France from the outbreak of the French Revolution to the fall of Napoleon, making successful political paintings for very different regimes.

Edgar DEGAS (1834-1917)

French artist. Studied law then art. Known for his paintings of dancers, racehorses and city life. Also made pastels and sculptures exploring movement. Exhibited with the Impressionists but didn't share all their ideas. Became a recluse in old age, suffering ill health.

Eugène DELACROIX (1798-1863)

French painter. Successful history painter and a leading figure of the Romantic movement. His loose, colorful style is often contrasted with the stricter, Classical work of **David** and **Ingres**.

Robert DELAUNAY (1885-1941) French painter. Made stage sets, then turned to art. Interested in color theory and Cubism. Known for his almost abstract pictures of colored circles.

Maurice DENIS (1870-1943)

French painter and theorist. Member of the Nabis. Tried painting with flat areas of unnaturally bright colors. In later life, devoted himself to religious imagery.

Otto DIX (1891-1970)

German painter and graphic artist. Influenced by **van Gogh** and the Futurists. Fought in WWI. Afterward, war became a dominant theme in his work. Like **Grosz**, he exposed German corruption through satire. After WWII he turned to painting religious subjects.

DUCCIO di Buoninsegna (about 1260-1319)

Italian painter. Influenced by Byzantine art. Clashed with authority, but rose to a position of power and wealth, becoming a leading master of the Sienese style. Known for his religious works.

Marcel DUCHAMP (1887-1968)

French artist. Worked as a librarian while studying art. Early paintings were influenced by Cubism. Became a leader of the Dada and Surrealist movements in New York. His 'readymades' changed people's views about what constitutes art. Also a professional chess player.

Albrecht DURER (1471-1528)

German artist. Son of a goldsmith. Famous for his engravings and woodcuts, which were widely reproduced. Studied Italian painting in Italy, and combined the innovations of the Renaissance there with northern artistic traditions.

Carel FABRITIUS (1622-54)

Dutch painter. Real name Carel Pietersz. Pupil of **Rembrandt** and teacher of **Vermeer**. Killed in the explosion of a gunpowder warehouse in Delft. Fewer than a dozen of his paintings are known.

Caspar David FRIEDRICH (1774-1840) German painter. Leader of the German Romantic movement. Known for his symbolic, atmospheric landscapes.

Thomas GAINSBOROUGH (1727-88)

British painter. Influenced by **Watteau**, Dutch and Rococo art. Born in Suffolk, but made his name in Bath, a fashionable spa town, where his flattering portraits were very popular. Later moved to London. Loved painting landscapes, sometimes basing

them on models made from broccoli and other materials.

Paul GAUGUIN (1848-1903)

French painter and sculptor. A sailor and then a stockbroker, he gave up his job to become an artist, but found it hard to make ends meet. He developed a flat, colorful style which influenced the Nabis. Worked in rural France, at one point living with van Gogh, then went to the South Seas, where he died.

Théodore GERICAULT (1791-1824)

French painter and sculptor. Became a leading figure of the Romantic movement in France. Often painted horses, but also darker subjects such as *The Raft Of The 'Medusa'* (1819). Worked with Ingres and **Delacroix** in Italy. Later visited England.

Alberto GIACOMETTI (1901-66)

Swiss sculptor and painter. Son of a painter. Known for his sculptures of eerily thin figures. Friend of **Picasso** and writers Simone de Beauvoir, Jean-Paul Sartre and Samuel Beckett.

Luca GIORDANO (1634-1705)

Italian painter. An important decorative artist who introduced the Baroque style to southern Italy. Completed many commissions in Italy and Spain, working so fast that he was nicknamed *Luca Fa Presto* ('Luca does it quickly.')

GIORGIONE (about 1478-1510) Italian painter. Born Giorgio, or Zorzi, da Castelfranco. Greatly influenced Titian. Died young, leaving several unfinished works. These were then completed by other artists, especially Titian.

GIOTTO di Bondone (about 1266-1337) Italian painter and architect. Very successful early Renaissance artist, admired by Michelangelo. Designed many important buildings in Italy. Also famous for his frescoes.

GIOVANNI di Paolo (about 1403-82) Italian painter. Trained in Siena and influenced by other Sienese artists, but developed a very personal style. Produced many works over his long career.

Andy GOLDSWORTHY (born 1956)
British artist. Worked on a farm as a teenager, forming an interest in nature.
Makes sculptures from natural materials.
These often decay, so they are preserved only through photos and documents.

Francisco GOYA

(1746-1828) Spanish painter. Worked in Madrid, creating portraits of wealthy patrons in an elegant style inspired by Velázquez, Gainsborough

and **Reynolds**. Also painted everyday scenes. Probably best-known for his shocking scenes of war and nightmares.

Juan GRIS (1887-1927)

Spanish painter and sculptor. Real name José Gonzalez. Became friends with **Picasso** in Paris and joined the avantgarde movement. Made slow progress until an art dealer gave him a contract. Then he could afford to focus more on his art and became a leading Cubist.

George GROSZ (1893-1959)

German painter. Deeply marked by his experiences fighting in WWI. Fiercely critical of post-war Germany, he made satirical drawings attacking the German government. A founding member of the Berlin Dada group. When the Nazis rose to power, he emigrated to the U.S.

Richard HAMILTON (born 1922)

British artist. His art studies were interrupted by WWII, when he worked as a draftsman. After the war, became a leading Pop artist. Also an influential teacher and writer.

William Michael HARNETT (1848-92)

Irish-born U.S. painter. Trained as a silverware engraver before turning to painting. Specialized in detailed *trompe l'oeil* still lifes, painting objects so accurately they almost look real.

Erich HECKEL (1883-1970)

German painter. Formed the German Expressionist group, *Die Brücke*, with **Kirchner, Schmidt-Rottluff** and others.

Damien HIRST (born 1965)

British artist. Achieved recognition and notoriety through his provocative works using dead animals suspended in formaldehyde preservative.

Meindert HOBBEMA (1638-1709)

Dutch painter. His natural-looking landscapes were popular after his death, but he was poorly paid in his lifetime and had to work as a customs officer.

David HOCKNEY (born 1937)

British artist. Spent a long time in the

U.S. A successful Pop artist, portraitist and theater designer. Developed a clean, flat style of painting. Also experimented with using photos, faxes and photocopies.

William HOGARTH (1697-1764)

British painter. Trained in print-making. Popular as a caricaturist as well as a painter. Celebrated for his depictions of contemporary English society and illustrations of moral tales.

Hans HOLBEIN the younger

(about 1497/98-1543)

German artist. Designed woodcuts for books, and painted portraits and religious scenes. Met the English king, Henry VIII, then spent much of his time working for him, painting portraits and designing court costumes, silverware, jewelry and triumphal arches.

Pieter de HOOCH (1629-84)

Dutch painter. Started out as a footman for a rich merchant. Painted scenes of middle-class life, like his fellow Dutch artist and contemporary **Vermeer**. Later turned to painting upper-class life in Amsterdam, but with less success.

Edward HOPPER (1882-1967)

U.S. painter and commercial illustrator. Admired for his realistic, atmospheric landscapes. His use of moody lighting helped create a distinctive American style.

Jean-Auguste-Dominique INGRES (1780-1867)

French painter. Made a living from portraits, including several for Napoleon. Painted in the Neoclassical style developed by David, though his choice of subjects was influenced by Romanticism. Leader of the Neoclassicists after **David**.

Wilhelm KALF (1622-93)

Dutch painter. Worked mainly in Amsterdam creating still lifes.

Vassily KANDINSKY (1866-1944)

Russian painter. Studied law before turning to art. Worked in Germany, Russia and France. Founded the avant-garde group *Der Blaue Reiter* with **Marc**. One of

the first abstract artists. Taught at the German art school, the Bauhaus. Had many works confiscated by the Nazis. In 1933, moved to France, where he worked with **Miró**.

Ernst Ludwig KIRCHNER (1880-1938) German artist. Studied art and architecture. Helped found the avantgarde group *Die Brücke*. Discharged from the army during WWI because of a mental breakdown. Completed several frescoes while recovering. In 1937, the Nazis condemned his art as 'degenerate.' Committed suicide in 1938.

Yves KLEIN (1928-62)

French artist. Studied judo and languages before turning to art. Worked with natural substances such as pure pigment, gold leaf and real sponge. Later experimented with fire and water. Also staged performances. In 1958, defied convention by exhibiting bare walls in a Paris gallery.

Gustav KLIMT (1862-1918)

Austrian artist. Set up a firm in Vienna producing mosaics and murals, and had a great influence on decorative art. One of several Viennese artists who resigned from official posts in order to focus on modern art. His paintings of alluring women scandalized some people at the time. Perhaps best known for *The Kiss* (1908).

Nicholas LANCRET (1690-1743)

French painter. Studied with **Watteau** and imitated his work.

Fernand LEGER (1881-1955)

French painter. Trained as an architect. His early Cubist paintings were nicknamed 'tubist' because of the tube-like shapes he created. Also designed film sets and costumes. Served in WWI and lived in the U.S. during WWII.

LEONARDO da Vinci

(1452-1519)

Italian painter, sculptor, architect, inventor and engineer. Studied in Florence. Worked in Florence and Milan as an artist and military engineer. Moved to the French court in

1517 and remained in France till his death. Received many commissions, but left several unfinished. Perhaps best known for the *Mona Lisa* portrait (c.1505-14). His notebooks, in mirror writing, contain detailed studies of anatomy and perspective, as well as many inventions.

Percy Wyndham LEWIS (1882-1957) British writer and painter. Influenced by the Futurists, he argued for the value of

violence, energy and machines. Was an official War Artist in WWII. Stopped painting after he went blind in 1951, but continued writing.

Roy LICHTENSTEIN (1923-97)

American painter and sculptor. Continued his art studies after serving in WWII. Made engineering drawings for extra money, then became a college professor. Best known for his striking comic-strip images.

The LIMBOURG brothers (worked in the early 1400s, all died by 1416) Flemish artists. The three brothers - Paul, Jean and Herman - made illuminated manuscripts. *The Very Rich Hours*, created for the Duke of Berry, is a masterpiece of the International Gothic style.

El LISSITZKY (1890-1941)

Russian artist. Born Lazar Markovich Lisitskii. Studied architecture in Germany until WWI forced him to return to Russia. Taught architecture and graphics with **Malevich**. Also designed books. Made influential abstract paintings in the 1920s. Later concentrated on design.

René MAGRITTE (1898-1967)

Belgian painter. Worked briefly as a wallpaper designer. Knew the Surrealists, including **Dali** and **Miró**, and developed his own version of Surrealism. His paintings only received wide attention after WWII, and have since influenced posters and advertizing.

Kasimir MALEVICH (1878-1935)

Russian painter. Experimented with various styles, and invented Suprematism, the abstract geometric style for which he is known. Designed opera costumes and scenery. Also an art teacher and theorist.

Edouard MANET (1832-83)

French painter. Greatly influenced by Spanish art. His work often provoked criticism at home, but was much admired by the Impressionists. Olympia (1865) was one of his most controversial paintings. It scandalized many people by breaking with convention and showing a female nude in modern surroundings, looking directly at the viewer. Although the writer Emile Zola defended him, he only found wide appreciation in his final years.

Franz MARC (1880-1916)

German painter. Son of a landscape painter. Founded the group *Der Blaue*

Reiter with **Kandinsky**. Explored colors in a way partly inspired by **Delaunay**, and developed his own Expressionist style. He often painted animals, and gave lessons in animal anatomy. Killed in WWI.

MASACCIO (1401- about 1428) Italian painter. Real name Tommaso di Giovanni. Worked in Florence. An inventive early Renaissance artist, he used his knowledge of perspective, anatomy and shading to paint religious scenes in a more realistic way. Influenced Michelangelo.

Henri MATISSE (1869-1954)

French painter and sculptor. Abandoned law studies to become an artist. Leader of the Fauve group and known for using bright, decorative colors. Mainly painted women, interiors and still lifes. Influenced the Expressionists but, unlike them, tried to represent happy emotions – he said art should be comforting, "like a good armchair." Influenced by **Cézanne**. He bought Cézanne's small painting *Bathers* in 1899, which he claimed sustained him spiritually through hard times.

MICHELANGELO Buonarroti (1475-1564)

Italian sculptor, painter, architect and poet. Like **Leonardo**, one of the most important artists in Renaissance Italy. Nicknamed the 'divine Michelangelo,' he worked for two popes, but found their demanding commissions frustrating. Created beautiful marble sculptures, including the famous statue of David in Florence. Probably best-known for his frescoes in the Sistine Chapel (1508-12). Also designed several important buildings, including St. Peter's in the Vatican.

John Everett MILLAIS (1829-96)

British painter. Studied art at the Royal Academy, London, from the age of 11. Founder member of the Pre-Raphaelite Brotherhood, along with **Rossetti**. Known for his detailed religious and historical paintings. Friend of influential art critic John Ruskin, until he married Ruskin's exwife. Later became Sir John and president of the Royal Academy.

Joan MIRO (1893-1983)

Spanish painter. Gave up work as a clerk after suffering a nervous breakdown. Exhibited with the Surrealists in Paris. Became known for his quirky, detailed paintings, though later simplified his style. Also did sculptures, etchings and murals.

Piet MONDRIAN (1872-1944)

Dutch painter. Began painting traditional landscapes, but soon made them brighter and more stylized. In 1909, he moved to Paris, where he was influenced by Cubism. His work became more linear and abstract, until it was a grid of black lines with blocks of primary colors.

Claude MONET (1840-1926)

French painter. Loved painting outside, directly from nature. His chief concern was the changing effect of natural light. Worked with **Renoir**, **Manet** and others to develop Impressionism – the name was taken from criticism leveled at his picture *Impression*, *Sunrise* (1872). Probably best-known for his water lily paintings, made in his own backyard at Giverny in northern France.

Gustave MOREAU (1826-98)

French painter. Taught **Matisse**. Made detailed, mysterious paintings of religious and historical subjects. His style became known as Symbolism.

Berthe MORISOT (1841-95)

French painter. Studied in Paris and exhibited with the Impressionists. Encouraged **Manet**, her brother-in-law, to paint out of doors.

Edvard MUNCH (1863-1944)

Norwegian painter. Influenced by van Gogh, he made intense, emotion-filled paintings and prints. His mother and sister died of TB during his childhood, and death is a recurring theme in his work. His best-known work, *The Scream* (1893), inspired the Expressionists.

Bartolomé Esteban MURILLO (1617-82)

Spanish painter. Contemporary of Velázquez and first president of the Seville Academy. His beautiful, sentimental images of the Virgin Mary were very popular in the 17th and 18th centuries.

Caspar NETSCHER (about 1635/6-84) Dutch painter. Settled in the Hague. Painted genre, religious and mythological scenes, then devoted himself to portraits.

Giovanni Paolo PANINI (1691-1765) Italian painter. Specialized in landscapes, picturesque ruins and architecture.

Pablo Ruiz PICASSO (1881-1973)
Spanish painter and sculptor. A child prodigy, encouraged to paint by his father, an artist and art teacher. Visited Paris in the early 1900s, then settled there, meeting many writers and artists. Developed Cubism with Braque, inspired by African art and Cézanne. Continued to experiment all his life, creating many innovative works and becoming one of the most famous 20th-century artists. As well as paintings, made sculptures and ceramics, and designed stage sets.

PIERO della Francesca (1415/20-92) Italian painter and mathematician. Used geometry to work out perspective and create harmonious compositions. He was a central figure of the Renaissance and an inspiration to the Cubists. But his work was not very fashionable. In old age, devoted himself to studying math.

PISANELLO (about 1395-1455) Italian painter and medal-maker. Real name Antonio Pisano. The last and most celebrated artist of the ornate International Gothic style. Known for his detailed, graceful paintings and frescoes. Also produced many portrait medallions.

Camille PISSARRO (1830-1903)
French painter. Knew Manet and Monet.
Earned his living by teaching and painting decorative blinds and fans. A major Impressionist and a great influence on Cézanne.

POLLAIUOLO Antonio (about 1432-98) Italian artist. Inspired by the classical past, he made a detailed study of anatomy. His brother Piero was also an artist, and often worked with him.

Jackson POLLOCK (1912-56)
American painter. Best known for his huge, Abstract Expressionist 'drip' paintings, made by letting paint fall onto canvases laid on the floor. He was killed in a road accident at the age of 44.

Nicolas POUSSIN (1594-1665) French painter. Moved to Rome, where he found inspiration in the hilly landscape and Roman ruins. In 1640, he was called back to France to run the prestigious Academy, but returned to Rome only two years later. He developed the genre of grand history paintings, much admired by the Academy.

RAPHAEL (1483-1520)

Italian painter. Real name Raffaello Sanzio. A very successful Renaissance artist, along with **Michelangelo** and **Leonardo**. His big commissions included decorating the pope's rooms and designing tapestries for the Sistine Chapel in the Vatican. He also painted many fine portraits, pictures of the Virgin Mary and Classical scenes. His attention to gesture and expression inspired many later artists.

Odilon REDON (1840-1916)

French artist and writer. An important Symbolist. Fueled by his imagination and love of literature, he created dramatic pastel drawings and prints, as well as richly colored paintings.

Paula REGO (born 1935)

Portuguese-born painter and illustrator, living in Britain since 1976. Says illustrated children's books were her greatest influence. Her work explores power, sexuality and social codes.

REMBRANDT Harmensz van Rijn (1606-69)

Dutch painter. Also worked as a teacher and art dealer. A prolific artist, painting everything from nudes to landscapes, biblical scenes and self portraits. He is known for his atmospheric use of light and shade. He made most of his money from portraits, but fell out with his patrons and went bankrupt.

Auguste RENOIR (1841-1919)

French painter. Trained as a porcelain painter. Studied with **Monet** and was one of the most successful Impressionists. Painted outdoors, directly from the subject, using soft colors. In later life, he also made sculptures.

Joshua REYNOLDS (1723-92)

British painter and portrait artist. Worked for the British king, George III. Tried to develop a more formal kind of portrait, influenced by Classical sculpture. Founded the Royal Academy of Art in London, and was elected its first president. Later became Sir Joshua.

Dante Gabriel ROSSETTI (1828-82) British painter and poet. Brother of the poet Christina Rossetti. Helped found the Pre-Raphaelite Brotherbood with **Millais**, but did not share the PRB's realistic approach to painting. Developed his own more Romantic style, making idealized paintings of beautiful women. He married the artist's model Elizabeth Siddal, who died tragically young. He threw a book of his poems into her grave, but dug them up later so he could publish them.

Mark ROTHKO (1903-70)

Russian-born U.S. painter. A leading Abstract Expressionist. Inspired first by **Miró** and the Surrealists, he later specialized in abstract images, especially floating, blurred rectangles. In 1970, he committed suicide in his New York studio.

Henri ROUSSEAU (1844-1910).

French painter. Nicknamed *le douanier* (French for 'customs officer.') Worked for a lawyer and then the army, though he never saw action. Later became a toll collector, painting in his spare time. Developed a deceptively child-like style. Began to paint full-time after he retired.

Peter Paul RUBENS (1577-1640) Flemish painter. Traveled widely and

spoke five languages. Worked as a diplomat for various European monarchs, as well as being a successful artist. Spent several years in Italy, where he was influenced by ancient Roman art and **Titian**. Also visited Spain, where he influenced **Velázquez**. Known for his grand mythological scenes and portraits. Knighted by Charles I.

Pieter SAENREDAM (1597-1665) Dutch painter. Painstakingly recreated the perspectives of churches and town halls.

SASSOFERRATO (1605-85)

Italian painter. Real name Giovanni Battista Salvi. Influenced by Raphael, he made many paintings of the Virgin Mary in a style similar to his.

Karl SCHMIDT-ROTTLUFF (1884-1976)

German artist. Studied architecture and helped found the group *Die Brücke*. Developed a harsh, angular style, influenced by African sculpture. During WWII, his work was confiscated by the Nazis.

Paul SERUSIER

(1863-1927)

French painter. Influenced by **Gauguin**. Founded the Nabis in 1889.

Georges SEURAT (1859-91)

French painter and theorist. His ideas on color led him to develop Pointillism, a technique using tiny dots of pure color.

Paul Signac (1863-1935) French painter. Worked with Seurat developing Pointillism.

Alfred Sisley (1839/40-99) Anglo-French painter. Born in Paris of British family, and worked mostly in France. A leading Impressionist.

Jan Havicksz STEEN (1625/6-79) Dutch painter. Depicted everyday Dutch scenes and moral tales in a humorous, anecdotal manner.

Harmen STEENWYCK (1612-56) Dutch painter. Specialized in still lifes, especially *vanitas* pictures designed to remind viewers of their own mortality.

Giovanni Battista TIEPOLO (1696-1770) Italian painter. A brilliant Rococo artist, he worked all over Europe. Known for his frescoes and colorful decorative panels.

TITIAN (about 1487-1576) Italian painter. Real name Tiziano Vecellio. Worked with Giorgione. Lived in Venice and rarely traveled, though his work (mainly in oils) became known across Europe and he made many paintings for European royalty. Admired for his range of subjects, brilliant colors and expressive style. Acknowledged as the greatest portrait painter of his time.

Joseph Mallord
William TURNER
(1775-1851)
British painter.
The son of a
barber, he began
exhibiting pictures in
his father's shop. Famous for painting
seas, skies and weather. Developed a
more modern style of landscape painting
which had a great influence on the
Impressionists. Shunned publicity and
adopted the false name 'Admiral Booth.'

Paolo UCCELLO (about 1397-1475) Italian painter. Worked in Florence and studied perspective. *Uccello* is Italian for 'bird,' and was probably a nickname – he was said to love animals.

Anthony VAN DYCK (1599-1641) Flemish painter. Later Sir Anthony. Was

chief assistant to **Rubens** in Antwerp, then worked in Italy. In 1631, he became court painter to the English king, Charles I. His elegant, flattering portraits were hugely influential.

Jan VAN EYCK (about 1390-1441) Netherlandish artist. Worked as a court painter and diplomat. Pioneered the use of oil paints. Created religious scenes and portraits. Much admired for his wonderfully detailed and lifelike style.

Vincent VAN GOGH (1853-90)

Dutch painter. An unsuccessful preacher, now very famous as an artist, though he sold only one painting during his life. He began painting somber rural scenes. Then moved to Paris, met **Degas**, **Gauguin**, **Pissarro** and others, and started doing colorful pictures of flowers, people and local scenery. Later, moved south to set up a studio with Gauguin, but argued violently with him and, suffering from mental illness, cut off part of his own ear. Shot himself two years later.

Jan VAN HUYSUM (1682-1749) Dutch painter. Specialized in painting still lifes, creating detailed imaginary arrangements of flowers and fruit.

Jan VAN OS (1744-1808) Dutch painter. Painted still lifes, imitating van Huysum. His son was also an artist.

Diego Rodriguez de Silva VELAZQUEZ (1599-1660)

Spanish painter. Worked for King Philip IV of Spain. Known for his history paintings and perceptive portraits of members of Philip's court. His work inspired many artists, including **Manet** and **Picasso**, who did a series of pictures based on *The Maids Of Honour* (1656), often known by its Spanish title, *Las Meninas*.

Jan VERMEER (1632-75)

Dutch painter and art dealer. Did not seem to sell much of his own work – over half of it was found in his house and studio when he died. He was almost forgotten for years, but much admired when rediscovered. Famous for creating quiet, beautifully lit interior scenes.

VERONESE (about 1528-88) Italian painter. Real name Paolo Caliari. Known as Veronese because he was born in Verona. Worked in Venice and became very successful, completing many large commissions in fresco and oils.

Elisabeth VIGEE-LEBRUN (1755-1842) French painter. Studied art with her father. Her attractive, flattering portraits were popular with many patrons, among them Queen Marie-Antoinette of France.

Bill VIOLA (born 1951)

U.S. video and installation artist. Worked at a video studio in Italy and studied Buddhism in Japan, before returning to live in the U.S. Awarded many fellowships for his video work.

Edouard VUILLARD (1868-1940)
French painter. Worked with Bonnard in Paris. Joined the Nabis. Usually painted richly colored, atmospheric domestic scenes. Seldom exhibited after WWI.

Andy WARHOL (1928-1987) U.S. artist. Worked in advertizing before getting involved with the U.S. Pop art movement. One of the most famous artistic personalities of modern times, known for his repeated prints of images taken from advertizing and the media. Also made experimental films.

Jean-Antoine WATTEAU (1684-1721) Flemish painter. Worked in Paris. Painted theater scenery, then worked with a court painter. Became a successful Rococo artist. Influenced by **Rubens**, he developed his own elegant, poetic style of dream-like landscapes.

James McNeill WHISTLER (1834-1903) American painter. Studied art after failing to qualify for the army. He based many paintings on delicate arrangements of color. After the art critic John Ruskin attacked his painting *Nocturne In Black And Gold* (1875), he sued for libel. He won the case, but was ruined by the legal costs.

Richard WILSON (1713/14-82) British painter. Born in Wales. Painted landscapes in England, Wales and Italy, where he was inspired by the scenery around Rome and by the works of Poussin and Claude. Sometimes called the 'father of English landscape painting.'

Johan ZOFFANY

(about 1733-1810) German painter. Studied in Rome, then moved to Britain. Mainly painted portraits, and theatrical and domestic scenes.

Glossary

There are lots of specialized words used in art. This glossary explains the names and terms used in this book, as well as some other common terms you may come across. Words in **bold** have their own entries.

For a link to websites where you can look up lots more technical terms used in art, go to www.usborne-quicklinks.com

2-D - abbreviation of two-dimensional. Used to describe something which is (or seems to be) flat, such as a drawing of a square.

3-D - abbreviation of threedimensional. Used to describe something which is (or seems to be) solid, such as a cube or a drawing of a cube.

Abstract art - art that has no recognizable subject matter, but is an arrangement of shapes and colors.

Abstract Expressionism - an art movement that flourished in New York in the 1940s and 50s. It centered on dramatic abstract paintings. Leading members were Mark Rothko and Jackson Pollock.

acrylic paint - paint made from pigment and acrylic resin. Invented in the 1950s and now widely used.

AD - used for dates, to indicate the years numbered forward from the supposed year of Christ's birth, or 'year 1.' AD stands for *Anno Domini*, which is Latin for 'year of the Lord.' Some people prefer to express AD dates as CE, or 'Common Era.'

aerial perspective - an effect caused by distance which makes colors seem to fade and turn blue.

allegory - something which has a hidden symbolic meaning.

altarpiece - a large painting, often made up of many panels, made to stand behind an altar.

ancient art - art from the ancient cultures of Egypt, Greece and Rome.

applied art - art which has a practical purpose, such as pottery.

art movement - a group of artists who work together and share ideas, and who often exhibit together too.

automatic drawing - a technique invented by the Surrealists. It involved trying to draw without thinking, as a way of trying to access their unconscious mind.

avant-garde - innovative, cutting-edge art. The term comes from the French name for the advance unit of an army.

Baroque - a dramatic, 17th-century style of art. Also used to describe the period when this style was popular. The term derives from the Portuguese word *barocco*, meaning 'misshapen pearl.'

Bauhaus, the - an influential German art school where all the students learned art, architecture and design, with the goal of creating a better environment for everyone. It was closed down by the Nazis.

BC - used for very early dates, to indicate the years numbered backwards from the supposed year of Christ's birth, or 'year 1.' BC stands for 'before Christ.' Some people prefer to express BC dates as BCE, or 'Before the Common Era.'

Blaue Reiter, Der - an Expressionist art movement founded in Germany, in 1911, by Vassily Kandinsky and Franz Marc. They chose the name, which means 'The Blue Rider' in German, because they liked blue and horses. They also published a periodical with the same title.

Book of Hours - an illustrated book containing prayers for different times of day, different days and different seasons. It was used at home rather than in church.

Brücke, Die - a German Expressionist art movement founded in 1905. Its members included Ernst Kirchner, Erich Heckel and Karl Schmidt-Rottluff. The name was meant to

signify a bridge to the future, to a new kind of art.

burnishing - polishing something to make it shine.

Byzantine art - art from the Byzantine empire (the eastern part of the Roman empire), which lasted from the 4th to the 15th century.

camera obscura - a device designed to help artists make accurate, 2-D sketches of 3-D scenes. There were several versions of it, but all projected images of real-life scenes onto flat surfaces - similar to a simple camera. The name means 'dark room' in Latin.

cartoon - a full-scale drawing on paper, which can be traced onto a wall, panel or canvas as a basis for a painting. Nowadays, also used to mean a caricature or funny picture.

chiaroscuro - this means 'light-dark' in Italian. In art, it is used to describe pictures where there is strong light coming from one side of the scene, so it casts strong shadows on the other side.

Classical art - ancient Greek and Roman art, especially Greek art from the 5th century BC.

Claude glass - a tinted mirror used by landscape artists. It simplified the colors of what it reflected in a way that was meant to resemble a painting by Claude.

Carolingian art - art from the time of the emperor Charlemagne (742-814).

collage - a technique where newspaper, wallpaper, fabric and other materials are glued onto the picture surface. Pioneered by Picasso and popular with **Pop** artists.

color wheel - an arrangement of the three primary colors (red, yellow and

blue) and the **secondary colors** (orange, green and purple) you get by mixing them. It is shown on page 92.

commission - to pay an artist to produce a work of art to order. Also used to describe a work produced in this way.

complementary colors - colors which lie opposite each other on the color wheel. Seen side by side, they contrast very strongly and make each other look brighter.

Conceptual art - art which emphasizes the idea behind a work of art, rather than the work itself.

Constructivism - an abstract art movement which grew out of the Russian Revolution of 1917. Its members wanted to help create a new society by designing art, buildings, furniture, etc. using geometric principles.

court painter - a painter employed by a ruler to work at his or her court.

Cubism - a style which draws attention to the contradictions involved in making a 2-D image of a 3-D scene. It was first developed in the early 20th century by Picasso and Braque. The name came from Braque's painting *Houses At L'Estaque* (1908,) which a critic described as looking like "a pile of little cubes."

Dada - an art movement formed during WWI. Its members created unconventional, often shocking, art to protest against the war and the state of society. The name (a word for 'hobby horse') was chosen at random from a dictionary.

death mask - a cast or model of someone's face made after he or she has died.

decorative art - art, such as embroidery or ornate silverwork, made to decorate other things.

'Degenerate' art - a term used by the Nazis to condemn modern art they disapproved of, such as works by Kirchner, Grosz and Picasso. The Nazis held an exhibition in Munich in 1937 to mock 'degenerate' works of art. **diptych** - a picture made up of two hinged panels.

drip painting - a technique made famous by Jackson Pollock, where paint is dripped and splashed from a brush, stick or pot onto a canvas laid horizontally on the floor.

egg tempera - paint made using pigment and egg, used widely before the 15th century.

engraving - a kind of print. First, a picture is 'engraved' or cut onto a metal plate. The plate is brushed with ink, so ink fills the hollows. Then a sheet of damp paper is pressed over the plate to pick up the ink.

etching - a kind of print made using a metal plate coated with a protective wax. A picture is 'etched' or scratched into the wax, revealing the metal beneath, and acid is used to burn the exposed metal. Then the plate is brushed with ink and printed in the same way as an engraving.

Expressionism - an early 20th-century development where artists use exaggerated shapes and colors to try to convey feelings and ideas, rather than showing how things really look. It was inspired by the work of Munch and van Gogh. There were two main groups, *Der Brücke* and *Der Blaue Reiter*. See also Abstract Expressionism.

Fauves - the name given to a group of young painters around 1905-10 who used vibrant, unnatural colors. Matisse was a leading member. The name means 'wild beasts' in French.

fête galante - a scene of courtly entertainment, such as dancing or music-making in an outdoor setting. A popular subject with Rococo artists, especially Watteau.

fine art - a collective term used to describe painting, sculpture, drawing, print-making and, sometimes, music and poetry. Unlike applied art or decorative art, fine art has no practical purpose.

Flemish - from, or in the style of things from, the region of Flanders,

(now part of Belgium, France and the Netherlands.)

Florentine - from, or in the style of things from, Florence, Italy.

found object - an object which an artist has not made, but has chosen to exhibit as a work of art. See also **ready-made**.

fresco - a wall painting made by applying colors to wet plaster.

Futurism - an early 20th-century art movement which celebrated the energy and speed of machines and city life. Its founders stated their goals in aggressive manifestoes.

genre - a particular kind of paintings, such as portraits, landscapes, history paintings and still lifes.

gesso - a thick, white paste used to prepare a surface for painting.

gild - to cover something, such as a frame, with a thin layer of gold.

golden section - a mathematical ratio known since ancient times, which can be used to help create pleasing compositions. It determines the distances between three points in a straight line. You can see it in a diagram on page 91.

gothic - a term used to describe the art and architecture of the Middle Ages. See also International Gothic.

Happenings - unscripted, bizarre **performances**, such as Joseph Beuys' *How To Explain Paintings To A Dead Hare* (see page 113.) Developed in the late 20th century.

harmonizing colors - colors, such as red and orange, which come next to each other on the color wheel. Seen side by side, they seem to blend together.

high culture - traditional art forms, such as paintings, which tend to be expensive and available only to small numbers of people. Often contrasted with pop culture.

history painting - a painting that tells a story, whether real or made-up. Most show scenes from Classical history and myths, or Bible stories. Originally described by Alberti and, in the 17th century, considered the highest form of painting. See also genre.

icons - holy images of religious figures, usually of saints, or the Virgin Mary and Jesus.

iconoclasts - people who wanted to destroy religious art, because they believed images led to the worship of idols. This happened in the 8th century in the Byzantine empire, and in the late 16th and 17th centuries in northern Europe.

illuminated manuscripts - books written and decorated by hand.

impasto - a very thick layer of paint.

Impressionism - the first major avant-garde art movement, formed in the 1860s. Its members wanted to paint outdoors and study the changing effects of natural light. Their work has a sketchy, spontaneous style. Leading members included Monet, Renoir and Pissarro. The name came from a hostile review of Monet's painting Impression, Sunrise (1874.)

installation - a work of art designed to be set up, or installed, in a particular location. Pioneered by Dada and Surrealist artists.

International Gothic - name given to the decorative, colorful style of painting developed in Europe in the 14th and 15th centuries.

Land art - a 20th-century art movement where artists work within the landscape, creating simple arrangements of natural materials. Often these are temporary, so they survive only in photographs and documents.

landscape format - a rectangle that is wider than it is tall.

landscapes - paintings where landscape or scenery is the main subject.

linear perspective - see perspective.

lithograph - a kind of **print** made by drawing onto a stone or metal tablet.

The tablet is wetted, then coated with ink, which sticks to the lines of the drawing. A print is then taken by laying paper over it.

manuscripts - texts written by hand. See also **illuminated manuscripts**.

medieval art - art from the Middle Ages (about 1000-1400).

medium - the material used to make an artwork, such as pastels, fresco or oil paints. Originally, it meant the liquid, such as oil or acrylic resin, that is mixed with dry pigment to make paint.

memento mori - an object such as a skull or a dying flame, included in a picture to make you think about death.

Minimalism - a 20th-century art movement where there is little obvious content, so viewers have to examine what is there very closely. Pioneered by Malevich.

Minoans - ancient Greek people who lived on the island of Crete.

mixed media - used to describe art made from more than one material or medium. 'Media' is the plural of medium.

mosaics - pictures made of tiny pieces of colored glass or stone set in plaster or cement on a wall or other surface.

movements - groups of artists who shared ideas and practices, and often exhibited together, as began happening in the 19th century.

Myceneans - ancient Greek people and famed warriors.

mythological - relating to Classical myths.

Nabis, the - a group of artists who exhibited together at the end of the 19th century. They were inspired by Gauguin to focus on color. The name is Hebrew for 'prophets.'

Neoclassicism - a revival of Classical style and subjects in art during the late 18th and early 19th centuries. Pioneered by David and continued by Ingres.

Netherlandish - from, or in the style of art from, Flanders and Holland (now the Netherlands, Belgium and France.)

oil paints - paints made by mixing pigment and oil, used widely from the 15th century until the 20th century. Often shortened to 'oil.'

old master - one of the many celebrated European painters between about 1400 and 1800, or a painting by one of them.

palette - a board on which an artist mixes his or her colors. Also used to mean the range of colors used by a particular artist.

pastels - chalky, colored crayons.

patrons - people who pay artists to produce work for them.

Performance art - a 20th-century movement where artists perform their work, which exists afterward only in photographs and documents. See also **Happenings**.

perspective - the rules used to create a sense of **3-D** space in a **2-D** drawing. One rule is that objects look smaller as they get farther away. The most accurate system, worked out during the **Renaissance**, is known as unified or linear perspective, and uses vanishing points. See also aerial perspective.

pigment - powdered substances used to create paint colors. In the past, they were made by grinding anything from earth to precious stones. In the 19th century, chemical pigments were introduced.

Pointillism - a technique where painters apply tiny dots of pure, unmixed colors instead of blending colors on a palette, to try and achieve a brighter, more vibrant effect. Seen from a distance, the dots seem to blend together. Pioneered by Seurat, who called it 'Divisionism.'

Pop art - an art movement developed in the late 1950s-60s which used images taken from pop culture. It celebrated and commented on the boom of pop culture and consumerism that followed the austerity of the war years. Pioneered in London by Hamilton and others; U.S. members included Lichtenstein and Warhol.

pop culture - short for 'popular culture.' It means television programs, films, magazines, advertizing and other productions aimed at a mass audience. Often contrasted with high culture.

portrait format - a rectangle which is taller than it is wide.

portraits - pictures of real people which try to capture a true likeness.

Post Impressionism - a term used to describe the variety of styles which developed after **Impressionism**.

Pre-Raphaelite Brotherhood - a group of young British painters who wanted to return to what they saw as the simpler, purer style of art before Raphael's time. Also known by its initials, PRB. Members included Rossetti and Millais.

primary colors - red, yellow and blue. All other colors can be made by mixing these colors together.

prime - to prepare a canvas for painting.

print - any picture made by taking an impression from somthing else, such as a piece of carved wood or linoleum covered in ink. Often used to make many copies of a picture. Etchings, lithographs and woodcuts are all kinds of prints.

pronk still life - a still life painting designed to show off expensive luxury items. The term comes from the Dutch for 'show off': pronk.

readymades - a name given by the artist Marcel Duchamp to works consisting of ordinary, factory-made objects, which the artist has chosen to present as art.

Renaissance, the - the cultural revolution of the 14th and 15th centuries, which saw a rebirth of interest in Classical ideas and many new scientific discoveries, such as perspective.

Rococo - an ornate, 18th-century style of art. The term comes from the French *rocaille*, meaning 'shells.'

Romanesque - the name given to the style of art and architecture which developed in western Europe between the 10th and 12th centuries.

Romanticism - a literary and artistic movement which emphasized the importance of emotions (especially feeling for nature) and the imagination. It flourished from about 1790-1840. Leading painters included Friedrich and Delacroix.

secondary colors - orange, green and purple. These are the colors you get when you mix two primary colors together.

sfumato - Italian for 'smoky.' In painting, it means blurring the transitions between highlights and shadows to create a softly lit, mysterious effect, like that in Leonardo's *Mona Lisa*.

silk-screen print - a kind of print made using a silk panel to help distribute the ink.

spalliera panel - a long painted panel made to decorate a chest or other piece of furniture. Often made for newly married couples in Renaissance Italy.

Socialist Realism - a realistic but melodramatic style of art, developed for propaganda by the Russian Communist party.

Stijl, De - an early 20th-century art movement aimed at promoting a colorful, abstract geometric style in art, architecture and design. Pioneered by Mondrian. The name is Dutch for 'The Style.'

still life - a painting mainly of objects that can't move, such as flowers, food and pots and pans. It can also refer to the actual arrangement of objects. The plural is always written 'still lifes' (not 'lives.') See also *pronk* still life and *vanitas*.

Suprematism - an early 20th-century style developed by Malevich, based on abstract geometric shapes.

Surrealism - a 20th-century art movement inspired by Dada and the writings of psychiatrist Sigmund Freud. The Surrealists, including Dalí and Miró, aimed to explore our unconscious minds, often using bizarre, dream-like imagery.

Symbolism - a 19th-century artistic and literary **movement** which rejected realism, emphasizing feelings and dreams instead. Leading artists included Moreau and Redon.

three-dimensional - see 3-D.

triptych - a picture made up of three panels.

trompe l'oeil - a highly realistic painted device which tries to deceive viewers into thinking they are looking at a real object instead of a painted image. The name means 'tricking the eye' in French.

two-dimensional - see 2-D.

underpainting - the first layer of colors applied to a painting.

unified perspective - see perspective.

vanishing point - a term used in perspective drawing to mean the point where parallel lines, such as train tracks, seem to come together in the distance.

vanitas - a still life which is meant to remind viewers of the futility of earthly achievements and encourage spiritual thoughts, by reminding them that success is only temporary and death comes to us all. The name is Latin for 'vanity' or 'futility.'

Venetian - from, or in the style of things from, Venice, Italy.

Vorticism - an early 20th-century avant-garde movement, based in London, inspired by Cubism and Futurism.

woodcut - a kind of print made by cutting a picture into a wooden block, leaving raised lines which are coated with ink (unlike an engraving, where the ink fills the hollows). The block is then pressed onto paper to make a print.

Amazing art facts

This page lists some fascinating facts about art and artists.

The world's largest painting is 313m (1,028ft) long, and covers 35,356m² (116,000ft²) It is a painting of sea creatures by Robert Wyland, and it surrounds the Long Beach Arena in California, U.S.A.

Some 18th-century European artists specialized in tiny portraits known as miniatures, painted on small pieces of precious ivory. But, in China and India, even smaller pictures have been made, some fitting onto a single grain of rice.

You might not think of painting as a dangerous business, but many traditional pigments are highly toxic. Poisonous lead can be used to make white paint, and some red, yellow, green and blue paints contain deadly arsenic. Cadmium, which is sometimes used to make yellows and reds, is both poisonous and radioactive.

Today, most toxic pigments can be replaced with safer artificial alternatives. But artists still use some surprising materials. As well as paint, Jackson Pollock added sand, pebbles, coins, tacks, keys, glass and even cigarette butts to his canvases, to try to create more interesting textures.

Damien Hirst once created an arrangement of old newspapers and left-over drinks for a London gallery – only to have it cleared away by the cleaner. Hirst said the cleaner's mistake was very funny.

Four of the top ten most expensive paintings ever sold were by Pablo Picasso. The most expensive

painting ever sold was by Vincent van Gogh. In 1990, his *Portrait of Dr. Gachet* broke all previous sales records by reaching US\$82.5 million at auction in New York. But its new owner had to sell it a few years later for only an eighth of this sum.

Art prices depend on fashion and taste. Many artists whose work now sells for millions struggled to make ends meet during their lifetimes. They include Jan Vermeer, Rembrandt van Rijn and van Gogh. Prices also reflect only what has come up for sale. Some of the world's most famous paintings, such as Leonardo da Vinci's Mona Lisa, have never been auctioned and are considered priceless.

No one knows the true identity of the model for the *Mona Lisa*. When the skull of one candidate, Italian noblewoman Isabella d'Aragona (1470-1524,) was examined, a black layer was found on her teeth, caused by treatment for a nasty disease. If Isabella was the model, it's not surprising she's smiling with her mouth closed.

When the Pope asked Italian painter Giotto di Bondone for a sample of his work, he dipped his brush in red paint and drew a perfect circle. Although it was a very simple picture, it clearly showed Giotto's skill at drawing. (He became a leading figure of the early Italian Renaissance.)

Italian Renaissance artist
Michelangelo is famous for
decorating the ceiling of the Sistine
Chapel in the Vatican. To do this,
he had to lie on a scaffold or hang
from the roof in a harness, and he
wrote several poems complaining
about how uncomfortable it was.

Thomas Gainsborough used brushes that were 1.8m (6ft) long, because he liked to stand well back from his paintings. Henri Matisse also used to draw with charcoal tied onto the end of a long pole, but only when he was very old and too ill to move around much

In 1994, thieves walked out of the National Gallery of Art in Oslo, Norway, with Edvard Munch's famous painting *The Scream*. They left a note saying: "Thanks for the poor security." The painting was recovered later the same year.

A portrait by Rembrandt, Jacob III de Gheyn, is the world's most stolen painting. It has been swiped four times, and was recovered in some unusual places, including under a bench in a London graveyard and on the back of a bicycle.

Some people believe French artist Nicolas Poussin included clues in his painting *The Shepherds Of Arcadia* to show the way to the last resting place of the Holy Grail. But no one has been able to prove this, and most experts are sceptical.

French Impressionist Claude Monet had cataracts - an eye condition which makes people see things in muddy, red and yellowish tones. You can see these colors in many of Monet's paintings from 1905 until 1923, when he had an eye operation to cure it.

Famed 20th-century artist Pablo Picasso was a very fast worker. On average, he completed 8.7 pictures each day of his adult life.

French Impressionist Edgar Degas was obsessed with ballet dancers, and made more than 1,500 drawings and paintings of them.

Using the Internet

Throughout this book, we have recommended interesting websites where you can find out more about art. To visit the recommended sites, go to the Usborne Quicklinks Website at www.usborne-quicklinks.com and type the keywords 'introduction to art.' There you will find links to click on to take you to all the sites.

Here are some of the things you can do on the recommended sites:

- Explore virtual exhibitions of paintings and zoom in on the details of individual pictures.
- Experiment with interactive artist's tools such as line and color.
- Escape from inside a painting in an on-line art adventure.
- · View works of art and send e-postcards of them.

Internet safety

When using the Internet, please make sure you follow these guidelines:

- Children should ask their parent's or guardian's permission before connecting to the Internet.
- When you are on the Internet, never tell anyone your full name, address or telephone number.
 Children should ask an adult before giving their email address.
- If a website asks you to log in or register by typing your name or email address, children should ask an adult's permission first.
- If you do receive an email from someone you don't know, do not reply to the email.

COMPUTER NOT ESSENTIAL

If you don't have access to the Internet, don't worry. This book is a complete, self-contained reference book on its own.

Site availability

The links in **Usborne Quicklinks** are regularly reviewed and updated, but occasionally you may get a message that a site is unavailable. This might be temporary, so try again later, or even the next day.

If any of the sites close down, we will, if possible, replace them with suitable alternatives, so you will always find an up-to-date list of sites in **Usborne Quicklinks**.

What you need

Most websites listed in this book can be accessed using a standard home computer and a web browser (the software that lets you look at information from the Internet.)

Some sites need extra programs (plug-ins) to play sound or show videos or animations. If you go to a site and do not have the necessary plug-in, a message will come up on the screen. There is usually a button on the site that you can click on to download the plug-in. Alternatively, go to **Usborne Quicklinks** and click on **Net Help**. There, you can find links to download plug-ins.

Internet disclaimer

The websites described in this book are regularly reviewed and the links in **Usborne Quicklinks** are updated. However, the content of a website may change at any time and Usborne Publishing is not responsible for the content of any website other than its own.

We recommend that children are supervised while on the Internet, that they do not use Internet chat rooms, and that parents and guardians use Internet filtering software to block unsuitable material. Please ensure that children read and follow the safety guidelines printed on the left.

For more information, see the **Net Help** area on the **Usborne Quicklinks Website**.

Index

abstract, 104-105, 108 Abstract Expressionism, 105 Abstract Speed, 100 Academy French, 11 Royal (London), 72 acrylics, 117, 118, 119 Adoration Of The Shepherds, 59 Africa, 103 Agony In The Garden, 50 Alberti, 10, 38, 128 Alexander the Great, 10 allegories, 17, 62, 69, 71 Allegory Of The Vanities Of Human Life, 69 Allegory With Venus And Time, 71, 127 altarpieces, 30 Ambassadors, 41, 123 anatomy, 10, 38, 44, 49 ancient Egypt, 19, 20, 22, 23 ancient Greeks, 21, 22-23 angels, 28-29, 45, 54, 58, 64 animals, 25, 31, 32, 33, 95, 103, 114, 115 Annunciation, 38 Anthropometries, 113 Apollo And Daphne, 46 architecture, 22, 25, 35 Arnolfini Portrait, 42-43 Art Of Conversation, 107 At The Theatre, 9 Attributes Of The Arts, 17 automatic drawing, 107 Autumn Landscape, 14 avant-garde, 99, 100 Avenue At Middelharnis, 64

Bacchus, 47, 57 Bacchus And Ariadne, 47, 123 Baldovinetti, 40, 128 Balla, 100, 128 Baptism Of Christ, 44 Baroque, 53-69 Bathers At Asnières, 6, 76-77, 90-91 Battery Shelled, 108 Battle Of San Romano, 39 Beach At Trouville, 1, 2, 89 Beat The Whites..., 108 beauty, 8, 22, 40, 43, 49, 114 Bec du Hoc, 92 Belgium, 14 Bellini, 50, 128 Belshazzar's Feast, 55 Berlin, 103 Bermejo, 31, 128 Bernini, 54, 128 Beuys, 113, 128 Bible, 10, 14, 16, 26, 30, 44, 50, 55, 56, 59, 83

Birth Of Venus, 49 Black Circle, 104 Blake, 112, 128 Blaue Reiter/Blue Rider, 103, 104 Boating On The Seine, 89 Bonnard, 93, 128 Book Of Kells, 24 Book Of The Dead, 20 Books Of Hours, 32 Botticelli, 48-49, 128 Braque, 97, 100, 125, 128 Bride, 114 Brücke/Bridge, 103 Bruegel, 51, 128 Brunelleschi, 39, 128 brushes, 37, 119 brushstrokes, 9, 12, 43, 57, 70, 85, 89, 90, 118, 119 brushwork, 9, 36, 66, 81 bull jumping, 21 Byzantine empire, 26, 27 Byzantium, 26

camera obscura, 65, 75, 121 Campin, 37, 128 Canaletto, 75, 121, 128 canvas, 7, 47, 56, 62, 73, 86, 90, 110, 119, 120, 123 Caravaggio, 56-57, 128 Carnival Of Harlequin, 107 Carolingian, 25 cartoons, 45 Catholic, 58, 59 cave paintings, 6 Cézanne, 96, 97, 128 Champaigne, 53, 58, 128 Chardin, 17, 128 Charlemagne, 25 Charles I On Horseback, 60 Charles Townley's Library, 74 Christianity, 24, 25, 26, 27, 33, 41, 80 Church (Christian), 24, 58, 60, 61 churches (buildings), 25, 26, 30-31, 44, 54 Cione, 30, 128 cities, 84, 94, 101 City, 101 Classical, 25, 35, 38, 40, 46, 50, 54, 78, 84 age, 22-23, 38 art, 22-23, 40, 72, 73, 74, 78 myths, 10, 16, 46, 47, 48, 54 Claude, 64, 65, 74, 128 collage, 97, 119 Colonel Banastre Tarleton, 73

color theory, 90, 92

color wheel, 92 Combing The Hair, 6 Communists, 108 complementary colors, 89, 102 composing pictures, 8, 49, 85, 91, 105 Composition In Red, Yellow And Blue, 105 conceptual art, 113 conservators, 122, 123 Constable, 80, 87, 128-129 Constructivists, 108 contrasting colors, 81, 90 Coronation Of The Virgin, 30 Cossacks, 104 court painters, 60 courts, 32, 33, 60-61, 63 Courtyard Of A House In Delft, 65 craftsmen, 10, 30, 38 Cranach, 46, 129 Creation Of Adam, 44 Crete, 21 Crivelli, 38, 129 Cubism/Cubists, 15, 97, 100, 101, 104 Cupid Complaining To Venus, 46

Dada, 106 Dalí, 106, 107, 129 Dark Ages, 24 David, 78, 79, 129 Degas, 6, 84, 85, 129 Degenerate Art, 109 Delacroix, 11, 81, 129 Delaunay, 101, 129 demons, 25 Denis, 93, 129 devils, 25, 31 diptychs, 28 Dix, 109, 129 donors, 31 doodle, 107 dragons, 25, 27, 43, 51, 82 dramatic art, 54-55, dreams, 82, 106, 107 Dresden, 81, 103 Duchamp, 106, 107, 129 Dürer, 120, 129 Dürer's Drawing Machine, 120 Dutch republic, 59, 64, 66, 68

Ecstasy Of St. Theresa, 54
Effects Of Intemperance, 67
egg tempera, 28, 36, 48, 118, 119
Egyptians, 19, 20, 21, 23, 115, 118
Eiffel Tower, 101
England, 62, 63, 72

everyday life, 66-67 exhibitions, 87, 90, 93 Expressionism, 102

Faa Iheihe, 94 Fabritius, 65, 129 Factory, 113 fakes, 124-125 see also forgeries Family Of Darius..., 10 fauns, 48 Fauves, 102 fêtes galantes, 70, 71 'Fighting Temeraire,' 87 Flanders, 14 Florence, 30, 39, 46 Flowers In A Teracotta Vase, 68 forgeries, 117 see also fakes Fountain, 106 Fox Hill, 88 frames, 122 France, 15, 25, 61, 70, 78, 79, 94 frescoes, 44 Freud, 106 Friedrich, 81, 129 Fruit, Flowers And A Fish, 16 Futurists, 100, 101

Gainsborough, 72, 129 Gauguin, 92, 93, 94, 95, 129 genres, 8, 16 Géricault, 11, 129 Germany, 81, 109 Giacometti, 109, 129 Giordano, 54, 55, 129 Giorgione, 51, 129 Giovanni, 14, 129 God, 29, 30, 43, 55, 58, 81 gold leaf, 29, 30, 118, 122 golden section, 91 Goldsworthy, 114, 115, 129 Goya, 79, 130 Grand Tour, 74-75 Greeks, 22, 23 Grís, 13, 130 Grosz, 109, 130 Guernica, 110-111

halos, 27, 37, 57, 82
Hamilton, 112, 130
harmonizing colors, 92
Harnett, 16, 17, 130
Harvest At Le Pouldu, 93
Heckel, 103, 130
high culture, 112
Hillside In Provence, 96
Hirst, 115, 130
historical scenes, 10, 60-61
history painting, 10-11, 78, 90
Hobbema, 64, 130

Hockney, 112, 130 Hogarth, 73, 130 Holbein, 41, 123, 130 Holland, 64, 65, 94 Hooch, 65, 130 Hopper, 15, 130 horizon line, 38 Hory, 125 Houses In L'Estaque, 97 Hunters In The Snow, 51 hunting, 20, 32, 33, 51

Icicle Star, 114
iconoclasts, 27, 59
icons, 27
illuminated manuscripts, 24
impasto, 93
Impressionist, 6, 89
Impressionism, 89
Ingres, 6, 79, 81, 130
Interior Of Saint Peter's, 75
Interior Of The Buurkerk, 59
International Gothic, 32
Ireland, 24
Italy, 36, 44, 69, 75

Jesus Christ, 25, 27, 28, 29, 30, 33, 37, 43, 44, 45, 50, 56-57
Julius Caesar, 23
Just What Is It..., 112

Kalf, 69, 130 Kandinsky, 103, 104, 109, 130 kings, 11, 25, 28, 29, 40, 60, 63, 79 Kirchner, 103, 130 Klein, 113, 130 Klimt, 82, 130

Lady And The Unicorn, 32 Lady In A Garden..., 71 Lady Teaching A Child To Read, 67 Lancret, 71, 130 Land Art, 15, 114 Landscape With Diana..., 74 Landscape With Hagar..., 64 landscapes, 8, 14-15, 23, 50-51, 64-65, 72, 80-81, 94, 96, 114 Large Blue Horses, 99, 103 Large Woman Upright IV, 109 Last Judgement, 25 Leger, 101, 130 lenses, 120, 121 Leonardo, 35, 39, 45, 46, 124, 130 Lewis, 108, 130-131 Liberty Leading The People, 11 Lichtenstein, 112, 113, 131 light, 6, 10, 15, 26, 36, 42, 50, 54, 55, 56, 57, 59, 69, 79, 85, 94, 96, 102, 111,

121, 123, see also sunlight

Limbourg brothers, 32, 131 Lissitzky, 108, 131 love, 32, 42, 46, 48, 49, 70

machines, 45, 100, 101 Madame Matisse, 102 Madame Moitessier, 6 magic, 20, 25, 82 Magritte, 107, 131 Malevich, 104, 131 Man In A Turban, 36 Manet, 6, 17, 84, 88, 131 manuscripts, 24, 25 Marc, 99, 103, 131 marriage, see weddings Marriage Settlement, 73 Mars, 48-49, 62-63 Masaccio, 38, 39, 131 materials, 9, 77, 117, 118-119 Matisse, 102, 125, 131 Medici family, 39 medieval, 14, 19, 24-33, 103 memento mori, 41 Michelangelo, 39, 44, 118, Middle Ages, 44, 118 Millais, 83, 131 Minoans, 20, 21 Miró, 107, 131 mirrors, 6, 13, 43, 55, 120, 121 Miss La-La..., 85 model books, 33 modern art, 99-115 Mona Lisa, 124 Mondrian, 105, 131 Monet, 1, 2, 15, 85, 88, 89, 131 Monet Working..., 88 morals, 9, 46, 48, 66, 67, 78 Moreau, 82, 131 Morisot, 89, 131 mosaics, 26 movements, 77 Mr. And Mrs. Andrews, 72 multiple views, 13, 97 Munch, 102, 131 Murillo, 55, 131 Music In The Tuileries, 84 Myceneans, 21 Myron, 22 mythological scenes, 23, 50, 60, 61, 62-63 myths, 10, 16, 48, 54

Nabis, 93
Nantes Triptych, 115
Napoleon I..., 79
Narcissus, 34-35, 46
Nazis, 109, 110, 125
Neoclassicism, 78, 79, 81
Netherlands, 36-37
Netscher, 67, 131
Nocturne In Black And Gold, 7
nude, 46, 61

Oath Of The Horatii, 78
oil (paints), 36, 42, 48, 50,
56, 62, 86, 90, 110, 114, 119
Old Models, 16
On Painting, 38
open air, 15
optics, 38
Ophelia, 83
Ophelia Among The Flowers, 2-3,
82
outdoor scenes, 88-89
Ovid Among The Scythians, 81

Pan, 61 Panini, 75, 131-132 parchment, 24 Paris, 84, 90, 94, 100, 101, 110, 124 Patinir, 50, 132 patron saints, 27, 28, 29, 33 patrons, 28, 39, 44, 50, 72 Peace And War, 62-63 performances, 112-113 Perseus Turning Phineas..., 54 perspective, 10, 14, 23, 38, 39, 50, 64, 65, 85, 86, 94, 97, 120 aerial, 45, 50, 64, 71 unified, 38, 96 pharaohs, 20 Philip IV In Brown And Silver, 60 photographs, 12, 13, 36, 111, 115, 127 Physical Impossibility Of Death ..., 115 Picasso, 13, 95, 97, 100, 109, 110-111, 132 Piero, 44, 132 pigments, 36, 95, 118, 119, Pillars Of Society, 109 Pisanello, 33, 132 Pissaro, 88, 89, 132 Pointillism, 90, 92 politics, 9, 11, 22, 108, 111 Pollaiuolo, 46, 132 Pollock, 105, 132 Pompeii, 23, 78 Pop art, 112-113 culture, 112, 113 Pope Julius II, 40 Portrait Of A Lady, 40 Portrait Of A Lady In Red, 12 Portrait Of A Lady In Yellow, 40 Portrait Of Dr. Gachet, 124 Portrait Of Picasso, 13 portraits, 8, 12-13, 23, 31, 40-41, 60, 72, 73, 79, 115, 124 self portraits, 12-13, 17, 36, 55, 57, 63, 87 Poussin, 61, 132 prayer, 30, 31, 32, 50, 58, 59

Pre-Raphaelite Brotherhood

(PRB), 83 priming, 119 prints, 113 propaganda, 108-109, 111 proportions, 22, 120 props, 13 Protestant, 58, 59 provenance, 125

queens, 60

Raft Of The Medusa, 11 railways, 84, 86 Rain, Steam And Speed, 86-87 Raphael, 8, 9, 40, 83, 132 readymades, 106 realism, 16, 22, 26, 36, 38, 44, 45, 56, 57 Red Tower, 101 Redon, 2, 82, 132 Regatta On The Grand Canal, 75 Rego, 114, 132 religion, 11, 25, 26-27, 30, 31, 33, 43, 50, 56-57, 58-59, 80, 81, 115 Rembrandt, 12, 13, 55, 59, 132 Renaissance, 34-51, 61, 96, 115, 119, 120 Renoir, 9, 89, 132 restorers, 37, 51, 122, 123 revolution, 11, 70, 78-97, 100 French Revolution, 70 Reynolds, 72, 73, 121, 132 robots, 101, 108 Rococo, 53, 70-75, 78 Roman empire, 24, 26 Romanesque, 25 Romans, 23, 78, 79 Romanticism, 80-81 Rome, 74, 75 Rossetti, 83, 132 Rothko, 105, 132 Rousseau, 4-5, 95, 132 Route 6, Eastham, 15 Rubens, 14, 62-63, 70, 132 Ruskin, 7

Saenredam, 59, 132 Saint George And The Dragon, 82 Saint Jerome In A Rocky Landscape, 50 Saint John The Baptist Retiring To The Desert, 14 Saint Lazare Station, 85 Saint Luke Painting The Virgin, 36 Saint Michael And The Devil, 31 saints, 8, 14, 24, 27, 28, 29, 30, 31, 33, 36, 43, 44, 45, 50, 51, 53, 54, 58, 69, 82 George, 27, 29, 31, 51, 82 John the Baptist, 14, 28, 44, 45 Salisbury Cathedral, 80

Sassoferrato, 58, 59, 132 Scale Of Love, 70 Schmidt-Rottluff, 103, 132 Scream, 102 sculptures, 10, 13, 19, 22, 23, 38, 44, 74, 78 Self Portrait, 55, 63, 87 Self Portrait Aged 63, 12 Self Portrait In A Straw Hat, 13 self portraits, 12-13, 17, 36, 55, 57, 63, 87 Sérusier, 93, 132 Seurat, 6, 77, 90-91, 92, 133 shark, 115 Sick Bacchus, 57 Signac, 92, 133 Sisley, 89, 133 Sistine Chapel, 44 skulls, 41, 69 Socialist Realism, 108 Soft Watch At Moment Of First Explosion, 106, 107 Spain, 31, 60, 61, 63, 79, 110, spalliera panels, 48, 49 statues, 20, 22, 126 Steen, 67, 133 Steenwyck, 69, 133 Stijl, 105 Still Life With Drinking Horn, 69 Still Life With Violin And Fruit, 97 still lifes, 8, 16-17, 23, 57, 68-69, 96, 97 stories, 8, 10, 11, 14, 26, 30, 44, 46, 56, 59, 61, 64, 78 Street Scene In Berlin, 103

Sunflowers, 92 sunlight, 15, 59, 64, 66, 80, 89 Sunset, 51 Supper At Emmaus, 56-57 Suprematist art, 104 Surrealism, 106 Surrealists, 95, 106-107 Symbolism, 82 symbols, 8, 17, 27, 41, 42, 50, 57, 63, 66, 69, 79, 80, 81, 111 status symbol, 40

Tahiti, 94 Talisman, 93 tapestries, 32 Third of May, 1808, 79 Tiepolo, 71, 133 Tiger In A Tropical Storm, 4-5, 95 Titian, 40, 47, 123, 133 To My One Desire, 32 Toilet Of Venus, 61 tomb paintings, 20, 115 townscapes, 64-65, 84-85, 101 trains, 85, 86-87 triptychs, 28, 115 Triumph Of Pan, 61 trompe l'oeil, 16, 55 tubes (of paint), 88, 118, 119 Turner, 86-87, 133

Uccello, 39, 133 unconscious, 106, 107 underpainting, 118

Untitled, 105 Van Dyck, 60, 133 Van Eyck, 36, 42-43, 133 Van Gogh, 7, 17, 92, 93, 94, 95, 102, 124, 133 Van Gogh's Chair, 17 Van Huysum, 68, 133 Van Meegeren, 125 Van Os, 16, 133 vanishing points, 38 vanity, 12, 46, 69 varnish, 87, 122, 123 Velázquez, 60, 61, 133 Venice, 10, 75 Venus, 46, 48-49, 61, 71 Venus And Mars, 48-49, 126 Vermeer, 66, 121, 125, 133 Veronese, 10, 133 Very Rich Hours, 32 videos, 114, 115 View Of Delft..., 65 viewpoints, 38, 96, 97, 100, 101, 120 Vigée-Lebrun, 13, 133 Vikings, 25 Viola, 115, 133 Virgin And Child, 38 Virgin And Child Before A Firescreen, 37, 122 Virgin And Child With St. Anne And St. John The Baptist, 45 Virgin And Child With St. John And Angels, 118 Virgin In Prayer, 58 Virgin Mary, 16, 27, 28, 29, 30, 37, 45, 58, 122

Virgin Of The Rocks, 45 Vision Of A Knight, 8 Vision Of St. Eustace, 33 Vision Of St. Joseph, 53, 58, 59 visual art, 6 Vuillard, 93, 133

war, 15, 21, 58, 62, 63, 73, 78, 79, 103, 105, 106, 108-109 First World War/World War One, 15, 103, 105, 106, 108, 110, 111, 125 post-war, 112 Second World War/World War Two, 109, 125 Warhol, 17, 112, 113, 133 Water Lily Pond, 15 Watteau, 70, 71, 133 weddings, 42, 43, 47, 49, 70, 71, 72, 73, 114 Wheatfield With Cypresses, 94 Whistler, 7, 133 Wilson, 74, 133 Wilton Diptych, 18-19, 28-29 Winter Landscape, 81 Woman Reading Music, 125 wood, 22, 28, 42, 49, 118, 119, 123 workshops, 30, 37, 118

Young Woman Standing At A Virginal, 66, 121

Zoffany, 74, 133

Cartoons by Uwe Mayer
Diagrams by Glen Bird; sample paintwork by Antonia Miller
Picture researcher: Ruth King; digital manipulation: Mike Olley and John Russell
Thanks to Abigail Wheatley and Katie Daynes for additional research, Brian Roberts for additional art historical advice, and Georgina Andrews, Fiona Patchett and Alice Pearcey for editorial assistance.

First published in 2003 by Usborne Publishing Ltd, 83-85 Saffron Hill, London EC1N 8RT (www.usborne.com). First published in America in 2004. AE. Copyright © 2003 Usborne Publishing Ltd. The name Usborne and the devices \mathbb{Q} \mathbb{C} are Trade Marks of Usborne Publishing Ltd. All rights reserved. No part of this publication may be reproduced, stored in a retrieval system or transmitted in any form or by any means, electronic, mechanical, photocopying, recording or otherwise, without the prior permission of the publisher. Printed in Dubai.

Acknowledgements

Every effort has been made to trace the copyright holders of the material in this book. If any rights have been omitted, the publishers offer their sincere apologies and will rectify this in any subsequent editions following notification. The publishers are grateful to the following organizations and individuals for their contributions and permission to reproduce material:

All National Gallery (NG) images © The Trustees of The National Gallery, London

Cover details (top row, left to right): The Wilton Diptych see credit for pages 28-29, The Avenue At Middelharnis see credit for page 64, Sunflowers see credit for page 92, Venus And Mars see credit for pages 48-49; (middle row) A Regatta On The Grand Canal see credit for page 75, Mr. And Mrs. Andrews see credit for page 72, Bathers At Asnières see credit for pages 90-91, A Young Woman At A Virginal see credit for page 66; (bottom row) Faa Iheihe see credit for pages 94-95, The Virgin In Prayer see credit for page 58, The Battle Of San Romano see credit for page 39, Bacchus And Ariadne see credit for page 47. Page 1 Detail from The Beach At Trouville see credit for page 89. Pages 2-3 Detail from Ophelia Among The Flowers see credit for page 82. Pages 4-5 Detail from Tiger In A Tropical Storm see credit for page 95. Pages 6-7 Madame Moitessier (1856) by Ingres, oil on canvas, 120 x 92cm (47 x 36in), NG; Combing The Hair (c.1896) by Degas, oil on canvas, 114 x 146cm (45 x 57in), NG; Detail from Bathers At Asnières see credit for pages 90-91; Nocturne In Black And Gold (1875) by Whistler, oil on wood, 60 x 47cm (24 x 18in) Detroit Institute of Art, Detroit/AKG-images/Erich Lessing. Pages 8-9 Vision Of A Knight (c.1504) by Raphael, egg tempera on poplar, 17 x 17cm (7 x 7in), NG; At The Theatre (1876-77) by Renoir, oil on canvas, 65 x 50cm (26 x 20in), NG. Pages 10-11 The Family Of Darius Before Alexander (1565-70) by Veronese, oil on canvas, 236 x 475cm (93 x 187in), NG; The Raft of the Medusa (1818) by Géricault, oil on canvas, 490 x 720 cm (193 x 283in), The Art Archive/Musée du Louvre, Paris/Dagli Orti; Liberty Leading The People (1831) by Delacroix, oil

on canvas, 260 x 325cm (102 x 128in), The Art Archive/Musée du Louvre, Paris/Dagli Orti. Pages 12-13 Portrait Of A Lady in Red (c.1460-70) by an unknown artist, oil and egg tempera on wood, 42 x 29cm (17 x 11in), NG; Self Portrait Aged 63 (1669) by Rembrandt, oil on canvas, 86 x 71cm (34 x 28in) NG; Self Portrait In A Straw Hat (after 1782) by Vigée-Lebrun, oil on canvas, 98 x 71cm (39 x 28in), NG; Portrait Of Picasso (1912) by Grís, oil on canvas © Burstein Collection/CORBIS/ADAGP, Paris and DACS, London 2003. Pages 14-15 Saint John The Baptist Retiring To The Desert (1453) by Giovanni, egg tempera on poplar, 31 x 39cm (12 x 15in), NG; An Autumn Landscape (1636) by Rubens, oil on oak, 131 x 229cm (52 x 90in), NG; The Water Lily Pond (1899) by Claude Monet, oil on canvas, 88 x 93cm (35 x 37in), NG; Route 6, Eastham (1941) by Hopper, oil on canvas, 71 x 97cm (28 x 38in) © Geoffrey Clements/CORBIS, by kind permission of Edward Hopper. Pages 16-17 Old Models (1892) by Harnett, oil on canvas, 138 x 72cm (54 x 28in) @ Burstein Collection/CORBIS; Fruit, Flowers And A Fish (1772) by van Os, oil on mahogany, 72 x 57cm (28 x 22in), NG; The Attributes Of The Arts (1766) by Chardin, oil on canvas, 112 x 141cm (44 x 56in) © Archivo Iconografico, S.A./CORBIS; Van Gogh's Chair (1888) by van Gogh, oil on canvas, 92 x 73cm (36 x 29in), NG. Pages 18-19 Detail from The Wilton Diptych see credit for pages 28-29. Pages 20-21 Egyptian tomb painting (c.1350BC) @ Archivo Iconografico, S.A./CORBIS; scene from The Book Of The Dead, British Museum/HIP; Minoan mural of bull jumping (c.1500BC) © Gustavo Tomsich/CORBIS; Mycenaean chariot krater (c.1400-1300BC), British Museum/HIP. Pages 22-23 Greek cup with dancer (c.500-400BC), British Museum/HIP; discus thrower statue © Araldo de Luca/CORBIS; bust of Caesar (c.AD1-50) © Ruggero Vanni/CORBIS; mural from Pompeii © Mimmo Jodice/CORBIS. Pages 24-25 St. Matthew from The Book Of Kells (700s) © Bettmann/CORBIS; panel showing Miracle of Cana (800s), ivory, British Museum/HIP; Viking brooch (1000s), silver, British Museum/HIP; carved monster (c.1115-25), stone © Michael Busselle/CORBIS. Pages 26-27 Photograph of church interior with mosaics (1100s) © Photo Scala, Florence/Palatine Chapel, Palermo 1990; mosaic panel of The Multiplication Of The Loaves And Fishes (500s) © Photo Scala, Florence/Sant'Apollinare Nuovo, Ravenna 1990, courtesy of the Ministero Beni e Att. Culturali; Italian icon of Madonna and Child (900s) © Photo Scala, Florence/St. Mark's, Venice 1999; Russian icon of St. George (1400s), tempera on panel, Museum of the History of Religion, St. Petersburg, Russia/Bridgeman Art Library. Pages 28-29 The Wilton Diptych (c.1395-99), egg tempera on oak, 57 x 29cm (22 x 11in), NG. Pages 30-31 The Coronation Of The Virgin (1370-71) by di Cione, egg tempera on poplar, 207 x 114cm (81 x 45), NG; St. Michael And The Devil (1468) by Bermejo, oil on wood, 179 x 82cm (70 x 32in), NG. Pages 32-33 May from The Very Rich Hours, often known by its French title Les Très Riches Heures du Duc de Berry (c.1416) by the Limbourg brothers, 14 x 16 cm (5.5 x 6in), Musée Condé, Chantilly/AKG-images; To My One Desire also known by its French title A Mon Seul Désir (c.1410-20) tapestry, Musée de Cluny, Paris © Francis G. Mayer/CORBIS; The Vision Of St. Eustace (c.1438-42) by Pisanello, egg tempera on wood, 55 x 66cm (22 x 26in), NG. Pages 34-35 Detail from Narcissus see credit for page 46. Pages 36-37 St. Luke Painting The Virgin (c.1530) by a follower of Quinten Massys, oil on oak, 114 x 35cm (45 x 14in), NG; Man In A Turban (1433) by van Eyck, oil on wood, 33 x 26cm (13 x 10in), NG; The Virgin And Child Before A Firescreen (1500-25) by Campin, oil on oak, 63 x 49cm (25 x 19in), NG. Pages 38-39 The Virgin And Child (1426) by Masaccio, egg tempera on poplar, 136 x 73cm (54 x 29in), NG; The Annunciation (1486) by Crivelli, egg tempera and oil on canvas, transferred from wood, 207 x 147cm (81 x 58in), NG; The Battle Of San Romano (c.1450s) by Ucello, egg tempera on poplar, 182 x 320cm (72 x 126in), NG; photograph of Florence @ Michael S. Lewis/CORBIS. Pages 40-41 Portrait Of A Lady In Yellow (1465) by Baldovinetti, egg tempera and oil on wood, 63 x 41cm (25 x 16in), NG; *Pope Julius II* (1522-12) by Raphael, oil on wood, 108 x 81cm (43 x 32in), NG; *Portrait* Of A Lady (c.1511) by Titian, oil on canvas, 120 x 100cm (47 x 39in), NG; The Ambassadors (c.1533) by Holbein, oil on oak, 207 x 210cm (81 x 83in), NG. Pages 42-43 The Arnolfini Portrait (1434) by van Eyck, oil on oak, 82 x 60cm (32 x 24in), NG. Pages 44-45 The Baptism Of Christ (1450s) by Piero, egg tempera on poplar, 167 x 116cm (66 x 46in), NG; Creation Of Adam (1508-12) by Michelangelo, fresco, 280 x 570 cm (110 x 224in) © Bettmann/CORBIS; The Virgin Of The Rocks (c.1508) by Leonardo, oil on wood, 190 x 120cm (75 x 47in), NG; The Virgin And Child With St. Anne And St. John The Baptist (c.1507-08) by Leonardo, charcoal, black and white chalk on tinted paper, 142 x 105cm (56 x 41in), NG. Pages 46-47 Cupid complaining to Venus (1530s) by Cranach, oil on wood, 82 x 56cm (32 x 22in), NG; Apollo And Daphne (c.1470-80) by del Pollaiuolo, oil on wood, 30 x 20cm (12 x 8in), NG; Narcissus (c.1490-99) by a follower of Leonardo, oil on wood, 23 x 26cm (9 x 10in), NG; Bacchus And Ariadne (1521-23) by Titian, oil on canvas, 172 x 188cm (68 x 74in), NG. Pages 48-49 Venus And Mars (c.1485) by Botticelli, egg tempera and oil on poplar, 69 x 173cm (27 x 68in), NG. Pages 50-51 The Agony In The Garden (c.1465) by Bellini, egg tempera on wood, 81 x 127cm (32 x 50in), NG; St. Jerome In A Rocky Landscape (c.1515-24) by Patinir, oil on oak, 36 x 34cm (14 x 13in), NG; Hunters In The Snow (1565) by Bruegel, oil on panel, 117 x 162cm (46 x 64in), The Art Archive/Kunsthistorisches Museum, Vienna; The Sunset (1506-10) by Giorgione, oil on canvas, 73 x 92cm (29 x 36in), NG. Pages 52-53 Detail from The Vision Of St. Joseph see credit for pages 58-59. Pages 54-55 The Ecstasy Of St. Theresa (1647-52) by Bernini, marble, height approx. 350cm (138in), Santa Maria della Vittoria, Rome © Massimo Listri/CORBIS; Perseus Turning Phineas And His Followers Into Stone (c.1680) by Giordano, oil on canvas, 285 x 366cm (112 x 144in), NG; Self Portrait (1670-73) by Murillo, oil on canvas, 122 x 107cm (48 x 42in), NG; Belshazzar's Feast (c.1635) by Rembrandt, oil on canvas, 168 x 209cm (66 x 82in), NG. Pages 56-57 The Supper At Emmaus (1601) by Caravaggio, oil and egg tempera on canvas, 141 x 196cm (56 x 77in), NG; Sick Bacchus (1593-94) by Caravaggio, oil on canvas, 67 x 53 cm (26 x 21in) © Archivo Iconografico, S.A./CORBIS. Pages 58-59 The Vision Of St. Joseph (c.1638) by de Champaigne, oil on canvas, 209 x 156cm (82 x 61in), NG; The Virgin In Prayer (1640-50) by Sassoferrato, oil on canvas, 73 x 58cm (29 x 23in), NG; The Interior Of The Buukerk At Utrecht (1644) by Saenredam, oil on oak, 60 x 50cm (24 x 20in), NG; The Adoration Of The Shepherds (1646) by Rembrandt, oil on canvas, 66 x 55cm (26 x 22in), NG. Pages 60-61 Philip IV In Brown And Silver (1631-32) by Velásquez, oil on canvas, 195 x 110cm (77 x 43in), NG; Charles I On Horseback (c.1637-38) by van Dyck, oil on canvas, 367 x 292cm (144 x 115in), NG; *The Toilet Of Venus* (1647-51) by Velásquez, oil on canvas, 123 x 177cm (48 x 70in), NG; *The Triumph* Of Pan (1636) by Poussin, oil on canvas, 134 x 145cm (53 x 57in), NG. Pages 62-63 Peace And War (1629-30) by Rubens, oil on canvas, 204 x 298cm (80 x 117in), NG; Self Portrait (1638-40) by Rubens, oil on canvas, 110 x 85cm (43 x 33in) © Francis G. Mayer/CORBIS. Pages 64-65 Landscape With Hagar And The Angel (1646) by Claude, oil on canvas mounted on wood, 53 x 44cm (21 x 17in), NG; The Avenue At Middelharnis (1689) by Hobbema, oil on canvas, 104 x 141cm (41 x 56in), NG; The Courtyard Of A House In Delft (1658) by de Hooch, oil on canvas, 74 x 60cm (29 x 24in), NG; A View Of Delft With A Musical Instrument Seller's Stall (1652) by Fabritius, oil on canvas stuck onto walnut panel, 15 x 32cm (6 x 13in), NG. Pages 66-67 A Young Woman standing At A Virginal (c.1670) by Vermeer, oil on canvas, 52 x 45cm (20 x 18in), NG; A Lady Teaching A Child To Read (c.1670s) by Netscher, oil on oak, 45 x 37cm (18 x 15in), NG; The Effects Of Intemperance (c.1663-65) by Steen, oil on wood, 76 x 107cm (30 x 42in), NG. **Pages 68-69** *Flowers In A Terracotta Vase* (1736) by van Huysum, oil on canvas, 134 x 92cm (53 x 36in), NG; Still Life With Drinking Horn (c.1653) by Kalf, oil on canvas, 86 x 102cm (34 x 40in), NG; An Allegory Of The Vanities Of Human Life (c.1640) by Steenwyck, oil on oak, 39 x 51cm (15 x 20in), NG. Pages 70-71 The Scale Of Love (1715-18) by Watteau, oil on canvas, 51 x 60cm (20 x 24in), NG; An Allegory With Venus And Time (1754-58) by Tiepolo, oil on canvas, 292 x 190cm (115 x 75in), NG; A Lady In A Garden Taking Coffee (c.1742) by Lancret, oil on canvas, 89 x 98cm (35 x 39in), NG. Pages 72-73 Mr. And Mrs. Andrews (1750) by Gainsborough, oil on canvas, 70 x 119cm (28 x 47in), NG; Colonel Banastre Tarleton (1782) by Reynolds, oil on canvas, 236 x 145cm (93 x 57in), NG; The Marriage Settlement (c.1743) by Hogarth, oil on canvas, 91 x 70cm (36 x 28in), NG. Pages 74-75 Charles Townley's Library

(1782) by Zoffany, oil on canvas, 127 x 99cm (50 x 39in), Towneley Hall Art Gallery and Museum, Burnley, Lancashire/Bridgeman Art Library; Landscape With Diana And Callisto (c.1757) by Wilson, oil on canvas, 103 x 139cm (41 x 55in), Board of the Trustees of the National Museums and Galleries on Merseyside (Lady Lever Art Gallery, Port Sunlight); Interior Of Saint Peter's, Rome (before 1742) by Panini, oil on canvas, 150 x 223cm (59 x 88in), NG; A Regatta On The Grand Canal (c.1740) by Canaletto, oil on canvas, 122 x 183cm (48 x 72in), NG. Pages 76-77 Detail from Bathers At Asnières see credit for pages 90-91. Pages 78-79 The Oath Of The Horatii (1784) by David, oil on canvas, 330 x 425cm (130 x 167in) © Archivo Iconografico, S.A./CORBIS; The Third Of May 1808 (1814-15) by Goya, oil on canvas, 267 x 345cm (105 x 136in) @ Archivo Iconografico, S.A./CORBIS; Napoleon I On His Imperial Throne (1806) by Ingres, oil on canvas, 259 x 162cm (102 x 64in) Musée de l'Armée, Paris/AKG-images. Pages 80-81 Salisbury Cathedral (1831) by Constable, oil on canvas, 152 x 190cm (60 x 75in), NG; Winter Landscape (1811) by Friedrich, oil on canvas, 33 x 45cm (13 x 18in), NG; Ovid Among The Scythians (1859) by Delacroix, oil on canvas, 88 x 130cm (35 x 51in), NG. Pages 82-83 St. George And The Dragon (1889-90) by Moreau, oil on canvas, 141 x 97cm (56 x 38in), NG; Ophelia Among The Flowers (1905-98) by Redon, pastel on paper, 64 x 91cm (25 x 36in), NG; Ophelia (1851-52) by Millais, 1851-52, oil on canvas, 76 x 112cm (30 x 44in), Tate London 2003. Pages 84-85 Photograph of Paris in the 19th century, Hulton Archive/Getty Images; Music In The Tuileries Gardens (1862) by Manet, oil on canvas, 76 x 118cm (30 x 46in), NG; Miss La-La At The Fernando Circus (1879) by Degas, oil on canvas, 117 x 78cm (46 x 31in), NG; Saint Lazare Station (1877) by Monet, oil on canvas, 54 x 74cm (21 x 29in), NG. Pages 86-87 Rain, Steam And Speed (before 1844) by Turner, oil on canvas, 91 x 122cm (36 x 48in), NG; The 'Fighting Temeraire' (1839) by Turner, oil on canvas, 91 x 122cm (35 x 48in), NG; Self Portrait (c.1799) by Turner, oil on canvas, 74 x 58cm (29 x 23in), Tate London 2003. Pages 88-89 Monet Working On His Boat (1874) by Manet, oil on canvas, 83 x 101 cm (33 x 40in) © World Films Enterprise/CORBIS; Fox Hill (1870) by Pissaro, oil on canvas, 35 x 46cm (14 x 18in), NG; The Beach At Trouville (1870) by Monet, oil on canvas, 38 x 46cm (15 x 18in), NG; Boating On The Seine (c.1879-80) by Renoir, oil on canvas, 71 x 92cm (28 x 36in), NG. Pages 90-91 Bathers At Asnières (1884) by Seurat, oil on canvas, 201 x 300cm (79 x 118in) NG. Pages 92-93 Le Bec Du Hoc (1888) by Seurat, oil on canvas, 65 x 82cm (26 x 32in), NG; Sunflowers (1888) by van Gogh, oil on canvas, 92 x 73cm (36 x 29in), NG; Harvest At Le Pouldu (1890) by Gauguin, oil on canvas, 73 x 92cm (29 x 36in), NG; The Talisman (1888) by Sérusier, oil on wood panel, 27 x 22cm (11 x 9in) © Archivo Iconografico, S.A./CORBIS. Pages 94-95 Wheatfield With Cypresses (1889) by van Gogh, oil on canvas, 72 x 91cm (28 x 36in), NG; Faa Iheihe (1898) by Gauguin, oil on canvas, 54 x 170cm (21 x 67in), NG; Tiger In A Tropical Storm (1891) by Rousseau, oil on canvas, 130 x 162cm (51 x 64in), NG. Pages 96-97 Hillside In Provence (1880s) by Cézanne, oil on canvas, 64 x 79cm (25 x 31in), NG; Houses At L'Estague (1908) by Braque, oil on canvas, 73 x 60cm (29 x 24 in), Rupf Foundation, Bern, Switzerland/Giraudon/Bridgeman Art Library @ ADAGP, Paris and DACS; Still Life With Violin And Fruit (1912) by Picasso, charcoal, chalk, watercolor, oil, newspaper and colored paper on cardboard, 64 x 50cm (25 x 20in) © Francis G. Mayer/CORBIS/Succession Picasso/DACS 2003. Pages 98-99 Detail from The Large Blue Horses see credit for pages 102-103. Pages 100-101 Abstract Speed (1913) by Balla, oil on canvas, 50 x 65cm (20 x 26in), Tate London 2003 © DACS 2003; Champ De Mars, La Tour Rouge (The Red Tower), (1911-12) by Delaunay, oil on canvas, 163 x 130cm (64 x 51in) © L & M Services B.V. Amsterdam 20030301; The City (1919) by Leger, oil on canvas, 231 x 300cm (91 x 118in) © Philadelphia Museum of Art/CORBIS/ADAGP, Paris and DACS, London 2003. Pages 102-103 The Scream (1893) by Munch, tempera and pastel on board, 91 x 74cm (36 x 29in) © J. Lathion/National Gallery Norway/Munch Museum/Munch-Ellingsen Group, BONO, Oslo/DACS, London 2003; Madame Matisse (1905) by Matisse, oil and tempera on canvas, 41 x 33cm (16 x 13in) @ Archivo Iconografico, S.A./CORBIS/Succession H. Matisse/DACS 2003; Berlin Street Scene (1913) by Kirchner, oil on canvas, 121 x 95cm (48 x 37in), Brucke Museum, Berlin, Germany/Bridgeman Art Library © (for works by E.L. Kirchner) by Ingeborg & Dr. Wolfgang Henze-Ketterer, Wichtrach/Bern; The Large Blue Horses (1911) by Marc, 107 x 180cm (42 x 71in) Collection Walker Art Centre, Minneapolis, Gift of the T.B. Walker Foundation, Gilbert M. Walker Fund, 1942. Pages 104-105 Cossacks (1910-11) by Kandinsky, oil on canvas, 95 x 130cm (35 x 51in), Tate London 2003 @ ADAGP, Paris and DACS, London 2003; Black Circle (1913) by Malevich, oil on canvas, 106 x 106cm (42 x 42in) © The State Russian Museum/CORBIS; Composition In Red, Yellow And Blue (1927) by Mondrian, oil on canvas, 38 x 35cm (15 x 14in) © Burstein Collection/CORBIS/2003 Mondrian/Holzman Trust c/o HCR International; Untitled (c.1955) by Rothko, oil on acrylic on paper, 61 x 48cm (24 x 19in) © Christie's Images/CORBIS/Kate Rothko Prizel and Christopher Rothko/DACS 1998. Pages 106-107 Fountain (1917) by Duchamp, 'Readymade' porcelain urinal (original now lost) height 60cm (24in) © Burstein Collection/CORBIS/Succession Marcel Duchamp/ADAGP, Paris and DACS, London 2003; Soft Watch At Moment Of First Explosion (1954) by Dalí, oil on canvas, 21 x 26cm (8 x 10in) © Christie's Images/CORBIS/Salvador Dalí, Gala-Salvador Dalí Foundation/DACS, London 2003; The Art Of Conversation (c.1963) by Magritte, oil on canvas, 65 x 81cm (26 x 32in) © Christie's Images/CORBIS/ADAGP, Paris and DACS, London 2003; Carnival Of Harlequin (1924-25) by Miró, oil on canvas, 66 x 93cm (26 x 37in) © Albright-Knox Art Gallery/CORBIS/ADAGP, Paris and DACS, London 2003. Pages 108-109 A Battery Shelled (1919) by Lewis, oil on canvas, 153 x 318cm (60 x 124in) The Imperial War Museum, London; Beat The Whites... (1919-20) by El Lissitzky, poster, ink on paper, 48 x 69cm (19 x 27in), Collection Van Abbemuseum © DACS 2003; Pillars Of Society (1926) by Grosz, oil on canvas, 200 x 108 cm (79 x 43in), SMPK, National galerie, Berlin/AKG-images © DACS 2003; Large Woman Upright IV (1960) by Giacometti, bronze © Christie's Images/CORBIS/ADAGP, Paris and DACS, London 2003. Pages 110-11 Guernica (1937) by Picasso, oil on canvas, 349 x 777cm (138 x 306in) © Burstein Collection/CORBIS/Succession Picasso/DACS 2003; photograph of Guernica after the bombing © Bettmann/CORBIS. Pages 112-113 Whaam! (1963) by Lichtenstein, acrylic on canvas, 172 x 406cm (68 x 160in), Tate London 2003 © The Estate of Roy Lichtenstein/DACS 2003; Just What Is It That Makes Today's Homes... (1956) by Hamilton, collage, 26 x 25cm (10 x 10in) Kunsthalle Tübingen/AKG-images © Richard Hamilton 2003, All Rights Reserved, DACS. Pages 114-115 Icicle Star, Scaur Water, Dumfriesshire, 12th January 1987 by Goldsworthy © Andy Goldsworthy; Bride (1994) by Rego, pastel on paper, 120 x 160cm (47 x 63in), Tate London 2003, by kind permission of Paula Rego; Nantes Triptych (1992) by Viola, video/sound installation, by kind permission of Bill Viola; The Impossibility Of Death In The Mind Of Someone Living (1991) by Hirst, 427cm (168in) tiger shark in glass tank filled with 5% formaldehyde solution © Damien Hirst. Pages 118-119 The Virgin And Child With St. John and Angels (c.1495) by Michelangelo, egg tempera on wood, 105 x 77cm (41 x 30in), NG; photograph of an artist's palette © James Marshall/CORBIS. Pages 120-121 Dürer's Drawing Machine (1525) by Dürer, engraving © Stapleton Collection/CORBIS; A Young Woman Standing At A Virginal see credit for page 66. Pages 122-123 Detail from The Virgin And Child Before A Firescreen see credit for page 37; photograph of a conservator working on a gilded frame, NG; details from Bacchus And Ariadne see credit for page 47; photograph of a conservator repairing The Ambassadors, NG. Pages 124-125 Portrait Of Dr. Gachet (1890) by van Gogh, oil on canvas, 67 x 56cm (26 x 22in) © Bettmann/CORBIS; Mona Lisa (c.1505-14) by Leonardo, oil on wood, 77 x 53 cm (30 x 21in) © Dallas and John Heaton/CORBIS; photograph of Han van Meegeren © Bettmann/CORBIS; Woman Reading A Letter (sometimes known as Woman Reading Music), (c. 1935-36) Vermeer fake by van Meegeren, oil on canvas, 57 x 48cm (22 x 19in), H.A. Meegeren/Rijks Museum, Amsterdam. Pages 126-127 discus thrower statue, see credit for page 22; Venus And Mars see credit for pages 48-49; Peace And War see credit for pages 62-63; An Allegory With Venus And Time see credit for page 71; The Beach At Trouville see credit for page 89; The Physical Impossibility Of Death... see credit for page 115.